Draw and Paint 50 Animals

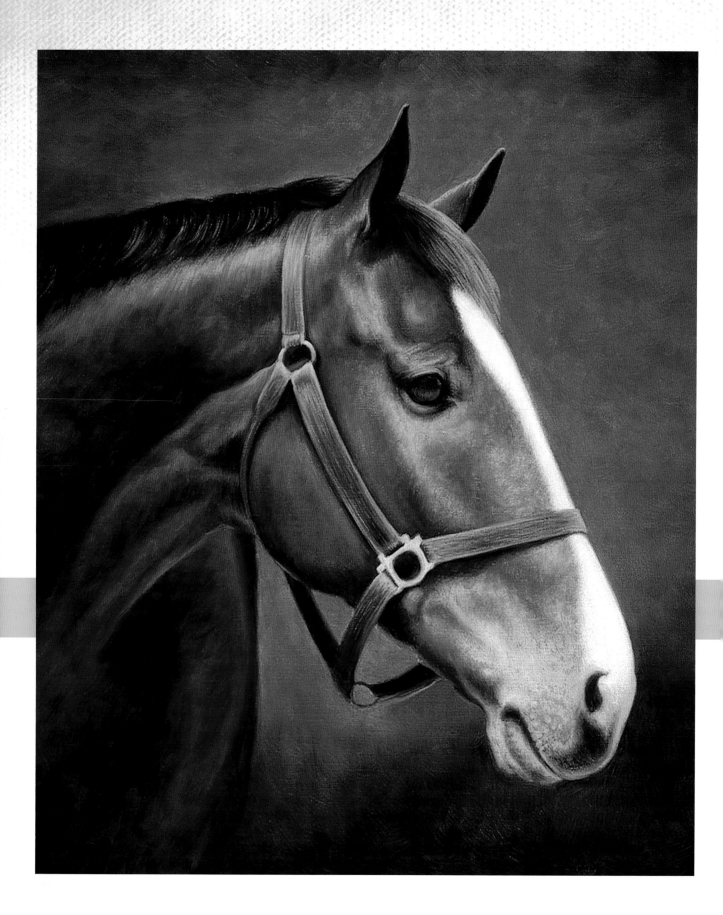

draw. AND paint 50 animals

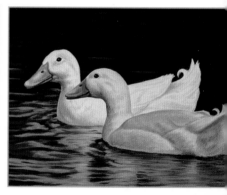

Jeanne Filler Scott

NORTH LIGHT BOOKS
CINCINNATI, OHIO
artistsnetwork.com

Contents

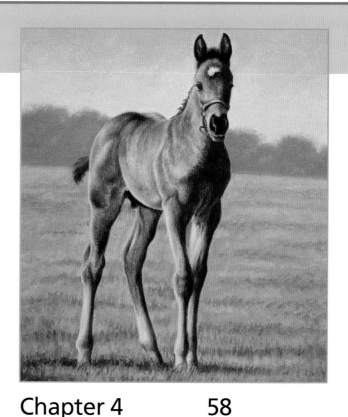

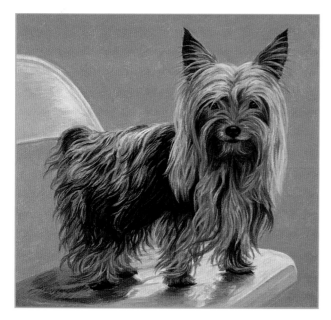

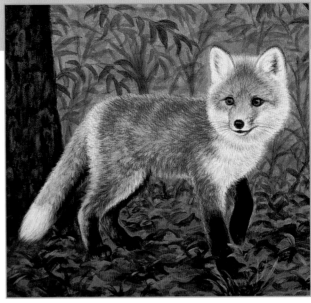

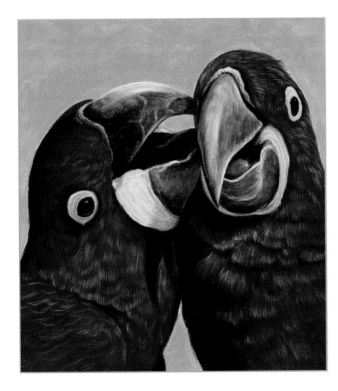

1 Getting Started

To get started drawing and painting, you will need the right supplies. You don't have to buy the most expensive art supplies, but you should get the best available to you. Remember, the most expensive brushes aren't the key to becoming a master, and a good artist can use moderately priced brushes to produce a masterpiece!

Three mediums are used in this book: acrylics, oils and pencil. In this section, I'll provide you with a list and description of everything you'll need for each medium. I'll also cover some basic techniques to get you started drawing and painting as well as finding references.

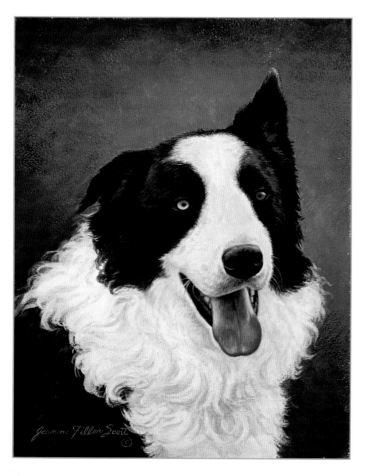

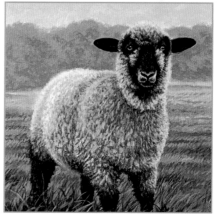

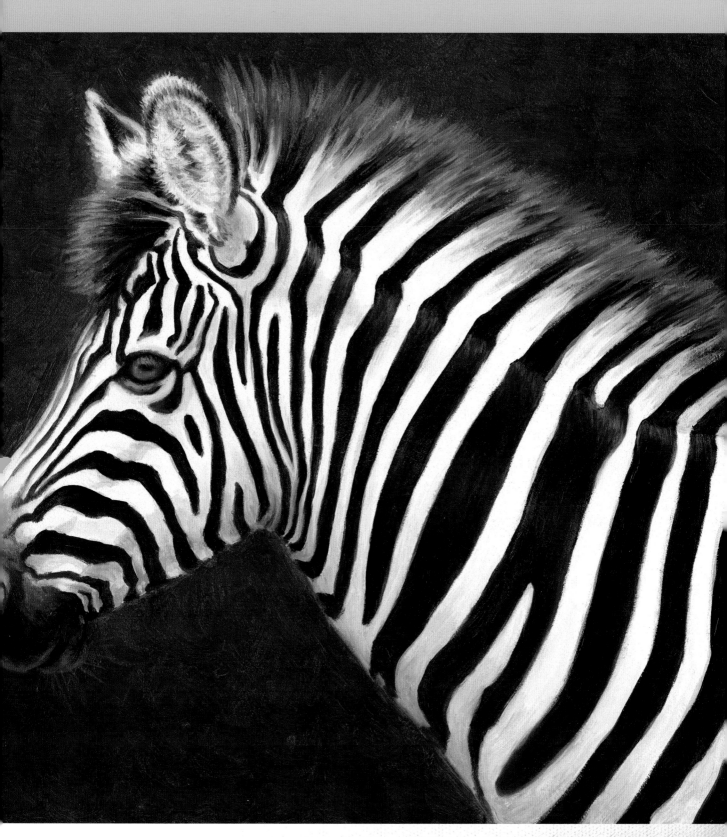

Drawing Materials

We'll start with pencil drawings, which require just a few simple materials:

Surface
Bristol paper with a smooth finish makes an excellent surface for fine pencil work and withstands some erasure without roughening the paper surface. You can also use hot-pressed illustration board, which has slightly more texture than the bristol paper and can also withstand erasures.

Pencils
Use a no. 2 pencil for your preliminary underlying sketch, whether you're sketching directly on the bristol paper or transferring your sketch with tracing paper.

For the final drawing, use ebony pencils. They are jet black and smooth to work with because they are softer and denser than ordinary pencils. This also makes them easier to blend with a stump.

Kneaded Eraser
The kneaded eraser is best for pencil work as it erases cleanly and can be formed into any shape for detailed erasures. Also, you can easily clean the eraser by kneading and working it around. You can use a kneaded eraser to lighten areas that have gotten too dark by repeatedly pressing the eraser lightly onto the area until it is the right tone.

Blending Stump
Similar to tortillions, stumps are made of soft, tightly spiral-wound paper. They are a good tool for smoothing and blending and give a softer look to some areas of your drawing than can be achieved by the pencil alone.

Pencil Sharpener
It's important to have a good pencil sharpener, preferably electric, so you can quickly sharpen your pencils to a fine point. It's a good idea to sharpen several pencils at once so when one gets dull, you don't have to stop to sharpen it.

Spray Fixative
Spray fixative stabilizes drawings so that the penciling won't smudge or smear if it is accidentally touched or rubbed. Workable fixative is best since it provides lasting protection, yet you can still rework the drawing if you decide to make changes. Apply it in a place with plenty of ventilation, placing the drawing on a larger piece of scrap paper or cardboard so you don't get the spray onto anything else. Cover the surface uniformly but without drips.

Gather Your Supplies
Here is what you'll need for your pencil drawings: a surface (bristol paper or illustration board), a no. 2 pencil, ebony pencils, kneaded eraser, blending stumps and spray fixative. It's also useful to have a good pencil sharpener and tracing paper for transferring your sketch to the surface. Drawing supplies are relatively inexpensive and easy to order over the Internet.

Painting Materials

The list of materials you'll need for painting is more extensive than for drawing. However, basic painting supplies are well worth the expenditure since they'll provide you hours of satisfaction and enjoyment as you create your own paintings.

Surface

The surface for most of the oil and acrylic painting demonstrations in this book is Gessobord, a pre-primed Masonite panel with a nice texture for realistic painting. It comes in a variety of sizes. I completed most of the demonstrations on 8" × 10" (20cm × 25cm) panels. Illustration board is fine for acrylic paintings, but since it is paper based, it is not suitable for oils. Although I prefer Gessobord for finished oil and acrylic paintings because of its permanence and smoother surface, illustration board has the advantage of being less expensive to buy, and it can be easily cut to any size you desire.

Paper Towels

Paper towels are useful for blotting excess paint, water, turpentine or medium from your brush. Keep a folded paper towel by your palette and a crumpled one in your hand or on the table.

Versatile Materials
Many of the same materials used for oil painting can also be used for acrylics—brushes, surface (Gessobord), palette knife, paper towels, no. 2 pencils and tracing paper. The difference is in the paints (oil or acrylic), medium (Liquin or water) and type of palette (disposable wax paper or Masterson Sta-Wet Palette).

Medium

Medium improves the flow of the paint so it is easier to spread and blend, and it can also be used for glazing. For acrylics, I use plain water instead of a manufactured medium. For oil painting, I use Winsor & Newton Liquin. It improves the flow of paint, makes the paint dry faster and is good for blending and glazing. I use turpentine or a turpentine substitute to thin a neutral color for blocking in the form in the first step of the painting and for cleaning brushes.

When painting with acrylics, it's important to change the water fairly frequently so it doesn't get too murky with paint. For oils, you may have to change your turpentine occasionally if it gets too saturated with paint. Always wipe as much paint from your brushes as possible with a paper towel before cleaning them.

No. 2 Pencil and Kneaded Eraser

You'll need a pencil and an eraser for drawing or tracing the image onto your panel. The kneaded eraser is good for making corrections and for lightening pencil lines so that they won't show through the paint.

Tracing Paper

You'll need tracing paper if you want to trace your sketch or the template drawing provided with each demonstration. After tracing your sketch, you can transfer it to the Gessobord using homemade carbon paper. The advantage of doing the sketch on a separate piece of paper, and not directly onto the panel, is that you have much more control over the size and placement of the subject, often resulting in a better painting.

Varnish

When an oil painting is completely dry (which can take six months to a year, depending on how thick the paint is), it should be varnished with a final picture varnish for total surface protection and to restore colors. You should keep a schedule and inform people who receive your art that they or someone else must apply the varnish to preserve the value of their acquisition. Although it isn't necessary, some artists also choose to varnish acrylic paintings because they want the painting to appear glossier or to add a protective layer.

Palette

The Masterson Sta-Wet Palette works well for acrylics because it keeps your paints from drying out for days or even weeks. The 12 " × 16 " (30cm × 41cm) size is best as it gives you plenty of room to mix colors. The palette consists of a 1¾-inch (4cm) deep plastic box with a sponge insert that fills the bottom of the box when wet. A special disposable paper, called acrylic film, sits on top of the sponge insert. The box has an airtight lid.

For oil painting, I use a 12 " × 16 " (30cm × 41cm) disposable wax paper palette. When you are finished with a sheet, you just tear it off and discard and use the new sheet underneath. A plastic box with a lid (similar to the one for the Masterson Sta-Wet Palette) will help keep your paints from drying out.

Acrylic Palette Tip

The directions that come with the Masterson Sta-Wet Palette tell you not to wring out the wet sponge. However, I find that if I don't gently press out some of the water, my paints become too runny after a short time. If the paints start to dry out, spray them lightly with water from a spray bottle.

Palette Knife

You'll need a palette knife for mixing both oil and acrylic colors. A tapered steel knife works best, and the trowel type with a handle lifted above the blade is the easiest to use. Be sure to clean your palette knife between colors. Wiping it on a paper towel is usually sufficient, but occasionally you'll have to rinse it in water or turpentine.

Wax Paper

It's useful to keep wax paper on hand for times when you want to paint a thicker acrylic layer (the Sta-Wet Palette always adds some water to the paint). Simply transfer some color from your palette to the wax paper. The wax paper will prevent the paint from becoming diluted, and the paint will immediately begin to dry out and thicken. Lightly spray the paint with water to keep it from drying up completely.

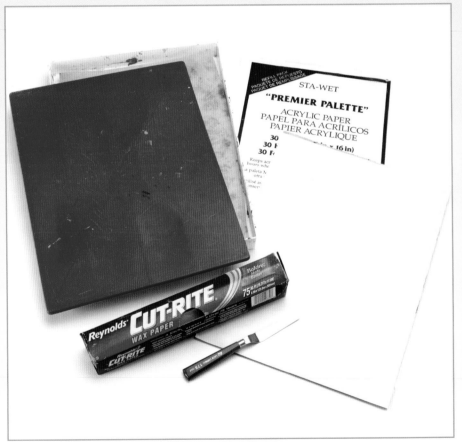

Palette Types
Oils and acrylics require different types of palettes, but you can use the same palette knife for both mediums.

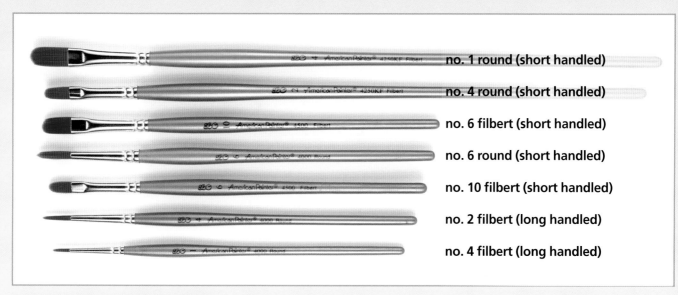

no. 1 round (short handled)
no. 4 round (short handled)
no. 6 filbert (short handled)
no. 6 round (short handled)
no. 10 filbert (short handled)
no. 2 filbert (long handled)
no. 4 filbert (long handled)

Keep Multiples of Each Brush Size
It's a good idea to have two or three copies of each of the round sizes and at least two of each of the filberts. That way, you can use two or three brushes alternately with different colors to blend without having to stop and clean your brush each time.

Brushes

I keep on hand dozens of brushes in all different brands, types and sizes. The numbers used to designate the sizes of brushes vary widely from one manufacturer to another. For example, a no. 1 round of one brand could be a very small brush used for detail, while a no. 1 round of a different brand could be much larger and not at all suitable for small detail. I've found that even within one brand, the length of the handle (long or short) can make a big difference in the size number. When I paint, I tend to pick up any brand of brush in a size and type that looks right for what I am doing. This method seems the most practical.

The brushes I use are made of a synthetic sable called golden Taklon and have firmness as well as flexibility. In order to have the right mix of types and sizes, I have used both long- and short-handled brushes.

There are several brush sizes used for the demonstrations in this book, including:

Rounds: no. 1, 4 and 6 with short handles.

Filberts: no. 6 and 10 with short handles and no. 2 and 4 with long handles.

Brights: no.10 (a stiff, short-haired flat brush).

Shaders: no. 8 and 10, good for backgrounds.

Rounds come to a fine point and are best for detail, such as animal eyes or blades of grass. Filberts are good for broader areas like large areas of grass or sky. They hold a lot of paint and are tapered so that it's easier to paint around objects.

It's best to have two or three of the more frequently used brushes, such as no. 1, 3, 4 and 10 rounds and no. 2 and 6 filberts. As you'll see in the demonstrations, you will often need two or three of the same size brush, each with a different color, so you can use them alternately while blending.

You can use the same brushes for the oil and acrylic demonstrations in this book. Just be sure to wash the brushes well at the end of your painting sessions. For acrylics, you need only to rinse the brushes well in water. For oils, you must rinse the brushes out well in turpentine or turpentine substitute, blot on a paper towel, then use water and a brush cleaner such as the Masters Brush Cleaner and Preserver to complete the cleaning. You can also use dish soap for this purpose.

Acrylics

I painted the demonstrations in this book with Liquitex Heavy Body Professional Artist Acrylic Colors that come in tubes. I like these paints because they have a good consistency—smooth but not runny—and can either be thinned to a watercolor-type glaze or applied in a thicker, more opaque layer with lots of possibilities in between. They are also permanent and richly colored, and will not crack or yellow when dry. However, there are many brands of acrylic paint available, so experiment and find out what works best for you. The colors I use most in this book include: Burnt Sienna, Burnt Umber, Cadmium Orange, Cadmium Red Medium, Cadmium Yellow Deep, Cerulean Blue, Hansa Yellow Light, Hooker's Green Permanent, Naples Yellow, Raw Sienna, Red Oxide, Scarlet Red, Titanium White, Ultramarine Blue and Yellow Oxide.

Mixing Acrylic Colors

Painting with pigments straight from the tube results in garish, unrealistic colors. Most of the colors you use will be a mixture of two or more pigments.

Be sure to mix a large enough quantity of each color so that you have enough to finish the painting. This is easier than trying to mix the same color a second time. Save all of your color mixtures until you have completed the painting. You never know when you may need a color again to reestablish a detail, for example. You can also use a previously mixed color as the basis for a new color by simply adding another color or two to a portion of a mixture you've already created.

Acrylic Color Requirements
Here are a few of the acrylic paints I use in this book. The colors required in the demonstrations vary with the subject, some requiring more or different colors than others.

Useful Acrylic Mixtures

Here are some useful color mixtures:

 Warm black: Mix Burnt Umber and Ultramarine Blue to paint an animal's coat. This black looks more natural than black from a tube.

Warm white: For painting highlights in animal fur, clouds or wildflowers, mix Titanium White and a touch of Hansa Yellow Light or Yellow Oxide.

 Basic green: Mix a basic green for grass and trees with Hooker's Green Permanent, adding a little Cadmium Orange and Burnt Umber to tone down the green. For darker shadows, mix in some Ultramarine Blue and more Burnt Umber. For highlight colors, add some Titanium White and Naples Yellow or Hansa Yellow Light.

 Basic grass: Mix a basic grass color with Hooker's Green Permanent, Titanium White, Naples Yellow and a little Cadmium Orange.

 Bluish green: For distant trees, mix Titanium White, Hooker's Green Permanent, Ultramarine Blue and a bit of both Cadmium Orange and Raw Sienna.

 Natural pink: For noses and white-furred animals, mix Titanium White, Scarlet Red and Burnt Umber or Burnt Sienna.

 Bluish shadow color: For shadowed areas in light, mix Titanium White, Ultramarine Blue and a little Burnt Umber or Burnt Sienna.

 Blue sky: Create this color with Titanium White, Ultramarine Blue and a touch of Naples Yellow. For a brighter blue, use Cerulean Blue instead of Ultramarine Blue.

Oils

I completed the oil demonstrations in this book with Grumbacher Pre-tested Oil colors, with the addition of Permalba White, a product of the Martin/F. Weber Co. Permalba White, a mixture of Titanium White and Zinc White, has a creamy, spreadable texture that makes it easy to paint with and to mix with other colors. The oil colors I used in this book include: Burnt Sienna, Burnt Umber, Cadmium Orange, Cadmium Red Light, Cadmium Yellow Light, Cerulean Blue, Naples Yellow, Permalba White, Raw Sienna, Ultramarine Blue Deep, Viridian and Yellow Ochre.

Oil Color Mixtures

Oil color mixtures are basically the same as the acrylic mixtures, except some of the colors are a little different and have different names (never mix oil and acrylic paints). Substitutions for acrylic to oil are as follows:

- For Ultramarine Blue, use Ultramarine Blue Deep. (Ultramarine Blue is available in some oil brands, but Grumbacher makes Ultramarine Blue Deep.)
- For Scarlet Red, use Cadmium Red Light.
- For Titanium White, use Permalba White. (Titanium White is also an oil color, but I prefer Permalba White.)

- For Hooker's Green Permanent, use Viridian.
- For Yellow Oxide, use Yellow Ochre.
- For Hansa Yellow Light, use Cadmium Yellow Light.
- For Red Oxide, use Indian Red.

Retouch Varnish

Oil paints tend to dry to a duller finish than when wet, which can make matching color mixtures difficult in subsequent painting sessions. Try applying damar retouch varnish once the painting is dry to the touch. Be sure to use with plenty of ventilation. The varnish takes only a few minutes to dry. Retouch varnish temporarily restores the luster and color to a painting so that it looks the same as when you first applied the wet paint. Since it is thin, retouch varnish allows the paint to keep drying underneath, which will prevent it from cracking later. When the painting is finished and fully dry, apply the final picture varnish. The colors will be restored and will all match because you used retouch varnish when starting each new painting session.

Oil Paint Brand Choices
I like Grumbacher oil colors because they are archival and permanent with rich color and a smooth consistency. There are many brands of oil paints available, so experiment and find out what works best for you.

Test Your Mixtures

When mixing a color on your palette, you can't be certain how it will look in the painting until you see it next to the other colors. Test the mixture by placing a small dab on the area to be painted. You can then modify the color so it will be the best for your painting.

Beginning a Painting

Template line drawings of each animal are provided with most of the demonstrations in this book. You can use these templates or create your own sketches.

Transferring Your Sketch

Whether you use the template or a sketch of your own, use a piece of tracing paper and a fine-point black marker to trace the image.

You can enlarge or reduce the size of the image to fit your panel with a copy machine or an opaque projector. If you use a photocopy, blacken the back of the copy with a no. 2 pencil, then tape the copy to your panel and trace the image with a pencil. You'll need to bear down with a fair amount of pressure, but this should result in transferring the graphite from the back of your photocopy onto the panel. Lift the tracing or copy paper occasionally to make sure you are pressing down hard enough and are getting the complete image. If your tracing comes out too dark (so that it will show through the paint), use a kneaded eraser to lighten it.

If you use an opaque projector, you can trace the sketch directly onto the panel from the projected image. This is a little more difficult than you might think, since you have to stand to one side so you don't block the light from the projector.

Doing an Underpainting

Once you have a pencil sketch on your panel, you are ready to do the underpainting. Neutral colors such as Burnt Umber or Payne's Gray, thinned with water, are good for this. As a rule of thumb, use Burnt Umber for brown or warm-colored animals—such as a chestnut horse—and Payne's Gray for gray, black or white animals—such as a dalmatian.

Squeeze out some of the underpainting color onto your palette, then mix it with a small amount of the water on the palette's surface. You want the paint to be thin but not too runny. Begin to paint, not worrying much about detail at this point. Just establish the main lines and the lights and darks. The purpose of the underpainting is to give you a rough guide to go by when you begin painting in full color.

General Steps for Completing the Painting

Once you have finished the underpainting, you are ready to apply the darkest value colors. This is followed by the middle value and then the lightest value colors. You will start with a small amount of detail, building upon this and adding more detail with each step. Doing a realistic painting is basically a process of refining as you go along and building upon what you've already done. In the final step, you will paint the finishing details.

Thickness of the Paint

When painting with acrylics, use just enough water so that the paint flows easily. You will usually need to apply two to three layers to cover an area adequately. Since the paint dries so quickly, this is easily accomplished. In general, shadows are painted fairly thin, while highlighted areas benefit from a little more thickness, which makes them stand out.

Transferring Your Sketch
With homemade carbon paper positioned underneath, the sketch is easily traced onto the panel.

Make Your Own Carbon Paper

Make your own carbon paper by blackening the back of a blank piece of tracing paper with a no. 2 pencil. You can use this homemade carbon paper over and over.

Types of Pencil Strokes

Here are some useful pencil strokes to use when sketching your preliminary animal drawings.

Smooth Parallel Strokes

With constant pressure on the pencil, lightly draw parallel lines of roughly the same length. This is a good basic shading technique.

Crosshatching

Shade with parallel lines, then shade over the first set of lines with strokes that go in a different direction. Crosshatching darkens areas more smoothly than simply shading in one direction.

Blending With a Stump/Tortillion

Rub a stump over pencil shading to soften and blend. Create different effects by varying the direction and pressure on the stump.

Layering Lines and Blending

Adding more pencil shading over a blended area can yield nice effects. Use the stump again, alternating between pencil and stump to achieve the desired texture.

Long, Curving Strokes

Use these strokes for tall grass, weeds and strands of hay or straw.

Flowing Strokes

These pencil strokes are good for flowing manes and tails.

Straight, Slightly Curved Strokes

Use these strokes for the stiff, slightly bending hairs of a donkey or zebra mane. These strokes are also good for depicting mowed grass.

Types of Brushstrokes

Learning to handle your brush is crucial in depicting the texture of fur, clouds, grass and feathers. There are several types of strokes you should be familiar with when painting the natural world.

Dabbing Vertical Strokes

These strokes are done quickly, in a vertical motion, with either a round or a flat brush. They are good for painting the texture of grass in a field.

Smooth Flowing Strokes

These strokes are good for long hair, such as a horse's mane or a long-haired cat's tail. Use a round brush with enough water so the paint flows, and make the strokes flowing and slightly wavy.

Dabbing Semicircular Strokes

These are done fairly quickly, in a semicircular movement, with a flat brush such as a shader. These strokes are good for skies, portrait backgrounds or other large areas that need to look fairly smooth, such as a wall or floor.

Small Parallel Strokes

Use this kind of stroke to paint detail, such as short animal fur or bird feathers, using the tip of your round. Be sure to paint in the direction the hair or feathers grow on the animal.

Glazing

A glaze or wash is used to modify an existing color by painting over it with a different color thinned with water so that the original color shows through. This creates a new color that you couldn't have achieved any other way. Dip your brush in water, then swish it around in a small amount of the glazing color. Blot briefly on a paper towel so you have a controllable amount of the glaze on your brush, then paint the color smoothly over the original color. In this detail of a log, a glaze of Burnt Sienna was painted over a portion of the log to show how the glaze warms up the colors.

Drybrush or Scumbling

This is when you modify a color you've already painted by painting over it with another color in an opaque fashion, so that the first color shows through. Dip a moist, not wet, brush into the paint, then rub it lightly on a paper towel so that there is just enough paint to create a broken, uneven effect when you paint over the original color. Repeat as necessary.

Smooth Horizontal or Vertical Strokes

These strokes are good for man-made objects and water reflections. Using enough water so the paint flows but is not runny, move your round brush evenly across the surface of the panel.

Creating Backgrounds

The background is frequently as important as the animal itself. Don't forget to include some of your subject's natural setting.

Work on the background and the subject simultaneously. This will make it much easier to integrate the animal with its surroundings. In a painting where the subject is defined by the background colors, such as white ducks against dark water, you will need to paint the background color earlier in the process.

There are two types of backgrounds used in the demos in this book: portrait and full (landscape) backgrounds.

Portrait Background

A portrait background usually consists of a basic color that sets off the main subject. There is often some variation, such as darker versions of the color in some areas that are blended into the main color. Another variation can be achieved by drybrushing another color over the original color. If the entire body of the animal is shown, it's a good idea to paint a shadow or a few sprigs of grass around the subject. A portrait background is often used when a detailed background would distract from the subject, such as when painting a head portrait.

Landscape Background

Landscape backgrounds are more of a challenge, but they can add a lot to a painting. The landscape does not need to have much detail to be effective. In fact, having too much detail in the background will distract the viewer from the focal point. Paint just enough detail to make the background look realistic.

Painting Trees
Paint trees with a basic green color mixture, using dabbing strokes and a flat brush. With a lighter green and a round brush, paint some detail to suggest clumps of leaves.

Clouds
Paint clouds in the sky with a warm white mixture. Use a flat brush and light, feathery dabbing strokes to paint the clouds right over the blue sky. Use a separate brush and the blue sky color to blend the undersides of the clouds with the sky.

Close-Up Grass
Paint close-up grass with a dark green shadow color and a lighter, basic grass color. Use round brushes to paint flowing, slightly curving strokes that taper at the ends and go in various directions. Overlap the greens and add some brown detail to integrate the animal and/or add realism, since most grass does not look as perfect as a golf course!

Broad Areas of Grass
Paint broad areas of grass with a combination of vertical and horizontal brushstrokes, with mostly vertical strokes in the foreground, transitioning to more horizontal strokes farther back. Make the strokes smaller as they recede into the landscape.

Skies
Paint skies with dabbing, semicircular strokes and a flat brush, such as a no. 10 shader. Make the sky lighter at the horizon by adding more Titanium White to a portion of the basic sky color, blending where the two colors meet.

Finding Animal Subjects

Here are some places to find wild and domestic animal subjects to draw and paint:

Zoos

Zoos are great places to sketch animals from life and gather great reference photos. Some modern zoos have the animals in naturalistic settings, which are not only better for the animals but also for the artist because it helps you place the animals in a more natural environment in your painting. If you tell the zoo employees that you are an artist, they will often be glad to assist, possibly even giving you a private showing of the animal you're interested in.

Parks

Parks and places where animals such as squirrels are fed and protected (and have lost much of their fear of people) can be good places to see wild animals up close. National parks such as Yellowstone National Park in Wyoming and Banff National Park in Canada, where hunting is not allowed, provide wonderful close-up wildlife viewing of animals such as deer, bighorn sheep, moose, bison, mountain goats, squirrels and many kinds of birds.

Wildlife Rehabilitators

Wildlife rehabilitators take in injured or orphaned wild animals and try to nurse them back to health so that they can be returned to the wild. If the animal cannot be released, they often provide it a home. I have found these people to be very friendly and helpful. They don't get the credit they deserve for all the good work they do, and they are usually happy to share the animals with people who are interested in them.

Veterinary Clinics

Veterinary clinics that take in wildlife can be approached for references. Some veterinarians volunteer their services to help wild animals in need, giving them emergency care and then turning them over to wildlife rehabilitators.

Hiking Trips

While hiking in the country or woods, always carry your camera and sketchbook in case an opportunity arises. You never know when you might happen upon an animal that is as surprised as you are at the encounter! You can also gather references for backgrounds—from wide-angle views of fields and forest clearings to small details such as ferns and toadstools.

Pet Owners

If you want to paint a Siamese cat, for example, ask your friends if they know anyone who has one, or call your local Humane Society or veterinary clinic for a referral. Most pet owners are proud of their animals and will gladly allow you to photograph them.

State and County Fairs

County fairs are often a good place to see a variety of domestic animals such as rabbits, chickens and horses. You can sketch and photograph them at your leisure. If you talk to the people who raise the animals, you have a good chance of being invited to their homes to see the animals in a quieter setting.

Farms

Horses, cattle, goats, chickens, llamas and other domestic animals can be found on farms. Take a drive through the country and pull to the side of the road to photograph or sketch animals. Always get the owner's permission before entering fields with animals.

Animal Shows, Pet Shops and More

Other places to see animals include horse shows, racetracks, dog shows, cat shows, herding dog trials, aquariums and pet shops. The opportunities for good reference gathering are out there—you just have to take advantage of them!

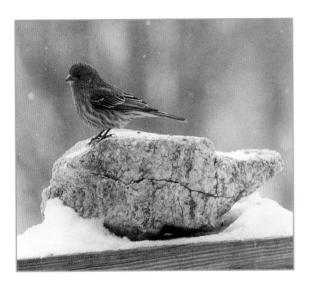

Painting at Home

In winter, we have many different kinds of birds at our feeders, including purple finches. Using a zoom lens, I took this photo through the glass doors that look out onto our deck. To paint the scene, I also referred to several bird books make sure the details of the bird's feathers were correct.

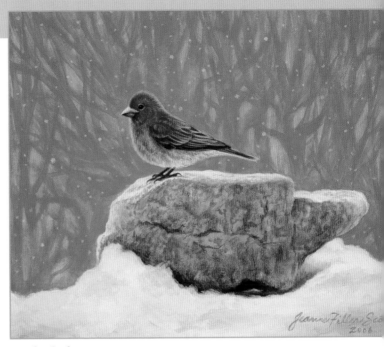

Purple Finch
Acrylic on Gessobord
8" × 10" (20cm × 25cm)

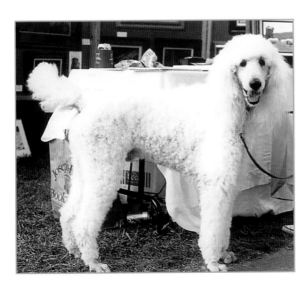

Borrowing From Strangers

At an outdoor art show in Lexington, Kentucky, this handsome white standard poodle and his owner stopped by to look at my artwork. With the owner's permission, I took a few photos of the dog, thinking that I might someday paint his portrait.

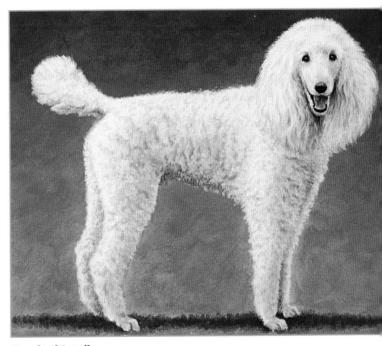

Standard Poodle
Acrylic on Gessobord
8" × 10" (20cm × 25cm)

Gathering References

There are many ways to collect your references, but photography and sketching are the most common.

Photography

If you are serious about being an artist who paints animals in a realistic, detailed style, photography is an important tool. Since animals move constantly, getting good photos is a challenge. While you can capture only a few lines in a sketch, photographs can preserve a moment in great detail. This gives you a lot more information to work from and more flexibility as an artist.

Manual Camera Equipment

For basic photography, I use a 35mm camera with a normal lens and a telephoto zoom lens. The zoom lens is the most important because it allows you to take close-ups of distant animals. The zoom feature allows you to choose how you want to frame your subject. Even tame, domestic animals can be quite uncooperative about staying close by when you want to photograph them! The normal lens is good for photographing animals that you can get very close to, as well as for taking background photos.

I generally use ASA 400 print film, as this film speed allows you to take photographs in fairly low light conditions. Also, a telephoto lens needs more light to operate, so the 400 speed gives you more latitude. For sunny days, ASA 200 film is good.

Make sure any camera you purchase has a motor drive (most do) so that you don't need to advance the film after each shot. If you're shopping for a camera, also consider purchasing a polarizing filter. These fit over the lens to cut down on haze and reflections.

Digital Photography

Recently I began using a digital camera to snap reference photos as well. I am able to take hundreds of photos without ever running out of film. Purchase a digital camera with the zoom lens built in. With good lighting, even a moderately priced digital camera will take great photos. You can then use a computer and color printer to enhance, enlarge, crop and print your photos. If this isn't an option, most copy shops will print your images for you.

Tips for Photographing Animals

There is more to photographing animals than simply pointing the camera and pressing the shutter release. Here are some tips:

Get down to the animal's level. Inexperienced photographers often take photos of animals while looking down at them. In most cases, it is better to look at the animal straight on. Sometimes this means you will have to spend a lot of time in an uncomfortable position, crouching or even lying on the ground to photograph smaller animals, but the results are worth it!

Take several rolls of film or dozens of digital shots. The more pictures you take, the greater the chance that you will get that one winning pose that is the basis for a great painting.

Take some close-ups of the animal's features. Photos of eyes, noses and feet can be extremely helpful when you are working on a painting and the animal is no longer in front of you. Often the smaller details don't show up well in photos of the entire animal.

Have someone with you for assistance. Often my husband or my son accompanies me to a photo session. Since they are very experienced with animals, they are real assets. One of the most common problems I have in photographing friendly animals like horses and dogs

Take Close-Ups
Take close-up photos of features such as eyes, noses and feet. You will find these to be very valuable later when you are painting in your studio.

is that they insist on walking right up to my camera and sniffing the lens! Another person can distract the animal so it will look in another direction rather than right at the photographer.

Make sounds or motions that attract the animal's attention. When I am photographing a dog that looks bored and refuses to put its ears up, I often imitate a cat's meow. This usually causes the dog to prick its ears and cock its head. But some animals just aren't that easily impressed! Sometimes tossing a small twig or a handful of grass will cause an animal to momentarily look alert.

Taking Background Photos

In the excitement of photographing the animal, don't forget to photograph the animal's environment if the location is appropriate for a painting. Later on when you are in your studio working on a painting, you'll be glad you stopped to take a few photos of the background. Also, take close-up photos of elements you might like to include, such as wildflowers, grass or rocks.

You can combine elements from different photos for use in a painting. When using more than one photograph—and when you have a strong light source in your main reference photo—be sure that you paint the background so that all light is coming from the same direction. If all of your photos were taken on a bright overcast day (which is the lighting preferred by many photographers), you don't have to worry about the light source.

Filing Your Photos

It is important to keep your photos in organized files, either in your studio (or close to where you paint) or on your computer. The more specific your files, the more useful they will be to you.

Sketching

Sketching is a great way to observe animals and have fun at the same time. While you'll discover that animals seldom hold a pose for more than a few moments or seconds, even while they are at rest, you'll learn a lot about their anatomies and their characters. Always carry your sketchbook so you can take advantage of opportunities—you never know when you might see an interesting animal, tree or other natural object. You'll enjoy looking at your sketchbooks later to see what you have captured and to remember the experience.

Books

Well-illustrated books about animals are a good source of information. I have a large collection of animal books that I refer to on a regular basis—animal encyclopedias, nature field guides and books on animals in art. I've purchased many of these books at used bookstores and library book sales, where you can buy books for a fraction of what they cost new. Children's books usually have good pictures, and you can find books that specialize in a particular animal or group of animals, such as pigs or farm animals, that you might not find in books written for adults.

Found Objects

Found objects are natural things that add interest to your paintings, such as wildflowers, fallen logs or an ear of corn. Bring these objects into your studio and incorporate them into your paintings. Position them so the lighting is the same as in your reference photo.

Don't Forget Your Sketchbook!
Sketching animals trains your artistic eye and helps you get to know your subject. Take your sketchbook with you wherever you go!

2 Cats

Our animal family currently includes ten cats, none of whom we actually planned to acquire! Our oldest cat, Hazel, simply showed up at our back door one day. Aslan, Otsu and Tamika, a brother and two sisters, were tiny orphaned kittens living in a patch of weeds next to a busy road. We caught them, one by one, with a live trap we borrowed from the local humane society. We found Isis, a beautiful black cat, abandoned with her four littermates along a wooded country road not far from our farm. Since we already had nine cats, we kept Isis and found good homes for the other kittens. We picked up Leo, a black-and-white cat with long, silky hair, and Sabrina, a pretty gray tabby with golden eyes,

as half-grown kittens along roads in our area. When we lived in Texas, my son, Nathaniel, found our other gray tabby, Sherpa, when she was a tiny kitten; she was wandering in and out of cages where stray dogs were held by the county. Delta, a young gray cat with white markings, showed up thin and hungry on our Kentucky farm one winter. She is now quite plump! Hester, a long-haired gray cat, lived in the crawl space beneath a restaurant. She was skinny and her hair full of tangles. Today she is a pretty cat who keeps herself very well groomed. I have enjoyed not only helping these cats, but getting to know them as distinct personalities.

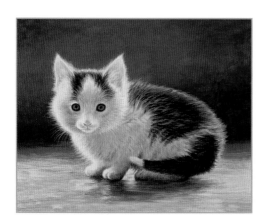

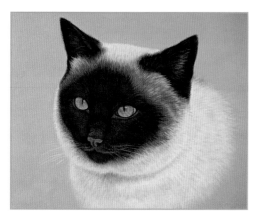

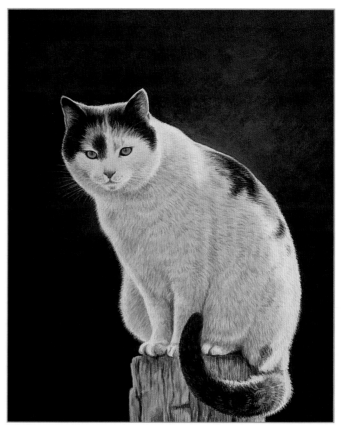

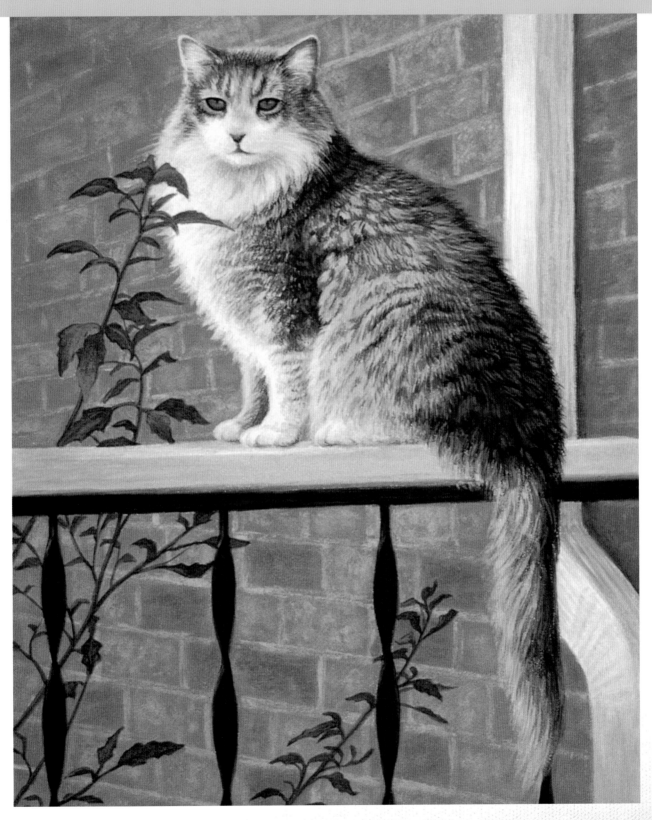

Project 1

Domestic Shorthair

Hazel showed up at our door fifteen years ago, apparently homeless. We fed her and she stayed. Two years later, one of our neighbors spotted the cat and told me that Hazel used to be their cat. The neighbor said they had decided to make Hazel an outdoor cat, so she must have gone shopping for a new home! I guess she likes us, as she has never left. Hazel is spending her old age as a pampered indoor cat.

Paints

Burnt Sienna

Burnt Umber

Cadmium Orange

Payne's Gray

Hooker's Green Permanent

Raw Sienna

Scarlet Red

Titanium White

Ultramarine Blue

Yellow Oxide

Brushes

no. 0, 1, 3, 4, 5 and 7 rounds

no. 10 shader

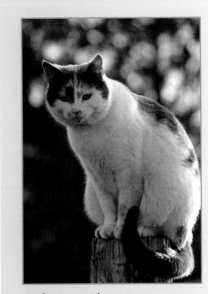

Reference Photo

1 Establish the Form and the Dark Values

Lightly draw the cat and fence post in pencil. Use a kneaded eraser to lighten any lines that come out too dark. With a no. 5 round and Payne's Gray thinned with water, establish the main lights and darks. For broad areas, use a no. 7 round.

For the black coat color, mix Burnt Umber and Ultramarine Blue. With a no. 3 round, paint the black parts of the cat's coat. Use a no. 1 round for the outline of the eyes. As the paint dries, add more layers until the dark areas are dense.

For the background, I mixed a dark green with Hooker's Green Permanent, Burnt Umber, Cadmium Orange and Ultramarine Blue. I painted with a no. 10 shader, using a no. 4 round to paint around the cat's outline.

2 Paint the Middle Values

Mix a bluish shadow color for the cat's coat with Titanium White, Ultramarine Blue and Burnt Sienna. First define the nose and muzzle using a no. 3 round and a mixture created with a small portion of the bluish shadow color and Cadmium Orange, Burnt Sienna and Burnt Umber. Then paint the shadowed areas with the bluish shadow color and a no. 7 round, using brushstrokes that follow the hair pattern. For smaller areas, such as the cat's face, use a no. 3 round. When dry, add another coat for good coverage.

Mix a ginger color for the coat with Titanium White, Raw Sienna and Cadmium Orange. Paint with a no. 3 round.

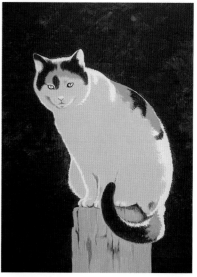

3 Paint the Outline and Begin Detailing the Coat

Paint the white highlighted outline of the cat with Titanium White and a no. 3 round, following the contours with your brush. Use a separate no. 3 round with the neighboring color to blend where the white meets the other color.

For the warm shadow color in the cat's coat, mix Titanium White, Ultramarine Blue, Burnt Umber and Burnt Sienna. Paint with a no. 3 round, using parallel strokes that follow the hair pattern. Blend the edges with a separate no. 3 round and the bluish shadow color.

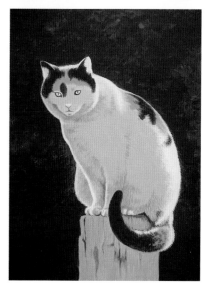

TIP

You don't want the white to become overly diluted, so wait to squeeze a small blob of Titanium White onto your palette until immediately prior to use. This will give you a thicker white that will handle and cover better.

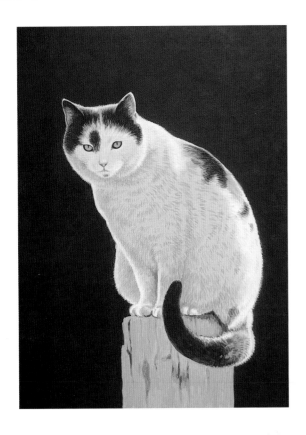

4 Add Detail to the Cat

Mix a pink color for the nose and inside the ears with Titanium White, Scarlet Red, Cadmium Orange and Burnt Umber. Paint with a no. 1 round. Paint the highlighted outline of the ears and top of the head with Titanium White and a no. 1 round. Use separate no. 1 rounds to blend the white with the adjacent black and ginger.

Mix a yellowish eye color with Titanium White, Yellow Oxide, Ultramarine Blue and a touch of Cadmium Orange. Paint with a no. 1 round. Re-establish the pupils and adjust the eye shape as needed with a no. 1 round and the black.

With a no. 1 round and Titanium White, add fur detail to the face. For detail in the black fur areas, use a no. 1 round to mix some of the bluish shadow color with the black on your palette. Paint strokes sparingly over the black fur. Re-establish any places that become too light with the black and a no. 1 round.

Tone down and soften the warm shadow fur detail using a no. 1 round and the bluish shadow color.

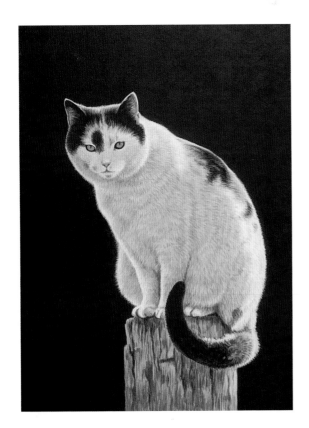

5 Add Detail to the Fur and Fence Post

Use a no. 1 round and Titanium White to add fur detail to the tail, the shadowed areas of the coat and around the cat's outline. Correct the outer contours as needed with a separate no. 1 round and the dark green background color. Tone down any white brushstrokes that are too prominent with a no. 3 round and some of the bluish shadow color.

Darken the shadow between the front legs and under the feet with a no. 1 round and some of the black mixed with some of the bluish shadow color.

Add detail to the fence post by painting roughly vertical cracks with a no. 3 round and the black. Add lighter tones with a no. 3 round and some of the bluish shadow color, using the same vertical strokes. Use a semi-drybrush technique with a no. 3 round to tone down and add detail with a grayish color made from the black and bluish shadow colors.

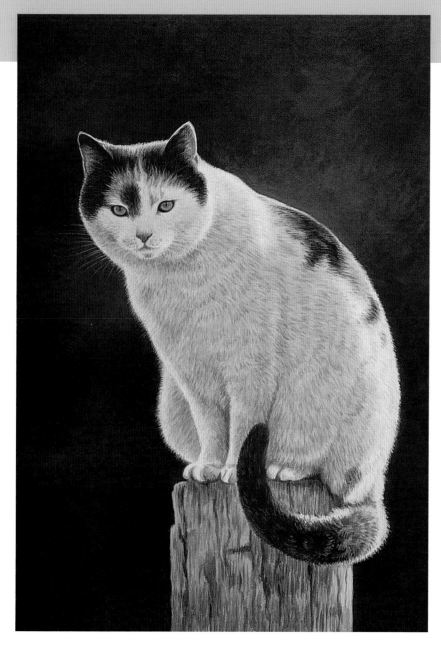

Hazel
Acrylic on Gessobord
12"×9"(30cm × 23cm)

6 Add Finishing Details

Paint detail in the black part of the tail with a no. 1 round and a bit of the bluish shadow color mixed with Burnt Umber. Blend with a separate no. 1 round and the black, using the same brush and color to "fuzz" the edges of the tail.

Use a no. 1 round and a small amount of Burnt Umber thinned with water to paint a circular wash around the pupils in the eyes, blending the edges to avoid a sharp line. Paint horizontal, slightly curved arcs for highlights in the eyes with a no. 1 round and the bluish shadow color. Re-establish the pupils as needed.

Paint a thin wash of Burnt Umber with a no. 3 round over the cat's nose and the ginger-colored fur on the head.

Paint the whiskers with a no. 0 round. Use the bluish shadow color for the whiskers on the right side of the face (overlapping the background) and for above the eyes. Use Titanium White for the whiskers on the opposite side of the face. Paint with curving, light-pressured strokes. If any whiskers come out too thick or stand out too much, use a separate no. 0 round to correct them with the color beneath the whiskers.

For the weathered gray fence post, I mixed together Titanium White, Ultramarine Blue, Burnt Sienna and Burnt Umber. I painted the fence post with vertical strokes.

Project 2

Kitten

One day in a field on the back part of our farm, I heard a faint mewing. I followed the sound and eventually came upon this tiny kitten, all by herself in the grass. I took her home and named her Peanut.

MATERIALS

Paints

Burnt Umber
Cadmium Red Medium
Cadmium Yellow Light
Payne's Gray
Raw Sienna
Titanium White
Ultramarine Blue
Yellow Oxide

Brushes

no. 3, 5 and 7 rounds

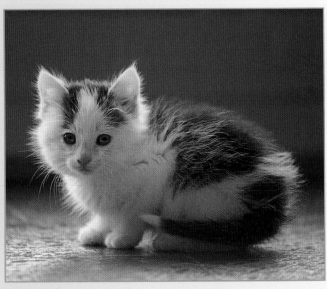

Reference Photo

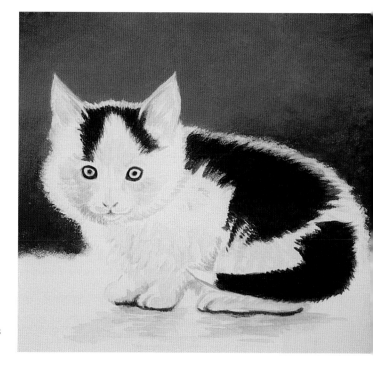

1 Establish the Form and the Dark Values

With a pencil, lightly draw the kitten onto your panel, using a kneaded eraser to make corrections. Thin Payne's Gray with water, then paint the main lines, lights and darks of the kitten with a no. 5 round. Switch to a no. 3 round for the eyes, nose and mouth.

Mix the black for the kitten with Burnt Umber and Ultramarine Blue. Paint with a no. 7 round, following the hair pattern. Use a no. 3 round to paint the outline of the eyes and the pupils.

2 Paint the Middle Values

For the shadow on the white fur, create a gray mixture of Titanium White, Ultramarine Blue and a small amount of Raw Sienna. Paint with a no. 7 round, following the hair pattern with parallel strokes.

Mix a light pink color for the nose and inside the ears with Titanium White, Cadmium Red Medium, Yellow Oxide and a touch of Raw Sienna. Paint with a no. 7 round. Mix a darker pink for the nostrils, mouth and around the eyes by adding a little more Raw Sienna, Cadmium Red Medium and a touch of Burnt Umber. Paint with a no. 3 round.

Mix the blue eye color with Titanium White, Ultramarine Blue and a small amount of Burnt Umber. Paint with a no. 3 round, correcting the eye shape as needed.

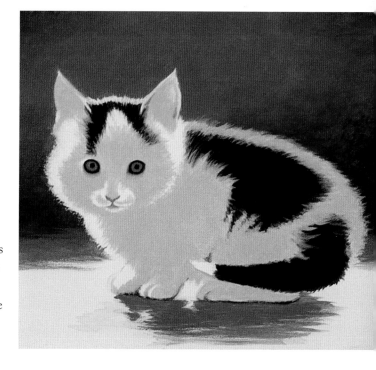

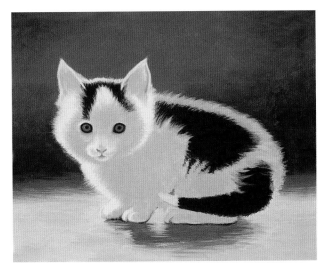

3 Paint the Light Values

Mix a warm white for the highlighted parts of the kitten with Titanium White and a touch of Cadmium Yellow Light. Paint with a no. 7 round, following the hair pattern. Switch to a no. 3 round for the muzzle and ears. For the slightly darker tail tip, mix a portion of the warm white and a bit of the gray from Step 2.

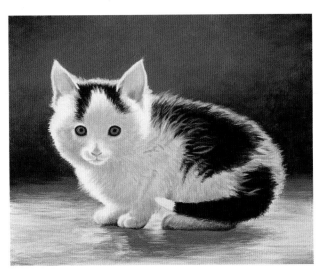

4 Add Detail

Mix a gray-brown detail color for the shadowed parts of the coat. Take a portion of the gray from Step 2 and mix in some Ultramarine Blue and Burnt Umber. Lightly paint the detail with a no. 5 round, then blend and soften with a separate no. 5 round and the adjacent color—the gray or black. Use a no. 3 round for smaller detail, such as the muzzle.

Darken the nose and inside the ears with the darker pink and a no. 3 round, blending with a separate no. 3 round and the light pink.

Paint hairs overlapping the black parts of the kitten with a no. 3 round and the gray. With a small amount of paint and light, feathery strokes, follow the fur pattern.

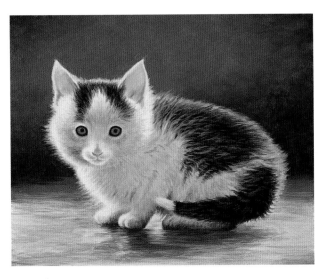

5 Refine and Add More Detail

With a no. 3 round and the gray-brown from Step 4, drybrush parallel strokes to soften the hairline along the kitten's back, stroking into and overlapping the black area.

Continue to paint hairs overlapping the black areas with a no. 3 round and the gray. Soften, darken or correct as needed with a no. 3 round and black. Use black to paint fuzzy hair along the outline of the tail and the black forehead patches, with curved strokes overlapping the neighboring color.

For darker shadows around the eyes and muzzle, mix a bit of the gray shadow color with black and paint with a no. 3 round. Blend with a separate no. 3 round and the gray.

Paint tufts of hair from the head and chest with a no. 3 round and the warm white from Step 3.

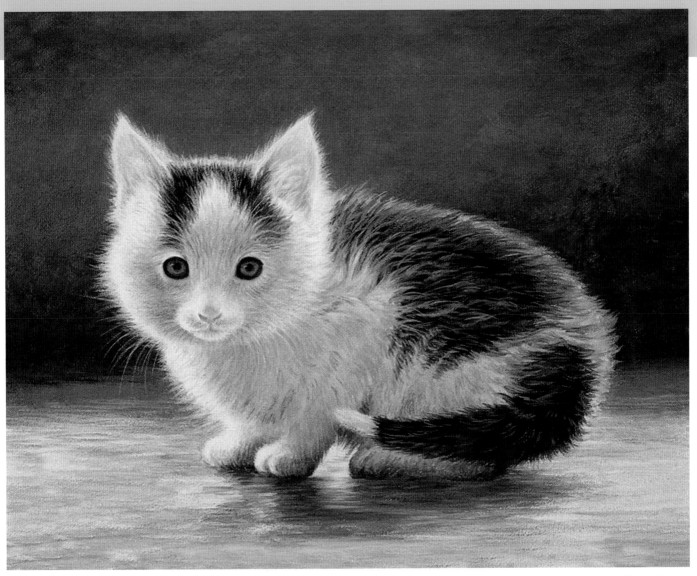

Peanut
Acrylic on Gessobord
8" × 10" (20cm × 25cm)

6 Paint the Finishing Details

Paint the fuzzy white hair at the outline of the ears and inside the ears with a no. 3 round and the warm white.

Mix a little of the blue eye color with some black, then use a no. 3 round to darken the blue part of the eye under the top lid, shading down into the blue. Use the same color to soften the black line around the eyes where it meets the blue. Paint small highlights in the eyes with the gray and a no. 3 round.

Warm up the shadowed areas with a very thin glaze of Raw Sienna. Using a no. 5 round, first dip the brush into the glaze, then blot quickly on a paper towel. Apply the glaze with quick, light strokes that follow the hair pattern.

Paint the whiskers, both above the eyes and around the muzzle, with a no. 3 round and the warm white. Paint thin, light strokes with just enough water so the paint flows. Make corrections with a no. 3 round and the neighboring color.

TIP

If, while you are applying it, a glaze appears too heavy, immediately use your finger to rub the surface in a circular motion. This will ensure that the glaze will not dry before you can spread it out.

Project 3

Domestic Longhair

One night I came home and found a young, fluffy-haired cat on our back porch, hungry and asking for help. We fed her and, of course, she stayed. She grew into a plump, not-too-bright but sweet cat with a plumed tail, named Marcie.

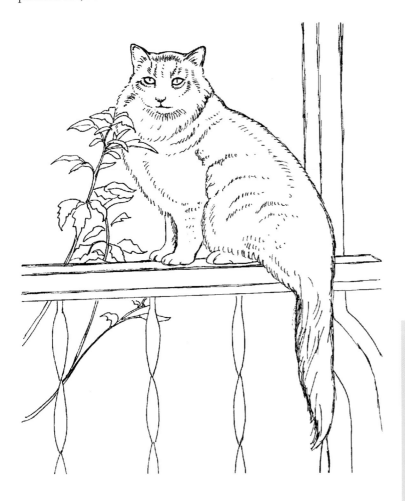

MATERIALS

Paints

Burnt Sienna

Burnt Umber

Cadmium Yellow Light

Payne's Gray

Raw Sienna

Scarlet Red

Titanium White

Ultramarine Blue

Yellow Oxide

Brushes

no. 1, 2, 3, 4, 5 and 7 rounds

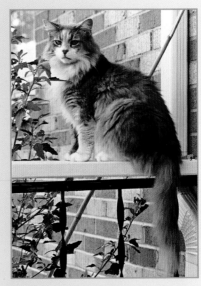

Reference Photo

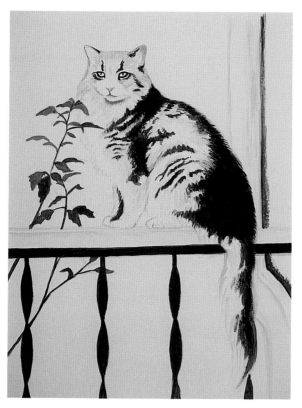

1 Establish the Form

With a pencil, lightly draw the kitten onto your panel, using a kneaded eraser to make corrections. Use Payne's Gray thinned with water to establish the form, with a no. 1 round for the facial features and a no. 5 round for the rest of the cat.

Mix a dark color for the cat's coat with Ultramarine Blue, Burnt Sienna and Burnt Umber. Paint the lines around the eyes and the pupils with a no. 1 round. Paint the dark parts of the cat's coat with a no. 7 round, with strokes that follow the hair pattern.

For the pink shadow under the chin, mix Titanium White, Scarlet Red and Burnt Sienna. Paint this area with a no. 1 round.

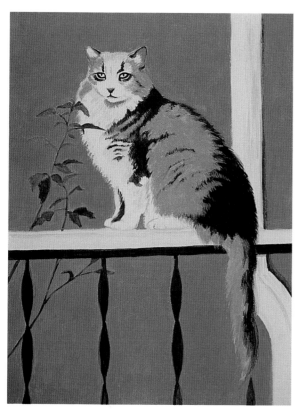

2 Paint the Middle Values

Mix the buff color for the cat's fur with Titanium White, Raw Sienna and Burnt Umber. Paint with a no. 7 round.

Paint the shadowed parts of the nose and mouth with a no. 1 round and the dark color from Step 1. Mix a pinkish color for the nose, mouth and inside the ears with Titanium White, Scarlet Red and Raw Sienna. Paint the nose and mouth with a no. 1 round, then blend with the dark color. Paint inside the ears with a no. 3 round.

33

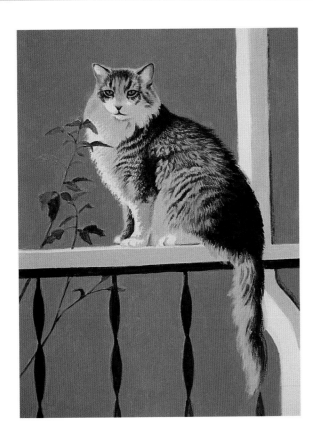

3 Paint Shadows and Fur Detail

Paint the cat's front legs and forehead with the buff color and the dark color using a fresh no. 5 round for each mixture.

Mix the blue-gray shadow color for the cat's fur with Titanium White, Ultramarine Blue and a touch of Burnt Umber. Paint the cat's fur with a no. 4 round, using strokes that follow the hair pattern. Use a no. 1 round for painting around the eyes and facial details.

Begin to add detail and to integrate the dark and light colored fur. Add enough water to the dark color so the paint flows, then paint the details with a no. 4 round. In areas where the detail is more muted, use a lighter touch and less paint.

Mix a green for the eye with Cadmium Yellow Light, Ultramarine Blue and a touch of Burnt Umber. Paint with a no. 1 round. Re-establish the pupils and eye shape with the dark color and a no. 1 round.

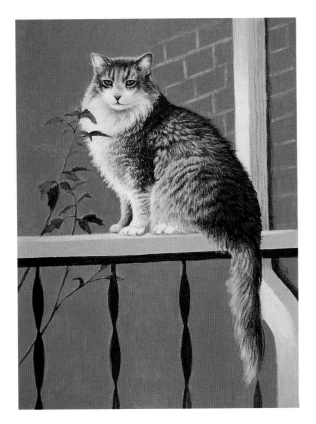

4 Add More Detail to the Cat's Fur

Mix a warm white for the cat's fur with Titanium White and a touch of Yellow Oxide. Paint with a no. 4 round. Blend the edges where the white meets the other colors with feathery strokes. Switch to a no. 1 round for the facial detail.

Use a no. 3 round and the blue-gray shadow color to add more detail to the dark parts of the coat. To a portion of the buff mixture, add some Raw Sienna and Burnt Sienna. With a no. 3 round, define the warm shadow under the chin. Then detail the dark parts of the coat. Blend these areas with a separate no. 3 round and the dark color.

Paint shadows under the toes with some of the blue-gray shadow color mixed with Burnt Umber.

TIP

To keep the viewer's eye from following the edges of objects, tone them down where they run off your painting. The softer edges will help the viewer to focus on the subject.

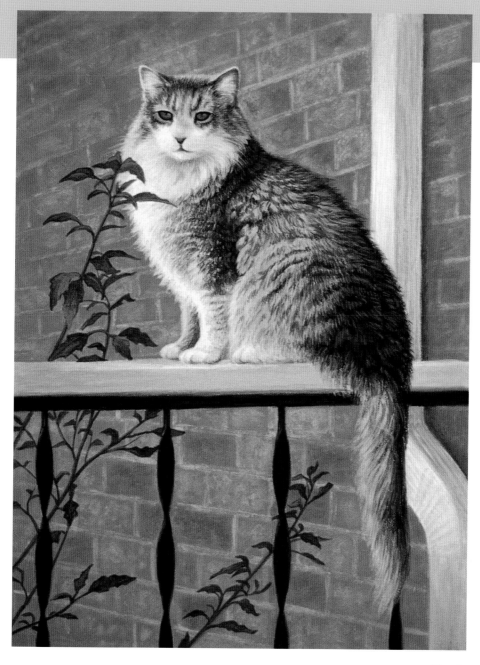

Marcie
Acrylic on Gessobord
12" × 9" (30cm × 23cm)

5 Paint the Final Details

Round out the cat's right cheek with a no. 3 round and the warm white. If you need to, re-establish the mouth. Use a no. 1 round and the warm white to reinforce the outlines of the ears.

Mix a highlight color for the eyes with a small amount of the warm white and a touch of the blue-gray shadow color. Paint the highlights in small, curved arcs with a no. 1 round. Use a separate no. 1 round and the green to blend and reinforce the eye's shape.

Paint the whiskers with a no. 1 round and the warm white, using long, curved, sweeping strokes.

Define the cat's toes by adding some of the blue-gray shadow color with a no. 2 round. Use a separate no. 2 round and the warm white to blend. Darken the shadows under the paws with a no. 1 round and the dark color, then tone down by drybrushing with the blue-gray shadow color and a no. 2 round.

Siamese

I have always thought that Siamese cats were beautiful with their dark masks and sapphire blue eyes. This cat's name is Sassy.

MATERIALS

Paints

Burnt Umber
Raw Sienna
Titanium White
Ultramarine Blue

Brushes

no. 3 and 5 rounds

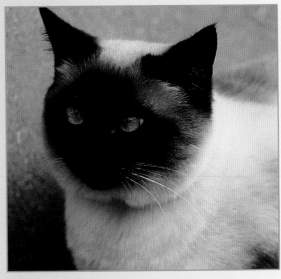

Reference Photo

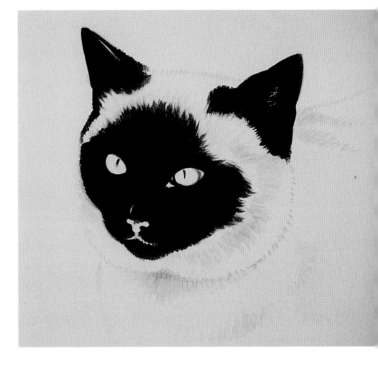

1 Establish the Form and the Dark Values

With your pencil, lightly sketch the cat onto the panel, using a kneaded eraser to lighten lines or make corrections. With Burnt Umber thinned with water and a no. 3 round, paint the eyes and nose, then use a no. 5 round for the broader areas.

Mix a dark brown for the cat's face and ears with Burnt Umber and Ultramarine Blue. Paint with a no. 5 round, switching to a no. 3 round around the eyes and nose. Use brushstrokes that follow the hair pattern. As the first layer of paint dries, add another coat for a good, dark coverage.

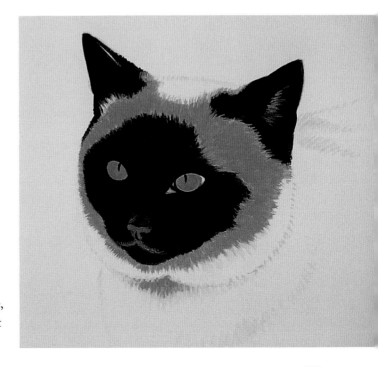

2 Paint the Middle Values

Mix the buff color for the cat's coat with Titanium White and Raw Sienna. Paint strokes that follow the hair growth pattern with a no. 5 round.

For the blue eyes, mix Ultramarine Blue and Titanium White. Paint with a no. 3 round. Use a separate no. 3 round and the dark brown from Step 1 to reinforce the eye's shape as needed.

Mix a gray for the nose and muzzle with Titanium White, Ultramarine Blue and a small amount of Burnt Umber. Paint with a no. 3 round.

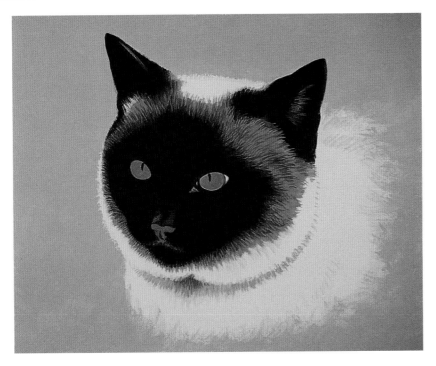

3 Begin Adding Detail

Begin to add detail to the cat's fur with a no. 5 round and the dark brown from Step 1. Mix the dark brown with enough water to make it flow smoothly.

Mix some of the gray from Step 2 with some Titanium White. Use this color and a no. 5 round to paint a shadow line on the cat's neck with parallel strokes.

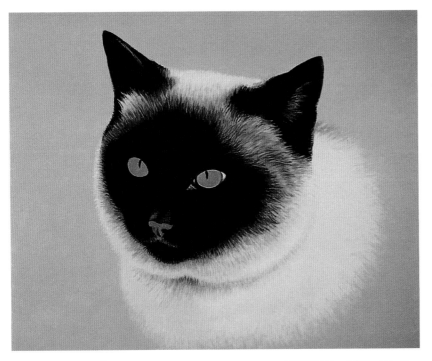

4 Paint the Light Values and Add Detail

Mix a cream color for the fur with Titanium White and a small amount of Raw Sienna. For the slightly more shadowed part, mix Titanium White with small amounts of Raw Sienna and Ultramarine Blue. Follow the pattern of the fur with parallel brushstrokes and a no. 5 round. Switch to a no. 3 round for smaller details. With a separate no. 3 round and the buff from Step 2, blend where the two colors meet. Use a no. 5 round to paint the light colored fur against the background.

TIP

To get the feel for the kind of delicate brushstrokes you'll need for the whiskers, first practice a few strokes on a piece of scrap board. This will help give you the skill and confidence to paint the whiskers.

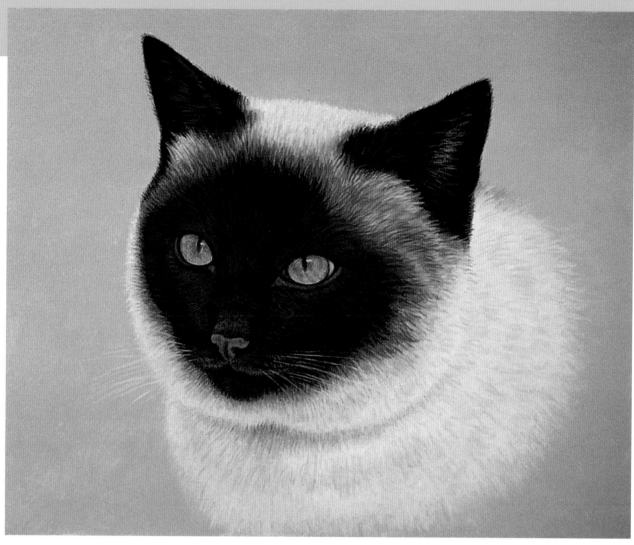

Sassy
Acrylic on Gessobord
8" × 10" (20cm × 25cm)

5 Add the Finishing Details

To highlight the dark brown fur, mix Burnt Umber, Ultramarine Blue and a small amount of Titanium White. Paint with a no. 3 round, using parallel strokes that follow the fur pattern. Also use this color to detail the cat's irises; paint small, parallel strokes that follow the curvature of the eye with a no. 3 round. Soften these lines with a no. 3 round and the blue eye color. Add detail to the nose with the same color and brush.

Take a portion of the buff color and mix it with a little Burnt Umber, then detail the fur detail around the eyes, on the muzzle and on the ears with a no. 3 round. Use a separate no. 3 round to lightly drybrush the dark brown along the edges, blending to create a soft look. Use the same brush and color to soften the edges of the cat's mask where it meets the buff.

For the shadows on the lighter fur, create a dusty bluish color. Mix Titanium White with touches of Raw Sienna and Ultramarine Blue. Paint with a no. 5 round. Mix a bit of Titanium White with a touch of Ultramarine Blue to paint highlights in the eyes. Mix this bluish highlight color with a touch of Burnt Umber to paint the white part of the left eye. Paint with a no. 3 round, blending the edges with a separate no. 3 round and the neighboring color.

To soften the ears against the background, use a no. 3 round and the dark brown to paint small, thin strokes around the edges of the ears. Use just enough water so the paint flows. Mix a color for the whiskers with a portion of the cream and a touch of Ultramarine Blue. With a no. 3 round and just enough water for the paint to flow, lightly paint slightly curved strokes.

3 Dogs

Our family loves dogs. I'm happy that we live on a farm, because it has allowed us to give homes to quite a few dogs who were down on their luck and really needed our help. All of them have repaid us with their grateful, affectionate and intelligent companionship.

One of my favorite rescue stories is about Sasha, a mostly German Shepherd dog I spotted at the corner of two rural roads in Texas. She was obviously waiting for whoever had abandoned her there to return. She would not approach me or anyone else who tried to coax her, and would run into the road if approached, but always returned to the same spot. All I could do was put food out for her. This went on for several days, and I had concluded that I would never be able to gain this dog's trust. I decided to take a photo of her and send it to the local newspaper, hoping they would publish it and her owner would come back for her. When I arrived at the crossroads, she was sitting with her ears pricked, looking at me intently. As I crouched to take the picture, Sasha got up, as if she had already made up her mind, and hesitantly walked toward me. I stretched out my arm, talking in a soothing voice as she came closer. Shyly, she approached and eventually leaned against my arm and licked my nose! She looked overwhelmed by her decision to trust me and a little unsure, but happy as she jumped into my car. I rode home with her front feet in my lap. Over the past seven years, Sasha has proved to be a wonderful dog. She has nine canine companions—two dalmatians, a white shepherd, two hounds and several mixed breed dogs—all with their own rescue stories to tell. As my husband Tim says, "We just can't resist a fuzzy face!"

Project 5

Dalmatian

Our dalmatian, Katie, is the subject of this demonstration. Dalmatians are unusual dogs, both in appearance and in behavior. They're alert and active during the day, but once they are bedded down for the night, they do not like to be disturbed! They like their routines and are almost catlike in their adherence to them. Dalmatians are so different from other dogs that, as a family joke, we refer to them as aliens.

Paints

Burnt Umber

Cadmium Red Medium

Cadmium Yellow Light

Payne's Gray

Titanium White

Ultramarine Blue

Yellow Oxide

Brushes

no. 1, 3 and 5 rounds

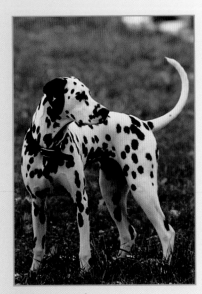

Reference Photo

42

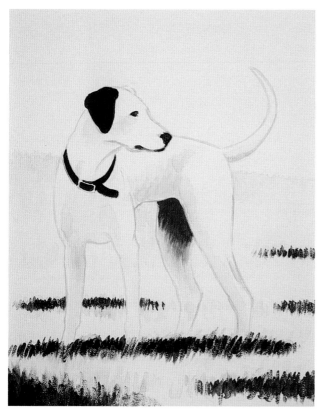

1 Establish the Form and the Dark Values

Draw the dog lightly in pencil onto the panel. Use Payne's Gray thinned with water and a no. 3 round to paint the main lines and values. Use a no. 5 round for the broad areas of shadow on the dog.

Mix the black for the ear and collar with Burnt Umber and Ultramarine Blue (you'll add the dalmatian's spots later). Paint with a no. 3 round.

Mix a pinkish brown for inside the hind leg with Titanium White, Cadmium Red Medium, Burnt Umber and Ultramarine Blue. Paint with a no. 3 round, using parallel strokes and feathering the edge so that it will be easier to blend into the next color.

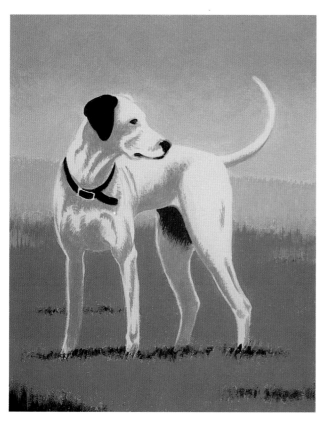

2 Paint the Middle Values

Mix the bluish shadow color for the dog's coat with Titanium White, Ultramarine Blue and Burnt Umber. Paint with a no. 3 round with smooth strokes.

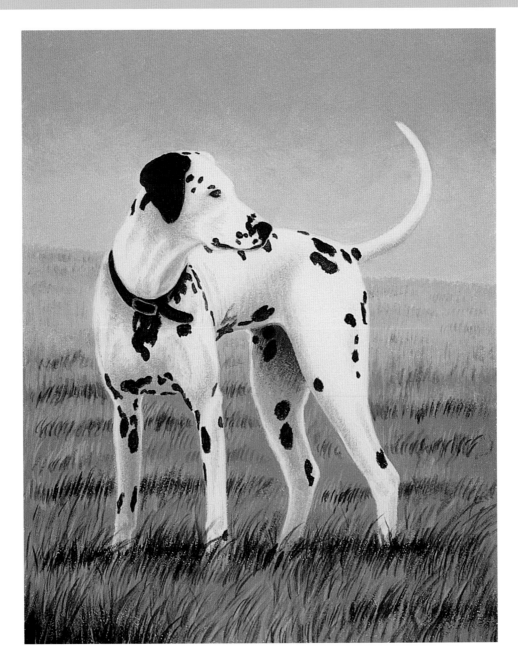

3 Paint the Light Values and Add the First Few Spots

Mix a warm white for the dalmatian's coat with Titanium White and a touch of Cadmium Yellow Light. Paint with a no. 5 round, using smooth strokes that follow the contours. With a separate no. 5 round and the bluish shadow color from Step 2, blend where the colors meet. Switch to a no. 3 round for the details. Soften and integrate the bluish shadow areas by drybrushing the warm white over them with a no. 5 round.

Blend the pinkish brown shadow on the inside of the hind leg with the bluish shadow color, using a no. 3 round.

Mix a bit of the bluish shadow color with the black, then use a no. 1 round to paint the buckle on the collar.

Looking at the reference photo for placement, start painting the dalmatian's spots. Use a no. 3 round and the black from Step 1.

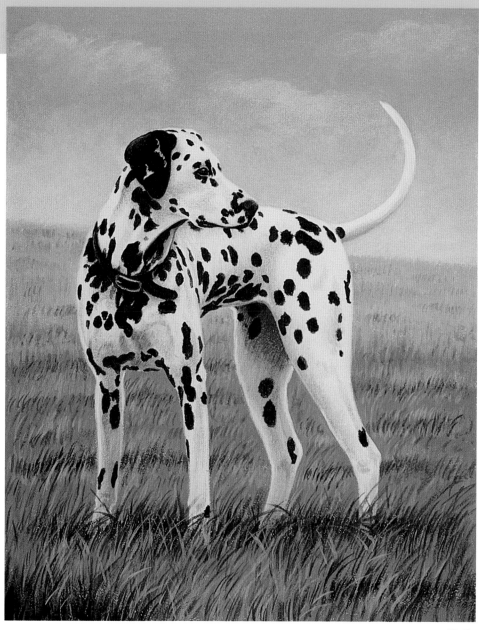

Katie
Acrylic on Gessobord
10" × 8" (25cm × 20cm)

4 Paint the Finishing Details

Finish painting the spots, then use a no. 1 round and the bluish shadow color to paint highlights on the nose and collar. Paint the white markings on the ear with the warm white and a no. 1 round.

Mix a dark brown eye color with Burnt Umber and a bit of the black. Paint the eye with a no. 1 round. Apply a light blue highlight (Titanium White, Ultramarine Blue and a touch of Yellow Oxide) with a no. 1 round.

For the muzzle, neck, chest, legs and around the eye, mix a pink from Titanium White, Cadmium Red Medium and Yellow Oxide. Paint the areas sparingly with a no. 1 round, keeping the amount of paint and your brushstrokes light. Blend with a separate no. 3 round and the warm white from Step 3.

Add a few more shaded areas in the white part of the coat with the bluish shadow color and a no. 3 round. Mix a bit of the bluish shadow color with a bit of the black to paint darker shadows on the legs, chest and neck.

Project 6

Mixed Breed

A few years ago, I found Laika, a border collie mix, looking lost and alone near our front gate. Since we could not find an owner, we kept her. She was a very sweet and intelligent dog. Two years later, Laika disappeared from our farm. We never found her, and I will always miss her.

Paints

Burnt Sienna

Burnt Umber

Cadmium Orange

Payne's Gray

Raw Sienna

Titanium White

Ultramarine Blue

Yellow Oxide

Brushes

no. 1, 3 and 5 rounds

no. 8 shader

Reference Photo

46

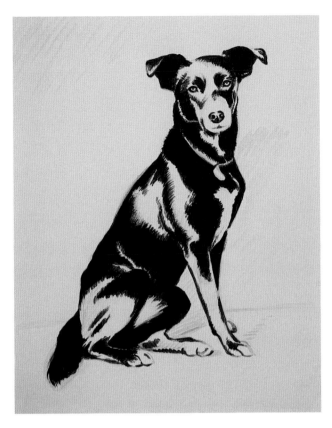

1 Establish the Form and the Dark Values

Draw the dog lightly in pencil, using a kneaded eraser to make corrections or lighten dark lines. Use Payne's Gray thinned with water and a no. 5 round to paint the main lines and indicate the shadowed areas of the dog. For smaller details, switch to a no. 3 round.

Mix a warm black for the dog's coat with Ultramarine Blue and Burnt Sienna. Paint with a no. 5 round, switching to a no. 1 round for the details. You will need to apply at least three coats, allowing the layers to dry in between for a good, dark coverage.

2 Paint the Middle Values

Mix the bluish color for the light reflections on the black coat with Titanium White, Ultramarine Blue and a small amount of Burnt Sienna. Paint with a no. 5 round, adding a second coat as the first layer dries. Switch to a no. 3 round for the details.

Mix a reddish brown for the warm coat reflections, the collar and the eyes with Burnt Sienna, Burnt Umber, Cadmium Orange and smaller amounts of Ultramarine Blue and Titanium White. Paint the coat reflections with a no. 3 round, using parallel strokes that follow the hair pattern, then paint the collar and the eyes.

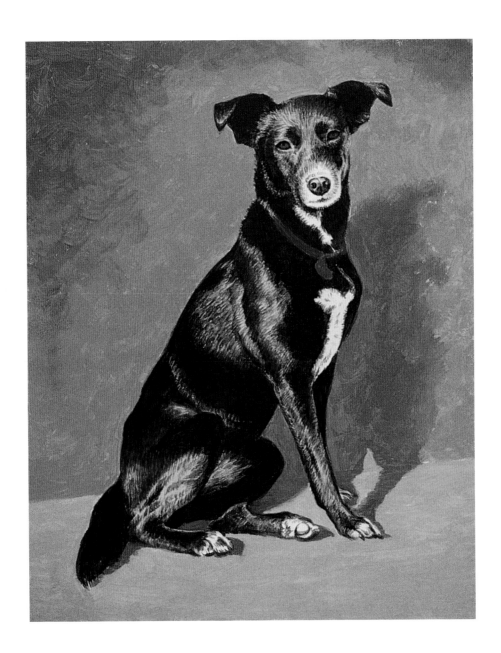

3 Paint the Light Values and Add Details

Mix a warm white for the dog's muzzle, chest and toes with Titanium White and touches of Yellow Oxide and Raw Sienna. Paint with a no. 3 round.

Take a portion of the warm black from Step 1 and transfer it to a dry wax paper palette. (This will make the paint more opaque.) With a no. 3 round, paint small, parallel strokes that follow the hair pattern over the bluish and reddish brown areas. Use just enough water so that the paint flows easily, and apply light pressure with the brush. Add a few dark hairs to the white chest marking, then paint strokes from the edges of the mark into the white to integrate. Use a no. 1 round and the warm black to re-establish the shape of the eyes. Add detail to the nose, muzzle and feet.

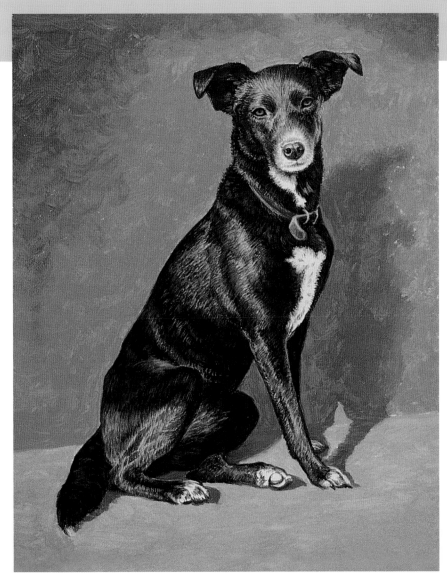

Laika
Acrylic on Gessobord
10" × 8" (25cm × 20cm)

4 Paint the Finishing Details

Add bluish reflection detail to the coat with a no. 3 round and the color from Step 2, softening and blending with the warm black as needed. Add reddish brown detail with a no. 3 round, again using the warm black to soften. For areas where the reddish detail is more muted—the tail, neck and chest—mix a bit of the bluish color with a portion of the reddish brown.

Add highlights to the collar with some of the warm white from Step 3 and a no. 3 round. Use the same color and brush to define the white toes and the white tail tip.

Add lighter detail to the eyes with a mixture of Titanium White, Yellow Oxide and Raw Sienna. Paint curved arcs in the lower parts of the eyes with a no. 1 round.

The subdued background I used in this painting is a classic choice for portraits because it complements the subject without distracting from it. To begin, I mixed a basic back-ground color with Titanium White, Raw Sienna and Burnt Sienna. I made a modified version of this mixture—Titanium White, Raw Sienna, Ultramarine Blue, Burnt Umber and a bit of Burnt Sienna—for the dog's shadow on the wall and floor. To paint the dog's shadow, I used a no. 5 round around the dog's outline and a no. 8 shader for the broader areas, dabbing with semicircular strokes. With a fresh no. 8 shader, I painted the wall behind the dog with the basic back-ground color, blending the edges where it met the shadow. Next I darkened the upper corners with a no. 8 shader and the shadow color, blending with the basic background color where needed.

For the floor, I mixed together a tan color from Titanium White and Raw Sienna. I painted sweeping, horizontal brushstrokes with a no. 8 shader, switching to a no. 3 round around the dog's feet.

Project 7

Yorkshire Terrier

Sindy belonged to Laurie, a nice lady from France whom I met at an art show in Long Island. She commissioned me to paint a portrait of her little dog.

MATERIALS

Paints

Burnt Umber

Cadmium Orange

Cadmium Yellow Light

Payne's Gray

Raw Sienna

Titanium White

Ultramarine Blue

Yellow Oxide

Brushes

no. 3 and 5 rounds

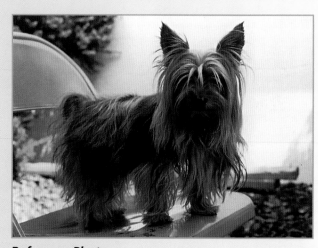

Reference Photo

50

1 Establish the Form and the Dark Values

With your pencil, lightly sketch the dog onto the panel, using a kneaded eraser to make corrections or lighten lines as needed. Use Payne's Gray thinned with water and a no. 3 round to paint the main lines of the dog.

Mix a dark steel gray for the gray fur's shadowed areas with Burnt Umber, Ultramarine Blue and a small amount of Titanium White. Paint with a no. 5 round.

Mix the black for the nose, mouth and around the eyes with Burnt Umber and Ultramarine Blue, painting with a no. 3 round.

Mix a dark brown for the tan fur's shadowed areas with Burnt Umber, Raw Sienna and a small amount of Ultramarine Blue. Paint with a no. 5 round. Add another coat for good coverage.

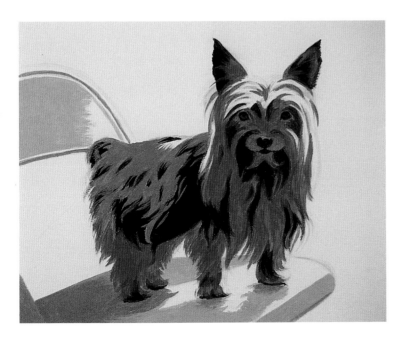

2 Paint the Middle Values

Mix a middle value blue-gray for the gray part of the coat with Titanium White, Ultramarine Blue and Burnt Umber. Paint with a no. 5 round, following the fur pattern with long, smooth brushstrokes. Dab a highlight on the nose with a no. 3 round.

Mix a middle value for the tan part of the coat with Raw Sienna, Cadmium Orange and a small amount of Burnt Umber. Paint with a no. 5 round.

Mix the eye color with Burnt Umber and Raw Sienna. Paint with a no. 3 round. With the dark brown from Step 1 and a no. 3 round, paint the pupils and reinforce the dark outlines around the eyes.

3 Paint the Light Values

Mix the light tan color for the dog's coat with Titanium White and a small amount of Yellow Oxide. Use a no. 3 round to paint smooth, flowing strokes. Use just enough water so the paint flows.

Mix the highlight color for the chair and for the gray parts of the dog's coat with Titanium White and a small amount of Ultramarine Blue. Paint the dog's highlights with a no. 3 round.

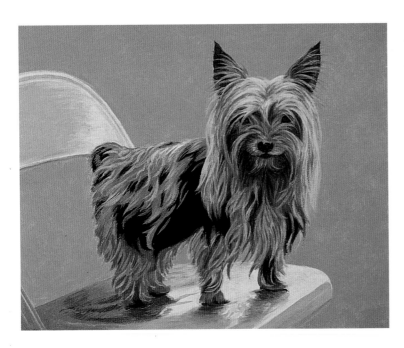

4 Add Detail to the Tan Parts of the Coat

With a no. 3 round, glaze the light tan fur with the middle value tan from Step 2. To re-establish the highlights on the head, mix a portion of the light tan from Step 3 with Titanium White and paint with a no. 3 round. Refine the fur using two no. 3 rounds, one for the light tan and one for the middle value tan. Paint fine lines with the middle value tan, blending with the light tan, and then vice versa. Use enough water for the paint to flow easily.

Detail the dark brown shadow areas of the ears, head and chest with a no. 3 round and the middle value tan. Use a no. 3 round to blend and re-establish the darks as needed, then add some darker detail to the dog's muzzle with fine, parallel strokes. In the shadowed areas, add a few fine lines of the dark brown.

Paint some long hair tufts from the ears with a no. 3 round and a mixture of the light tan and a bit of the middle value tan, softening the tips of the tufts.

TIP

If your colors begin to dry out on the wax paper palette, lightly spray them with water from a spray bottle.

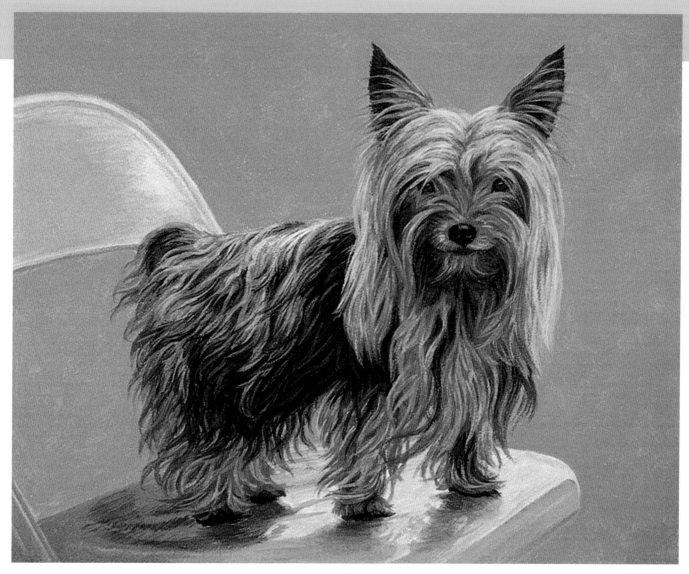

Sindy
Acrylic on Gessobord
8" × 10" (20cm × 25cm)

5 Add the Final Details

With a no. 3 round, take a bit of the middle value blue-gray from Step 2 and mix it with a bit of the dark steel gray from Step 1. Use this color to add detail to the darkest parts of the coat with flowing strokes. Use a separate no. 3 round and the dark steel gray to detail the blue-gray fur of the coat and the tan fur of the hind legs. Paint fine strokes following the fur's pattern. Blend and soften with a separate no. 3 round and the neighboring color.

Paint locks of hair from the legs and hindquarters, using separate no. 3 rounds for the middle value gray, the dark value gray and a new tan color (a mixture of the dark and middle value tans). Add some lighter locks with the new tan mixture.

Detail the feet with separate no. 3 rounds for the dark brown and middle value tan.

Mix the eye highlight color with a small amount of the blue-gray and Titanium White. Reduce the size of the lock of hair falling across the right eye using the eye color and a no. 3 round. Then paint the highlights in small, curved arcs.

Paint highlights on the nose with a no. 3 round and the blue-gray. Blend with a separate no. 3 round and the black from Step 1.

Brighten the highlights on the head with a mixture of Titanium White and a touch of Cadmium Yellow Light. Paint with a no. 3 round, using a separate no. 3 round with the middle value tan to blend and soften.

Project 8

Golden Retriever

MATERIALS

Paints

Burnt Sienna

Burnt Umber

Cadmium Orange

Hooker's Green Permanent

Payne's Gray

Raw Sienna

Scarlet Red

Titanium White

Ultramarine Blue

Viridian

Yellow Oxide

Brushes

no. 1, 3, 4 and 5 rounds

no. 8 shader

Golden retrievers are a popular breed because they embody what a lot of people think of as the ideal family dog: they are good natured, playful and affectionate. Webster, a dog whose portrait I painted for his owners, was no exception.

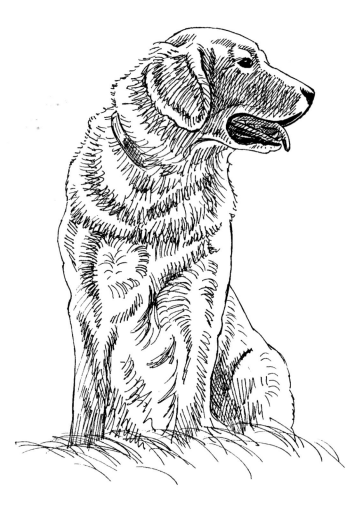

Reference Photo

54

1 Establish the Form and the Dark Values

Draw the dog lightly in pencil, using a kneaded eraser to lighten any dark lines or make corrections. Use Burnt Umber thinned with water and a no. 4 round to establish the form.

Mix Burnt Umber and Ultramarine Blue for the black parts of the dog—the nose and jowls. Paint with a no. 3 round. Mix Burnt Umber, Burnt Sienna and Ultramarine Blue for the shadowed parts of the dog's coat. Paint with a no. 5 round, using strokes that follow the hair pattern. For the darkest shadows, apply more than one coat of paint after the first layer is dry.

2 Paint the Middle Values

Mix the reddish gold color for the retriever's coat with Raw Sienna and Burnt Sienna. Paint with a no. 4 round. Paint thinly enough so the white panel shows through with strokes that follow the hair pattern.

I mixed the dark green background color with Viridian, Cadmium Orange and Burnt Umber. I used dabbing strokes with a no. 8 shader, switching to a no. 4 round for around the dog's outline. For the foreground grass, I painted sweeping strokes with the no. 8 shader.

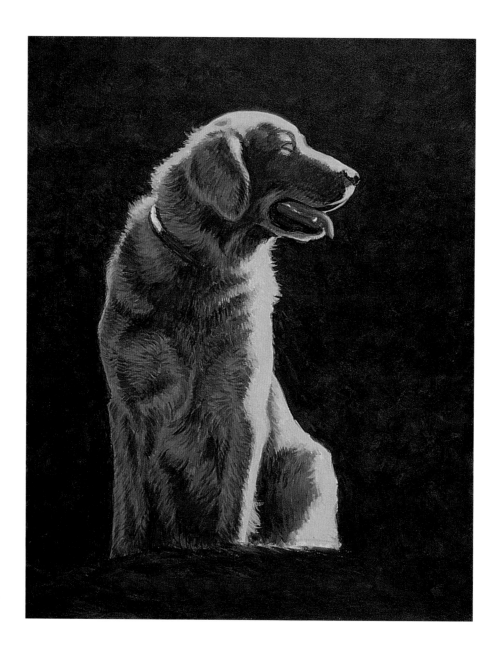

3 Add Lighter Values and Begin the Details

Mix a pinkish shadow color for the tongue with Scarlet Red, Burnt Sienna and a small amount of Ultramarine Blue. Paint with a no. 3 round. For the tongue's highlight color, mix Titanium White, Scarlet Red and Yellow Oxide. Paint with a no. 3 round.

Mix a highlight color for the dog's coat with Titanium White and a small amount of Yellow Oxide. Transfer a portion of this color to a dry wax paper palette, then use a no. 3 round to paint.

Transfer a portion of the shadow color from Step 1 to the dry paper. Begin to integrate the dark shadows in the dog's coat with a no. 3 round, painting strokes in the direction of hair growth. Start your strokes from the shadows and overlap the lighter areas.

I darkened the background by adding another layer of the dark green color using the same brushes.

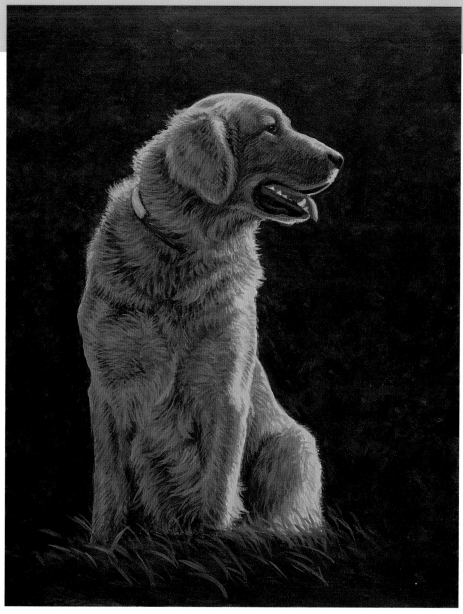

Webster
Acrylic on Gessobord
10" × 8" (25cm × 20cm)

4 Add the Finishing Details

Mix a golden copper color for integrating the dog's coat with Titanium White, Raw Sienna, Yellow Oxide and small amounts of Cadmium Orange and Burnt Sienna. With a no. 3 round, paint strokes that follow the hair pattern, from the lighter parts of the coat overlapping the darker areas. For details in the darker parts of the coat, take a portion of this color and add more Cadmium Orange and Burnt Sienna. Use a separate no. 3 round and the shadow color from Step 1 to soften and integrate. Use a no. 3 round and the darker golden copper to add some detail to the highlighted parts of the dog's coat.

For the bluish areas of the nose and jowls, mix Ultramarine Blue, Burnt Umber and Titanium White. Paint with a no. 1 round.

Use a no. 1 round to mix a small amount of Titanium White with touches of Ultramarine Blue and Burnt Umber, then paint the teeth.

I mixed a portion of the dark green background color with Titanium White and Cadmium Orange. Then I used this color to paint some blades of grass around the dog with a no. 3 round, using sweeping, curved strokes.

4 Horses

Ever since I was a small child, I have loved horses. My grandfather worked at Calumet Farm in Kentucky and introduced me to my first horses when I was three years old. I can still remember seeing the horses looking out of their stalls. I grew up in New Jersey where there was no place to keep a horse, so I had to content myself with drawing pictures of them and reading horse stories. My favorite book was *Black Beauty*.

When I was in my late thirties, my husband, son and I moved to the family farm in Kentucky, and one of the first things we did was acquire some horses. Getting to know these beautiful animals has been a high points in my life. We now have seven of them—two Arabians, two Belgian draft horses, a paint horse and two small Shetland ponies. I love watching them—whether they are galloping through a field or just quietly grazing and swishing their tails. They are some of my favorite subjects to paint.

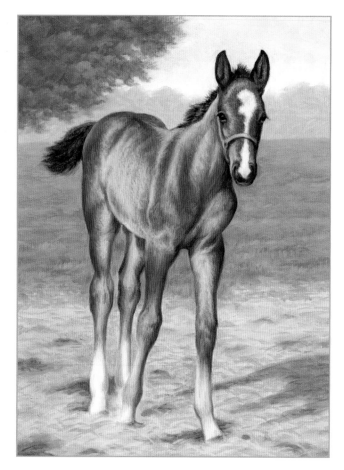

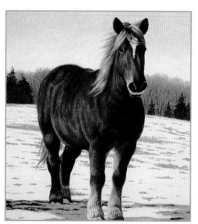

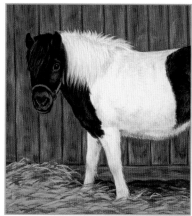

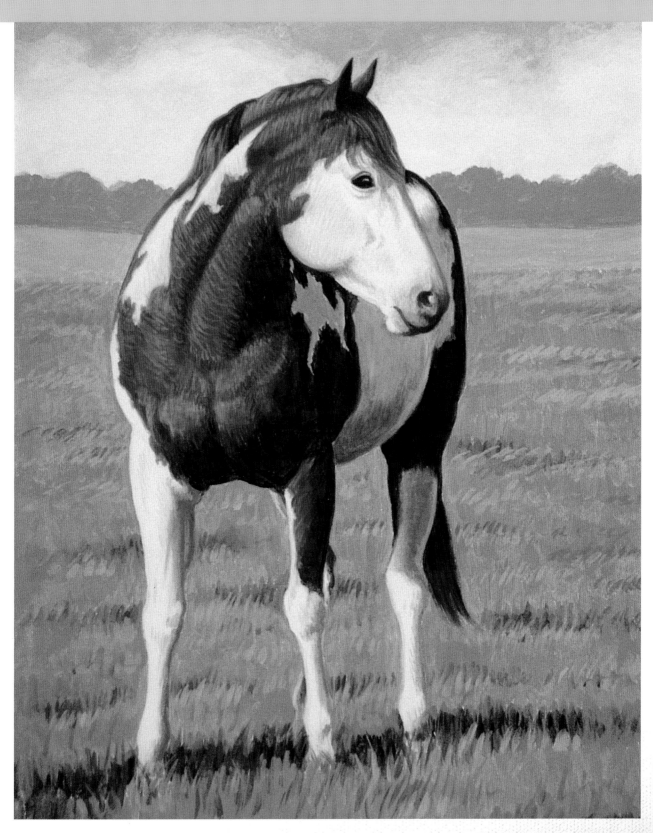

Thoroughbred

Vasari was a handsome thoroughbred hunter-jumper horse. I was fortunate to be able to travel to California to sketch and photograph Vasari. His owner commissioned me to do three paintings of him—a head study, an informal pose and a conformation pose. This illustration serves as a study for the third painting.

MATERIALS

Paints

Burnt Sienna
Burnt Umber
Cadmium Orange
Raw Sienna
Titanium White
Ultramarine Blue
Yellow Oxide

Brushes

no. 1, 3, 4 and 6 rounds
no. 8 shader

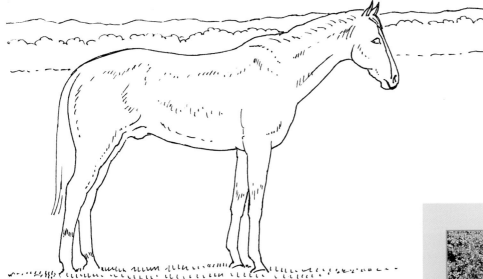

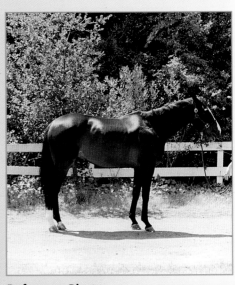

Reference Photo

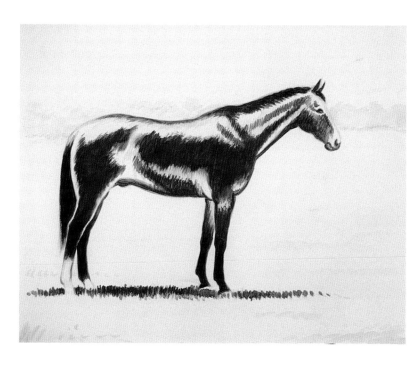

1 Establish the Form and the Darker Values

Draw the horse's outline lightly in pencil, using a kneaded eraser to lighten any lines that become too dark. With a no. 4 round and Burnt Umber thinned with water, paint the darker areas.

For the black parts of the horse—the mane, tail and lower legs—mix Burnt Umber, Ultramarine Blue and a small amount of Burnt Sienna. Paint with a no. 4 round, dipping the brush first in water, then blotting on a paper towel before dipping it into the paint. To achieve a good dark covering, paint three to four coats, letting the paint dry in between layers.

For the coat's dark brown, mix Burnt Sienna and Ultramarine Blue. Paint with a no. 8 shader for the broad areas, switching to a no. 4 round for the details. Feather the edges to avoid a sharp line when you apply the next color.

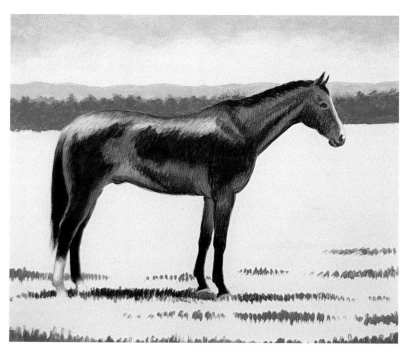

2 Paint the Middle Values

Mix a middle value brown for the horse's coat with Burnt Sienna and Cadmium Orange. Paint with a no. 4 round. In areas that will be highlighted, use paint thinned with quite a bit of water. Use brushstrokes that follow the horse's body contours. Mix the bluish color for the shadowed areas of the horse's white sock and stocking, the hooves, the highlights on the top of the tail and the upper edge of the hind leg with Titanium White, Ultramarine Blue and Burnt Sienna. Paint with a no. 4 round.

TIP

When painting the legs and the outer lines of the horse's body, paint fine lines to establish the contour first, then fill in.

3 Blend the Dark and Middle Values

Using separate no. 4 rounds and the color mixtures for the dark and the middle value browns, blend the edges where these colors meet. Blend wet-into-wet. When this is dry, overlap the edges with parallel brushstrokes. Paint details on the broad dark areas with strokes of the middle value brown. Add more layers to strengthen the middle value brown. Use a no. 4 round and a wash of Ultramarine Blue thinned with water to tone down and darken the horse's coat.

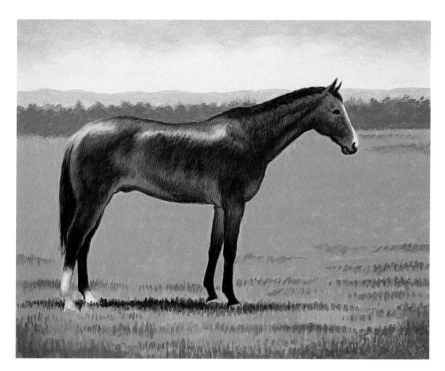

4 Refining Details and Painting Highlights

With a no. 4 round and the dark value brown, refine the edge lines of the horse's lower neck, cheek, chin, blaze and belly. Strengthen the darks on the legs, tail and mane with a no. 3 round and the black. Mix the lightest highlight color with Titanium White and small amounts of Cadmium Orange and Yellow Oxide. Paint the highlights on the back and rump with a no. 4 round, using light-pressured, parallel strokes that follow the body contours. With Cadmium Orange and Yellow Oxide, mix a darker highlight color for the head, belly, legs and lower rump. Paint with a no. 4 round, using parallel strokes. Use this darker highlight color to soften and blend the edges of the brighter highlights on the back and rump, alternating with a separate no. 4 round and the lighter highlight color. Then blend the edges of the highlights with a no. 4 round and the middle value brown from Step 2, using the same technique.

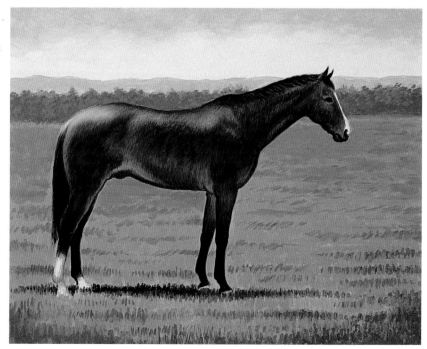

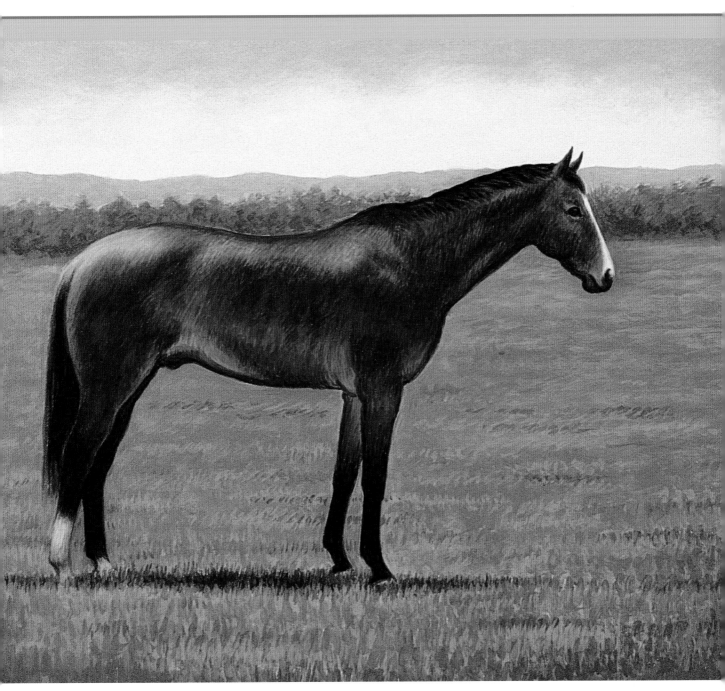

Vasari
Acrylic on Gessobord
8" × 10" (20cm × 25cm)

5 Add the Finishing Details

Use no. 1 rounds to finish the details of the head and the legs. Refine the shape of the eye, ears, mouth and back legs with the color mixtures from the previous steps. Mix a warm white with the Titanium White and a touch of Yellow Oxide to paint the blaze. Soften the edge with the darker highlight color. Paint a highlight in the eye as a small curved arc with some of the bluish shadow color mixed with a bit of Burnt Umber, then blend the edge of the highlight with the eye color and a separate brush. Define the shadow area of the white socks with the bluish shadow color mixed with a little Burnt Umber. Use a different brush with Titanium White mixed with a little of the bluish color to blend. Tone down the rump highlight with a wash of Raw Sienna and water using a no. 6 round. Tone down the white sock on the near hind leg by making a wash with the bluish shadow color and applying with a no. 3 round.

63

Shetland Pony

We bought Moonlight about fifteen years ago, not knowing that we were getting two for the price of one! Several months later, Moonlight gave birth to a tiny foal we named Epona. Both mother and daughter have been our pets ever since.

MATERIALS

Paints

Burnt Umber

Payne's Gray

Raw Sienna

Ultramarine Blue

Titanium White

Yellow Oxide

Brushes

no. 1, 3, 5 and 7 rounds

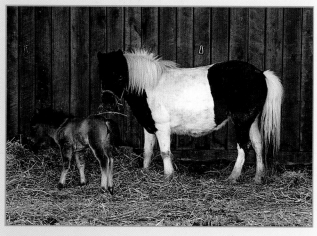

Reference Photo

1 Establish the Form and the Dark Values

Lightly draw the pony onto the panel with your pencil, using a kneaded eraser for corrections. With Payne's Gray thinned with water and a no. 5 round, paint the main lines and values, switching to a no. 3 round for details.

Mix the black for the pony's coat with Burnt Umber and Ultramarine Blue. Paint with a no. 5 round, switching to a no. 3 round for details. For the dark brown eye color, mix more Burnt Umber into a portion of the black.

I used the black mixture and a no. 5 round to paint the dark spaces between the boards with sketchy, vertical strokes. Next I added the pony's shadow in the straw with dabbing strokes.

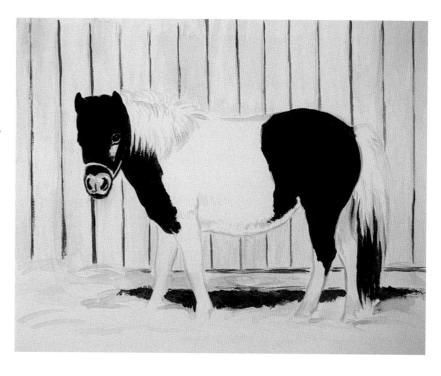

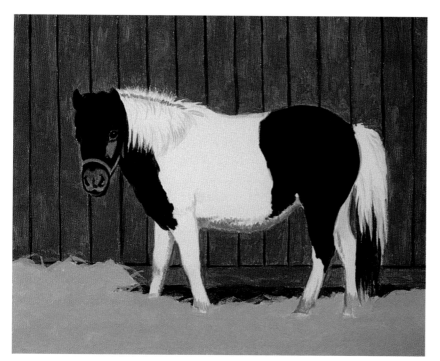

2 Paint the Middle Values

Mix a middle value blue-gray for the pony's nose, halter, highlight under the left eye, lower legs and the line of the belly with Titanium White, Ultramarine Blue and Burnt Umber. Paint with a no. 3 round.

A mixture of Burnt Umber, Titanium White and Raw Sienna works well on the nose and around the pony's eyes.

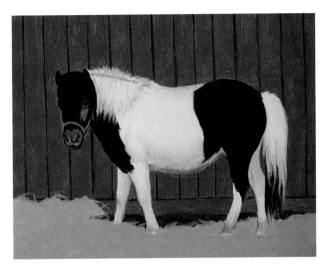

3 Paint the Light Values

Mix a light blue-gray with Titanium White and small amounts of Ultramarine Blue and Burnt Umber. Paint this color on the belly, legs, back, mane and tail with a no. 5 round to indicate shadows and shape.

Mix a warm yellow with Titanium White, Yellow Oxide and Raw Sienna. With a no. 3 round, paint some long strokes on the mane and tail.

Mix a warm white from Titanium White and a touch of Yellow Oxide. Paint with a no. 7 round, with dabbing strokes on the body and long, flowing strokes on the mane and tail.

For the barn wood, I used the same color that I did for the nose and around the pony's eyes—Burnt Umber, Titanium White and Raw Sienna. I painted with a no. 7 round, dabbing vertical brushstrokes (horizontal for the baseboard). I re-established the dark spaces between the boards with a no. 3 round and black.

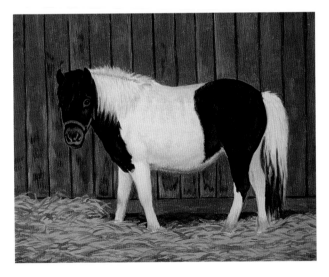

4 Blend the Colors and Add Detail

Using separate no. 3 rounds for the black from Step 1 and the middle value blue-gray from Step 2, begin detailing the pony's head. Blend with the neighboring color. Add detail to the forelock with both colors, using flowing strokes and a small amount of paint.

With the warm brown from Step 2, drybrush details in the black part of the hindquarters, neck and chest. Use a separate brush to add detail with the middle value gray, blending with a no. 5 round and the black.

Add detail to the warm white part of the body, mane and tail with the light blue-gray from Step 3 and a no. 5 round. With a no. 3 round, paint some of the warm brown from above onto the halter, letting some of the middle value blue-gray remain.

Here, I took a portion of the barn wood color and added some Raw Sienna. With this color and a no. 3 round, I painted shadow detail in the straw with basically horizontal, slightly curved strokes that varied in direction.

At this point, I began detailing the barn. For this, I mixed together a lighter color for the barn wood with Titanium White, Raw Sienna and Yellow Oxide. With a fairly dry no. 5 round, I followed the wood grain with light-pressured brushstrokes. I used a fresh no. 5 round and black to detail the dark wood grain.

TIP

The middle value blue-gray may appear too bright in some areas. Tone it down by mixing in a little black.

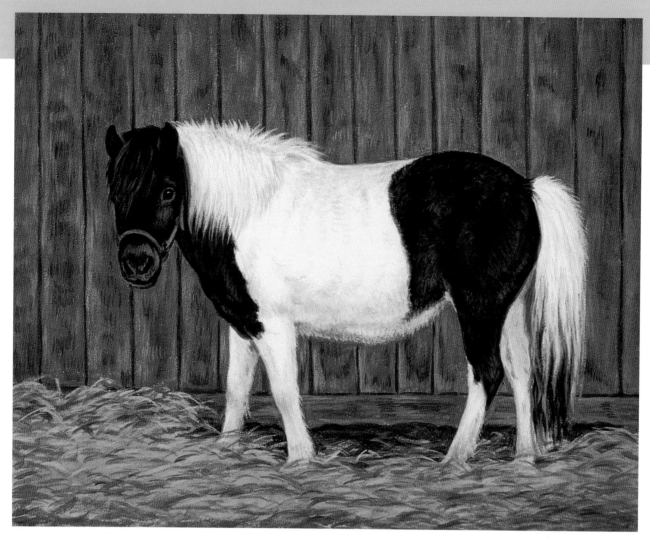

Moonlight
Acrylic on Gessobord
8" × 10" (20cm × 25cm)

5 Paint the Finishing Details

Add some detail to the mane and tail. Use a no. 3 round and Titanium White to soften and tone down the blue shadow line at the crest of the mane, then add hair tufts from the mane, tail and legs.

Tone some of the middle value grays and light blue-gray areas by selectively painting some of the warm yellow onto the belly, back, legs, mane and tail. Using a no. 5 round, drybrush the color on the body with long strokes, and short, light strokes on the mane and tail. Tone down and blend with a separate no. 5 round and the light blue-gray from Step 3.

Use a no. 3 round to tone down the nose with a wash of black and water. Refine this area with the middle value blue-gray and a no. 3 round.

For the highlight in the eye, paint a small curved arc with a no. 1 round and the middle value gray. Make corrections with a fresh no. 1 round and the dark brown eye color.

I decided to tone down the dark lines between the wood boards. They were too strong, leading the eye away from the pony and out of the painting. To tone them down, I used a no. 7 round to drybrush some of the barn wood color over the dark lines so that they became lighter toward the top. Once I was satisfied with that, I moved on to the straw. With a no. 7 round, I laid a glaze of the warm yellow over the straw. Next I darkened the pony's shadow on the floor with black and a no. 5 round, adding a few dark strokes to the straw with a thinned black. I mixed a bit of Titanium White with a portion of the warm yellow to paint some highlights.

With no. 3 rounds for the middle value blue-gray and the warm white, I worked to make the pony's feet show a bit more through the straw. I used another no. 3 round and the warm yellow to overlap the hooves with a few blades of straw.

Project 11

Foal

One misty morning on a horse farm in central Kentucky, I met this handsome colt. Even at this young age, you can already see the regal stance of the thoroughbred.

MATERIALS

Paints

Burnt Sienna

Burnt Umber

Cadmium Orange

Cadmium Yellow Light

Raw Sienna

Titanium White

Ultramarine Blue

Yellow Oxide

Brushes

no. 1, 3 and 5 rounds

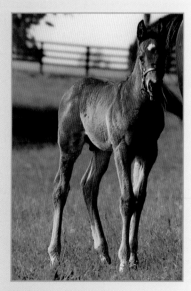

Reference Photo

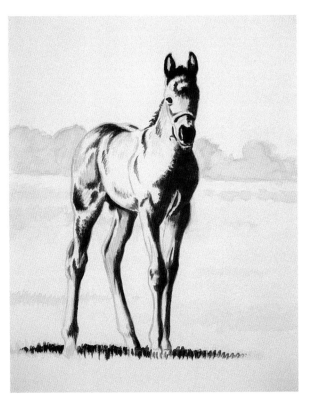

1 Establish the Form and Add the Dark Values

Draw the foal lightly in pencil onto your panel, using a kneaded eraser for any corrections. With a no. 3 round and Burnt Umber thinned with water, paint the main lines of the foal, indicating the light and dark areas.

Mix Burnt Umber and Ultramarine Blue for the black for the ears, eyes, muzzle and darker body shadows. Paint with a no. 3 round.

Mix Burnt Umber, Burnt Sienna, Raw Sienna and a small amount of Ultramarine Blue for the dark brown areas of shadow. Paint with a no. 5 round, using a no. 3 round for the smaller details. Use a no. 3 round to paint black accents over the dark brown on the lower legs, chest, etc.

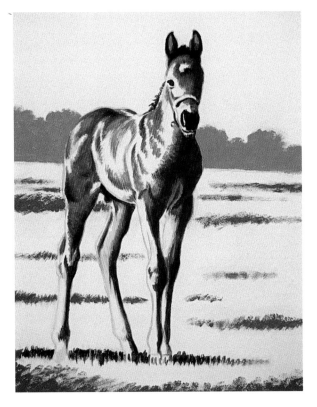

2 Paint the Middle and Lighter Values

Mix a red chestnut for the foal's coat with Burnt Sienna, Cadmium Orange and Titanium White. Paint with a no. 5 round, following the hair pattern with parallel strokes.

Mix a golden buff color for the lighter parts of the foal's coat with Titanium White, Yellow Oxide and Cadmium Orange. Paint with a no. 5 round.

Mix the bluish shadow color for the coat with Titanium White, Ultramarine Blue and Burnt Sienna. Use a no. 5 round for the legs and a no. 3 round for the halter, muzzle and eyelids.

Mix the warm white for the legs and the white star on the forehead with a portion of the golden buff color mixed with more Titanium White. Paint with a no. 3 round.

69

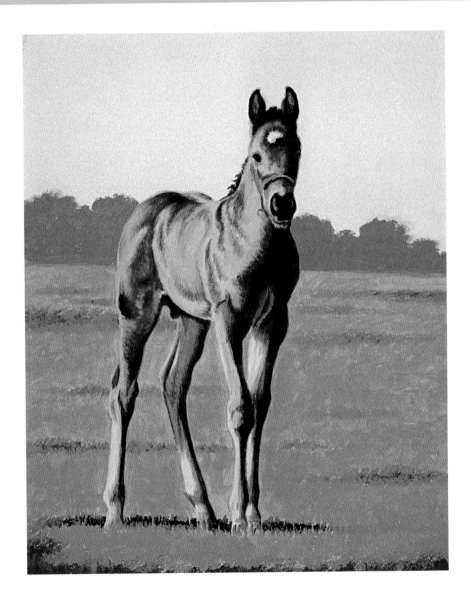

3 Add Detail to the Foal

Blend the foal's coat using separate no. 3 rounds for the red chestnut and the golden buff. Blend where the two colors meet, using a small amount of paint and light-pressured strokes. Use the same technique to blend the foal's other colors—dark brown and red chestnut, and red chestnut and bluish shadow colors. In some areas, such as the upper part of the left hind leg, blend by painting thin parallel strokes of red chestnut over the bluish shadow color. Use these same brushes and colors to add detail to the foal.

Paint the tail with dark brown and a no. 3 round with slightly curved strokes. Use a separate no. 3 round and the bluish shadow color to paint a subtle highlight on the top of the tail, softening the edges.

TIP

You can use your artist's license to paint the foal's tail, although it doesn't show in the reference photo. This gives the painting a more lifelike quality, as if the foal had just swished his tail.

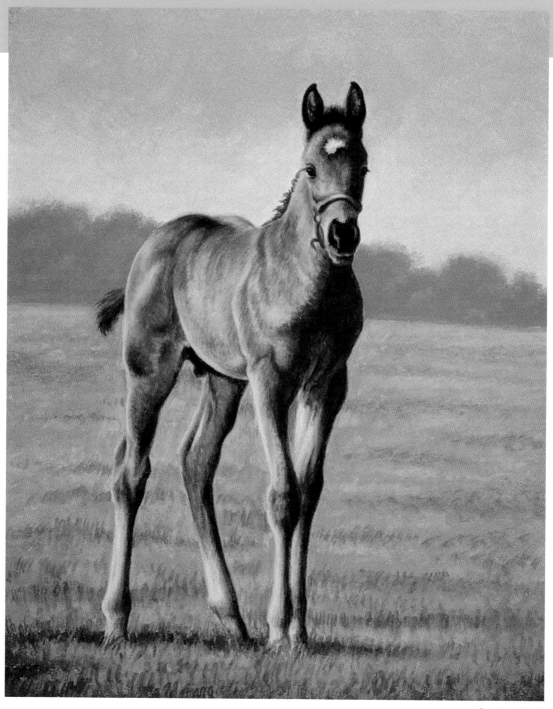

Chestnut Colt
Acrylic on Gessobord
10" × 8" (25cm × 20cm)

4 Paint the Finishing Details

Mix a highlight color for the foal with Titanium White and a touch of Cadmium Yellow Light. Paint with a no. 3 round.

Mix a bit of Titanium White, Ultramarine Blue and a touch of Yellow Oxide with a touch of Burnt Umber. Use this mixture to paint highlights in the eyes with a no. 1 round with small strokes.

TIP

To make the background look farther away than the foreground, use colors that are lighter in value and more bluish. This is called atmospheric perspective.

Project 12

Paint Horse

This strikingly patterned paint mare was part of a herd of paint horses on a farm in Kentucky. I spent the whole morning sketching and photographing the horses. They have been the subjects of several of my paintings.

MATERIALS

Paints

Burnt Sienna

Burnt Umber

Cadmium Orange

Cadmium Yellow Light

Payne's Gray

Raw Sienna

Scarlet Red

Titanium White

Ultramarine Blue

Yellow Oxide

Brushes

no. 1, 3, 4, 5 and 7 rounds

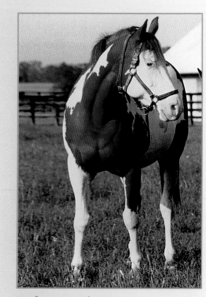

Reference Photo

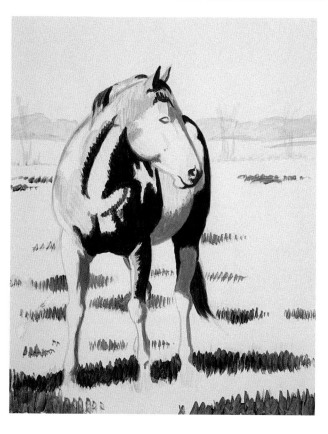

1 Establish the Form and the Dark Values

Draw the horse lightly in pencil, using a kneaded eraser to make corrections or lighten lines that are too dark. With Payne's Gray thinned with water and a no. 4 round, paint the main lines and form.

Mix a dark brown for the shadowed parts of the red coat with Burnt Umber, Burnt Sienna and Ultramarine Blue. Paint with a no. 3 round. When the first layer of paint is dry, add another coat.

Mix a bluish shadow color for the white parts of the horse with Ultramarine Blue, Burnt Sienna and Titanium White. Paint with a no. 3 round.

Mix a warm pink shadow color for the nose with Titanium White, Burnt Sienna, Scarlet Red, Cadmium Orange and Burnt Umber. Paint with a no. 3 round.

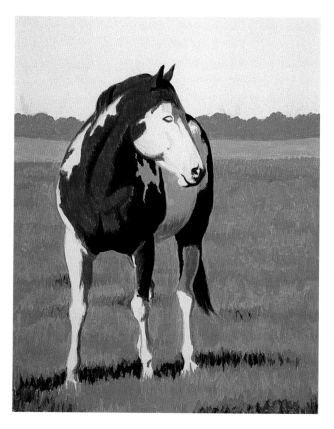

2 Paint the Middle Values

Mix the red for the horse's coat with Burnt Sienna, Cadmium Orange and Scarlet Red. Paint with a no. 5 round.

Mix the lighter blue shadow color with Titanium White, Ultramarine Blue and a small amount of Burnt Sienna. Paint with a no. 5 round.

TIP

It's okay to make changes in a painting as you go along. I decided that including the barn and fence that appear in the reference photo would have distracted from the openness of the landscape behind the horse.

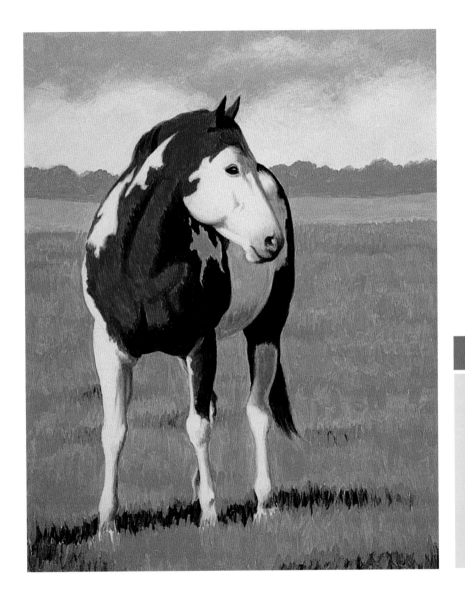

3 Paint the White Parts of the Horse and the Details

Mix the pink for the horse's nose with Titanium White, Raw Sienna, Scarlet Red and a touch of Cadmium Orange. Paint with a no. 3 round. Blend the edges where the pink meets the darker color on the nose with a no. 1 round and some of the warm pink shadow color from Step 1.

Mix the eye color with Burnt Umber and a bit of Burnt Sienna. Paint the eyes with a no. 1 round, adding another coat when it's dry. Mix Titanium White with a touch of

Ultramarine Blue for the highlight, and paint in a curved arc with a no. 1 round. Correct and blend with the dark eye color and a no. 1 round.

Mix a warm white for the white parts of the horse on a piece of dry wax paper palette with Titanium White and a touch of Yellow Oxide. Paint with a no. 3 round, switching to a no. 1 round for the smaller details. Use a no. 3 round with the neighboring color to correct and blend the edges. If the paint begins to dry on the wax paper, add water.

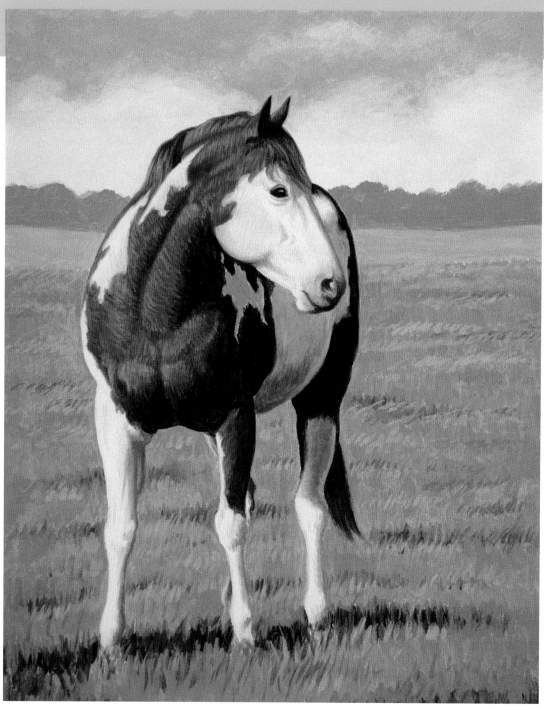

Sturdy Paint
Acrylic on Gessobord
10" × 8" (25cm × 20cm)

4 Add the Finishing Details

Mix a highlight color for the red parts of the coat with Titanium White, Cadmium Orange, Yellow Oxide and Cadmium Yellow Light. Paint with a no. 3 round, following the contours with parallel brushstrokes. With a fresh no. 3 round, blend the red coat color with quick, light strokes. Adding the red will also warm up the highlights.

Use a no. 7 round and a wash of Burnt Umber and water to paint a shadow on the horse's belly and on the shadowed white part of the left hind leg. With a no. 3 round and the bluish shadow color, add a little more detail to the white parts of the horse's head and body. Use a small amount of paint and fine, parallel lines. Soften with a separate no. 3 round and the warm white.

Draft Horse

Nelly is one of our Belgian draft horses. She is a big, strong mare with a beautiful flowing mane and tail. Nelly is smart, too: when a horse fly is bothering her, she will run toward the nearest person and then quickly position herself so the selected person can swat the pesky fly.

MATERIALS

Paints

Burnt Sienna
Burnt Umber
Cadmium Orange
Titanium White
Ultramarine Blue
Yellow Oxide

Brushes

no. 1, 3 and 5 rounds
no. 8 shader

Reference Photo

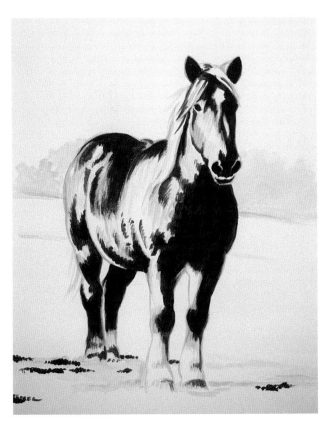

1 Establish the Form and the Dark Values

With your pencil, lightly draw the horse onto the panel, using a kneaded eraser for corrections or to lighten lines that come out too dark. Use Burnt Umber thinned with water and a no. 5 round to paint the main lines and shadow areas.

Mix Burnt Umber, Burnt Sienna and Ultramarine Blue for the dark shadow color. Paint with a no. 5 round for the darkest shadow areas, adding another layer after the first coat is dry. Switch to a no. 3 round for smaller areas.

Mix the black for the nostrils and muzzle with Ultramarine Blue and Burnt Umber. Paint with a no. 3 round.

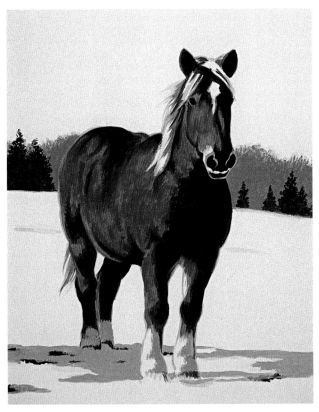

2 Paint the Middle Values

Mix the red coat color with Burnt Sienna, Cadmium Orange and a small amount of Titanium White. Paint with a no. 5 round, using a no. 8 shader for the broader areas. Use dabbing strokes that follow the horse's contours.

Mix the bluish shadow color for the white parts of the lower legs and around the nostrils and mouth with Titanium White, Ultramarine Blue and a small amount of Burnt Sienna. Paint with a no. 3 round.

3 Paint the Lighter Values

Mix a blond color for the mane, nose and lower front legs with Titanium White, a small amount of Yellow Oxide and a bit of Cadmium Orange. Paint with a no. 3 round, using flowing strokes for the mane.

Mix a color for the shadowed parts of the hooves. First, create a warm gray with Titanium White, Burnt Umber and Ultramarine Blue. Take a small portion of this warm gray and add more Burnt Umber and Ultramarine Blue. Paint the shadows with a no. 3 round. For the highlighted parts of the hooves, mix a bit of the warm gray with some of the blond.

For the shadowed part of the blaze, mix a bit of the bluish shadow color from Step 2 with some Titanium White and a touch of Burnt Sienna. Paint with a no. 3 round.

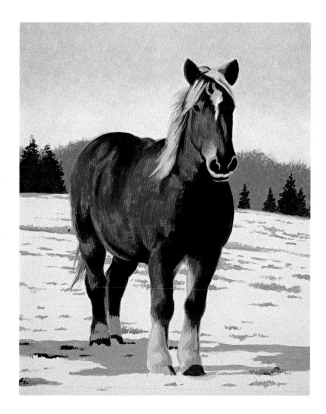

4 Add Detail

Re-establish the eye's shape with a no. 1 round and the dark shadow color. Mix a small amount of this color from Step 1 with some Burnt Sienna. Use a no. 5 round to detail the horse's coat with parallel strokes that follow the fur pattern. Use a no. 3 round with the red coat color from Step 2 to soften the edges.

With your palette knife, transfer a small amount of the red to a clean spot on your palette, then make a glaze with water. Paint a thin wash over the blond mane, muzzle and lower legs to make these areas glow in the late afternoon light.

Use a no. 3 round to mix some of the dark shadow color with a bit of the bluish shadow color. Use this to paint darker detail on the hooves and lower legs, using a no. 3 round to blend into the neighboring color. Mix some of the red with Burnt Sienna for the details in the dark shadows of the horse's coat and paint with a no. 3 round.

Mix a highlight for the eye by mixing a bit of the bluish shadow color with a touch of Burnt Sienna. Use a no. 1 round to paint the curved arc. With a no. 1 round, tone down the bluish highlights around the nostrils and chin with a thin glaze of the dark shadow color. Use a separate no. 1 round and the bluish color to soften.

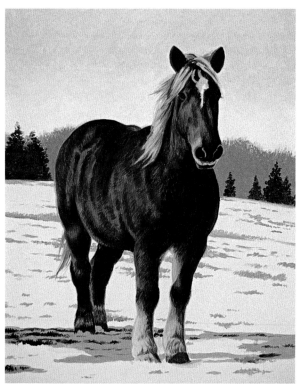

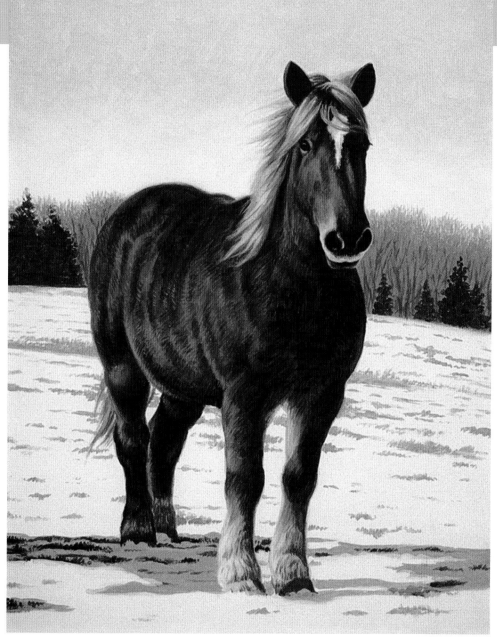

Nelly
Acrylic on Gessobord
10" × 8" (25cm × 20cm)

5 Finish the Drawing

Paint the white, highlighted part of the horse's white face marking with Titanium White mixed with a touch of Yellow Oxide and a no. 3 round. On a dry palette, mix a highlight color for the horse's coat with Cadmium Orange, Yellow Oxide and a small amount of Titanium White. Use a no. 3 round to drybrush the highlights with small, parallel strokes.

Add more detail to the mane and tail with separate no. 3 rounds for the highlight color, red coat color and dark shadow color. Add some highlights to the nose and lower legs with a no. 3 round and Titanium White mixed with a small amount of Yellow Oxide.

Project 14

Appaloosa

I spotted this handsome leopard Appaloosa, standing next to a hay roll, while I was driving along a gravel road not far from where we live. Impressed by the horse and the composition, I stopped and photographed the scene for future reference.

MATERIALS

Surface

bristol paper

Pencils

no. 2 pencil

ebony pencils

Other Supplies

kneaded eraser

blending stumps

tracing paper

medium

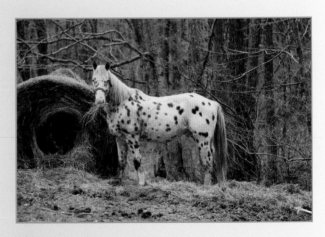

Reference Photo

1 Draw the Main Lines

Lightly sketch or trace the main lines of the horse and hay roll with a no. 2 pencil. Reinforce the lines with a sharpened ebony pencil. Begin to shade in some of the darker areas.

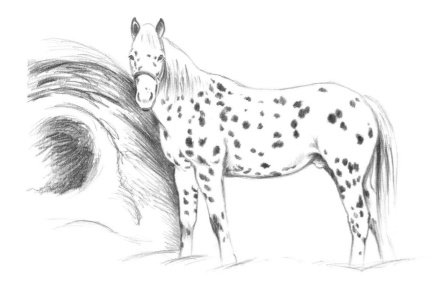

2 Shade in Darker Values

Add more Appaloosa spots to the horse's coat and more shading to the hay. Using an ebony pencil, make short strokes for the spots and long, sweeping strokes for the hay. Add more shading to the horse's body.

TIP

To see the dark values more clearly in your reference photo, squint your eyes and the dark values will pop out at you.

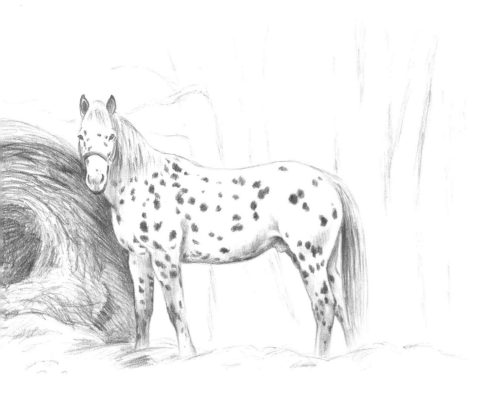

3 Add the Middle Values to the Horse and Hay

Shade in some middle value shadow tones and any other Appaloosa spots you missed in Step 2. Begin to use the stump to blend with smooth strokes following the direction of the pencil strokes. Use an ebony pencil throughout this step.

Add detail to the hay roll with pencil strokes that curve in different directions to create the texture. Add shadows and sketchy details to the hay on the ground. Lightly sketch in the shapes of the trees in the background. Begin to shade in the trees.

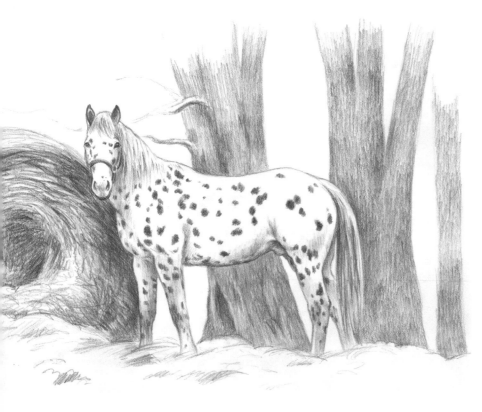

4 Add More Detail

Shade the trees using vertical strokes with a fairly light pressure on the pencil. Gradually darken some of the shadowed areas, but don't make them as dark as the shadows on the horse. This will make the horse stand out against the background.

Use a kneaded eraser to correct any mistakes or to lighten areas that have become too dark. Darken shadows on the horse and the hay roll.

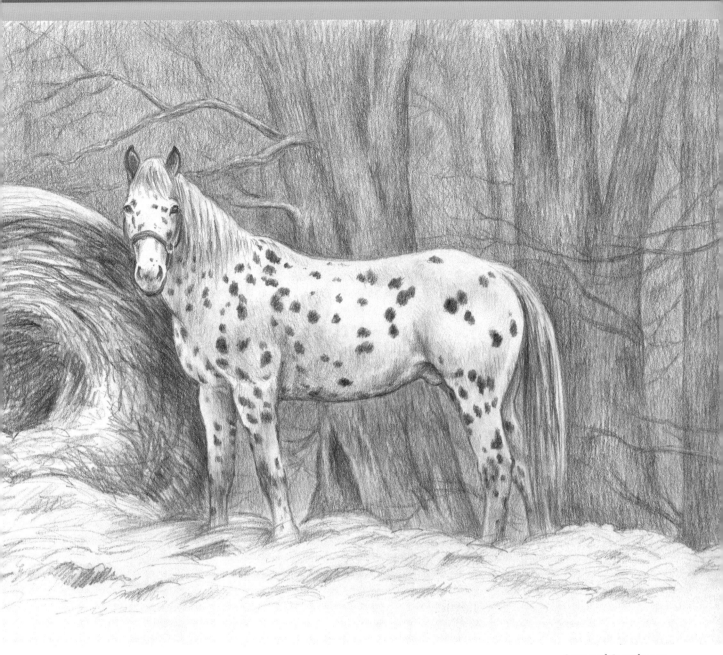

Leopard Appaloosa
Ebony pencil on bristol paper
8" × 10" (20cm × 25cm)

5 Finish the Drawing

Finish shading the tree trunks, then shade lightly between the trees, using parallel strokes. Crosshatch in different directions over the original pencil strokes, then blend with a stump.

Gradually darken the shadows on the tree trunks, then add some shadowy trees in the background. Lightly sketch in some branches.

Add more shading on the horse, using a stump to blend and soften. Make any corrections using a kneaded eraser. Add more detail to the hay in the foreground with sketchy strokes.

Project 15

Thoroughbred Foal

This fine-looking Thoroughbred colt was born at Millford Farm near Midway, Kentucky. I visited the farm because his owner had commissioned me to paint a mare and foal. I had a good time observing and photographing a whole field full of mares and foals!

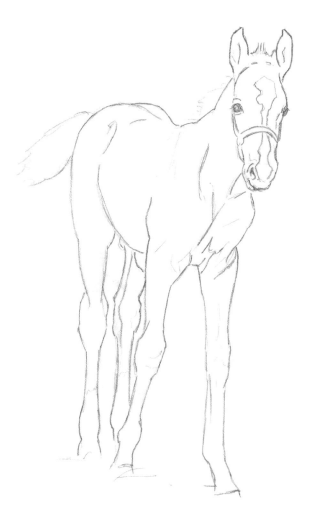

MATERIALS

Paints

Burnt Sienna
Burnt Umber
Cadmium Orange
Cadmium Yellow Light
Cerulean Blue
Naples Yellow
Permalba White
Raw Sienna
Ultramarine Blue Deep
Viridian
Yellow Ochre

Other Supplies

medium
turpentine

Brushes

no. 1, 4, 6 rounds
no. 4, 6, 10 filberts

Reference Photo

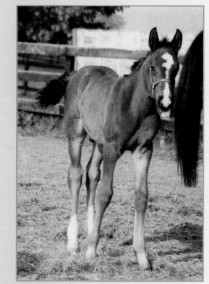

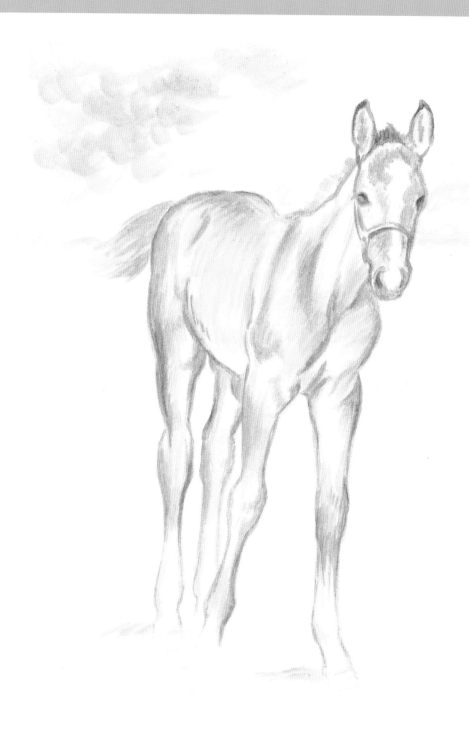

1 Establish the Form

Use Burnt Umber thinned with turpentine to indicate the main lines and shadowed areas of the foal. Use a no. 4 round for detail and a no. 6 round for the broader areas.

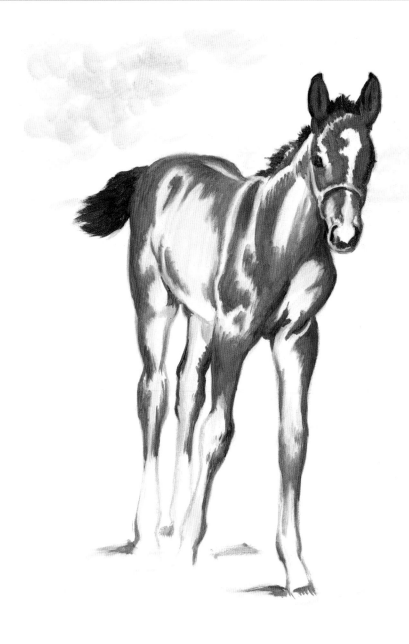

2 Paint the Darkest Values

Mix warm black with Burnt Umber and Ultramarine Blue Deep. Paint the darkest areas of the foal with a no. 4 round, using a no. 6 round for the tail. Mix dark red-brown with Burnt Sienna, Cadmium Orange and Ultramarine Blue Deep. Use smooth strokes, following the foal's contours, using no. 4 and no. 6 rounds. Blend where the two colors meet with a separate brush. Use enough medium so the paint flows smoothly and is not too opaque. For broader areas, use a no. 6 filbert.

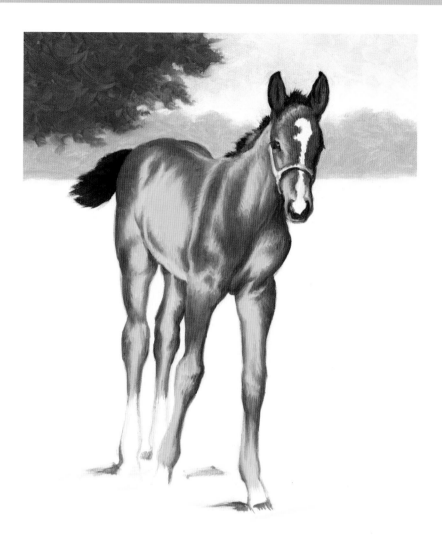

3 Paint Middle Values of Foal and Begin the Background

Mix the green tree color with Viridian, Burnt Umber, Cadmium Orange and Permalba White. Paint the closest tree with a no. 10 filbert, using dabbing, semicircular strokes. Mix the atmospheric blue for the distant tree line with Permalba White, Ultramarine Blue Deep, a little Burnt Umber and some of the green tree color. Paint with a no. 10 filbert with dabbing strokes.

Mix the sky blue color with Permalba White, Cerulean Blue and a little Naples Yellow. Paint with a no. 10 filbert with dabbing strokes, leaving a space above the tree line. Mix a light sky blue color with the sky blue plus Permalba White. Use a separate no. 10 filbert to paint just above the tree line, blending up into the sky blue. Paint around the foal's ears with a no. 6 round.

Use no. 10 filberts to re-establish and lightly blend the near and far trees with the green tree color and atmospheric blue.

Mix the golden buff color for the lighter parts of the foal's coat with Permalba White, Cadmium Orange and Yellow Ochre. Paint with a no. 10 filbert, using a separate no. 10 filbert to lightly blend with dark red-brown where the colors meet. Use no. 6 rounds for smaller areas. Paint with smooth strokes following the foal's contours.

Mix blue-gray with Permalba White, Ultramarine Blue Deep and a small amount of Burnt Umber. Paint the bluish shadows on the foal's hind legs and also around the nostrils with no. 4 rounds. Blend with the adjacent colors. Darken the mane and tail with another layer of warm black, using a no. 4 round.

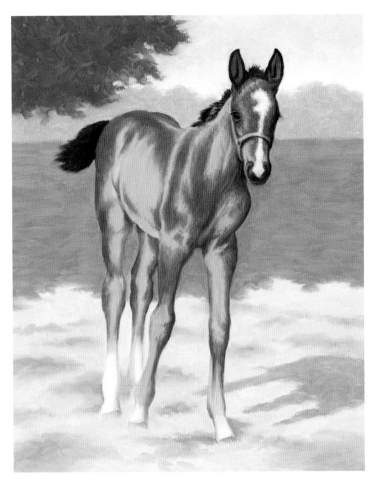

TIP

When mixing a color, check to see if the color is what you want by dabbing a small amount on your painting. Colors look different on a palette than on your painting. This way, you can make adjustments before committing to the color.

4 Paint the Straw and Field and Add Detail to the Foal

Paint the foal's shadow with the blue-gray color and a no. 10 filbert.

Mix a straw shadow color with Permalba White, Raw Sienna and a little Burnt Umber and Ultramarine Blue Deep. Paint the shadows in the straw with a no. 10 filbert. Mix a straw color with Permalba White, Naples Yellow and a little Raw Sienna. Use a no. 4 filbert to paint the straw, lightly blending the straw shadows into the straw color with a no. 10 filbert. Use a no. 6 round to paint around the foal's legs.

Mix the green field color with Viridian, Permalba White, Naples Yellow and Cadmium Orange. Paint smooth, horizontal strokes with a no. 10 filbert. Use a no. 6 round to paint around the foal's contours.

Mix a bluish shadow color with Permalba White, Ultramarine Blue Deep, a little Burnt Umber and a touch of Burnt Sienna. Paint the shadows on the white parts of the legs with a no. 4 round. Blend with the adjacent color.

Use no. 4 rounds to paint the hooves with the dark red-brown for the shadowed parts, blending with the golden buff.

Mix warm white with Permalba White and a little Naples Yellow. Paint the blaze on the face with a no. 4 round, blending the edges with small strokes of the dark red-brown. Use no. 4 rounds to paint the lower part of the muzzle with the bluish shadow color, and add detail to the nostrils, blending with warm black.

Mix light brown for the halter with the straw shadow color and Permalba White. Paint with a no. 1 round. Reinforce the halter shadows with warm black and a no. 1 round.

Paint a thin glaze of dark red-brown over the dark red-brown and golden buff parts of the foal with a no. 10 filbert. Refine the shape of the foal's right eye, then paint a highlight with a bit of the bluish shadow color and a no. 1 round. Let dry.

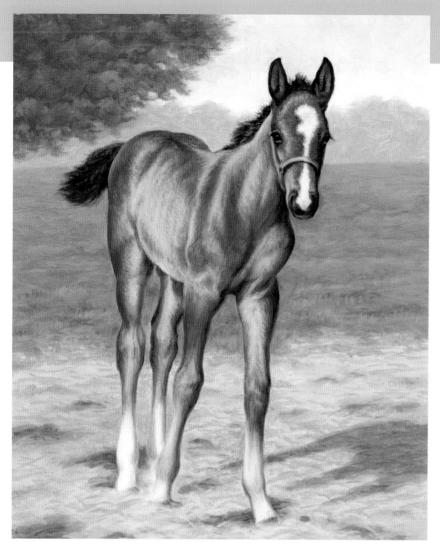

An oil painting will lose its sheen and the colors will become dull as they dry. Use a spray damar retouch varnish to lightly spray the painting before you begin to work on it again. It takes only a few minutes for the varnish to dry. This restores the colors so they look the same as when you applied them and will ensure that the colors you use in a new painting session will match the colors from the previous painting session.

A Fine Looking Colt
Oil on Gessobord
8" × 10" (20cm × 25cm)

5 Finish the Drawing

Use a no. 4 round and dark red-brown to paint lightly over the golden buff areas of the coat. Darken the shadows on the hind legs with warm black, blending with blue-gray.

Paint a thin glaze of medium and Burnt Umber over the straw with a no. 4 filbert. Mix a tree highlight color with the green field color, Permalba White and Cadmium Yellow Light. Dab with a no. 6 filbert, blending lightly with the green tree color. Soften the edges of the tree with feathery strokes.

Paint shadows in the field with no. 6 filberts and the green tree color. Mix a grass highlight color with a portion of the green field color plus more Permalba White and Cadmium Yellow Light. With a no. 6 filbert, paint highlights. Use no. 6 filberts to paint vertical strokes of the green tree color and grass highlight color.

Paint detail in the straw with the straw shadow color and a no. 4 round. Use a separate no. 4 round with the dark red-

brown to paint darker strokes in the shadowed areas. Use the straw shadow color and blue-gray to soften and blend.

Mix the coat highlight color with Permalba White, Cadmium Yellow Light and Yellow Ochre. Paint highlights on the coat with a no. 4 round, blending with the adjacent color and using separate no. 4 rounds. Add detail to the dark red-brown areas of the coat with the golden buff.

Paint highlights in the tail with blue-gray and a no. 4 round, blending with warm black. Define the left eye with blue-gray and a no. 1 round. Paint a highlight in the eye. Use warm black with a no. 4 round to darken shadows on the foal.

Paint a glaze of Ultramarine Blue Deep over the foal's shadow with a no. 6 filbert, then darken the shadows in the straw. Blend the shadow edges with a bit of blue-gray.

With the coat highlight color and a no. 4 round, add a few strokes in the straw around the foal's feet.

Project 16

Lipizzaner Stallion

My husband, son and I attended the World Famous Lipizzaner Stallions tour when it visited Lexington, Kentucky. These magnificent white stallions inspired me to draw and paint them with their strength, agility and flowing manes and tails. I was able to get some great reference photos, including the photo this drawing is based on. For this demonstration, I chose to draw just the horse without tack or handler, although the photograph would also make a fine drawing or painting reference just the way it is.

MATERIALS

Surface

bristol paper

Pencils

no. 2 pencil
ebony pencils

Other Supplies

kneaded eraser
blending stumps
tracing paper

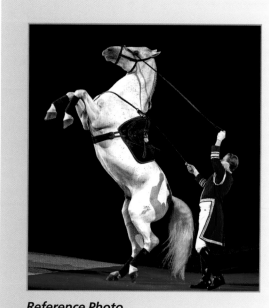

Reference Photo

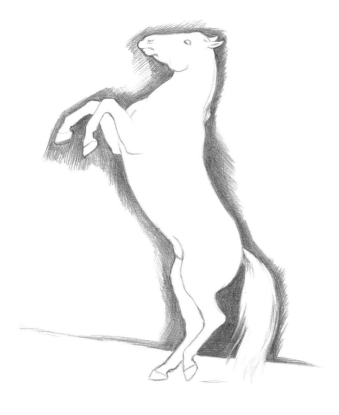

1 Establish the Horse's Outline

Lightly draw or trace the horse's outline onto the bristol paper with a no. 2 pencil. Reinforce the lines with a sharpened ebony pencil.

Begin shading around the horse's contours with the ebony pencil, using hatching and crosshatching. Make any corrections with a kneaded eraser.

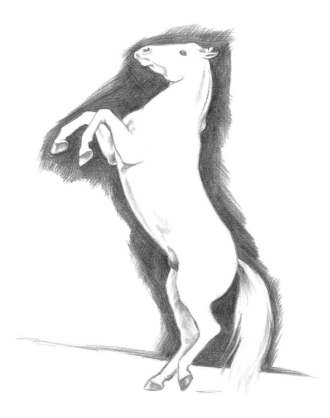

2 Begin to Add Detail

Shade in some of the detail on the horse using a stump to blend. Darken and sharpen the lines around the horse's outline, adding more shading going outward from the horse, gradually darkening with crosshatching.

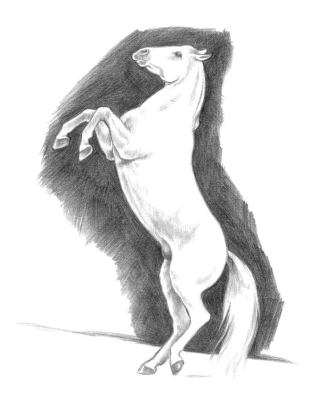

TIP

Since the trainer was standing next to the horse and he is not included in the drawing, eliminate any shadows cast onto the horse by the man or by the tack. When you choose to make changes from your reference, look out for these kinds of inconsistencies.

3 Keep Adding Detail and Background Tone

Continue adding detail to the horse with light parallel strokes that follow the horse's contours. Use a stump to blend in the same direction as the pencil strokes. Keep shading the background tone.

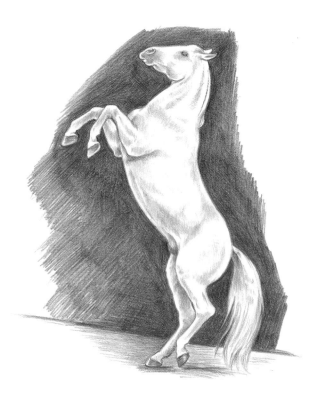

4 Add More Detail to the Horse and Background

Add shading to the horse's body, blending with the stump. Indicate shadows under the hooves with parallel lines. Begin to shade the medium tone of the carpet the horse is standing on. Make any corrections or lighten areas that have become too dark with a kneaded eraser. To lighten an area, lightly press the eraser down on the spot as many times as it takes to achieve the effect.

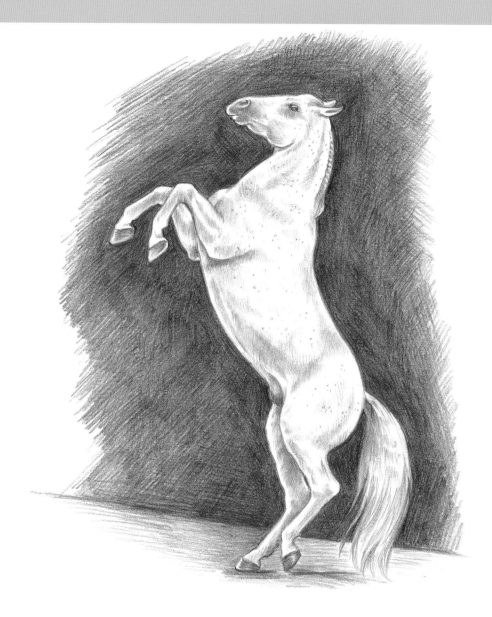

Beautiful White Stallion
Ebony pencil on bristol paper
9" × 7" (23cm × 18cm)

5 Add the Finishing Details

Draw the rest of the details of the horse, including the braiding pattern on the mane and the small speckles or spots on the coat. If the spots appear too dark, lighten them with the kneaded eraser.

Shade out from the edges of the darkness around the horse, gradually lightening the tone and forming an irregular but pleasing shape around the horse.

TIP

You can use a stump to soften and blend pencil strokes as well as to extend and create shading in new places.

Project 17

Arabian Filly

The model for this demonstration was my Arabian horse, Poey, when she was about ten months old. At this age, she would race around the field, frisking, frolicking and arching her neck. I found this pose particularly appealing as she playfully pranced around with a wisp of hay in her mouth. Poey is a gray horse, but at this stage she looked like a bay.

MATERIALS

Paints

Burnt Sienna

Burnt Umber

Cerulean Blue

Raw Sienna

Titanium White

Ultramarine Blue

Yellow Oxide

Brushes

no. 1 and 4 rounds
no. 4 and 6 filberts

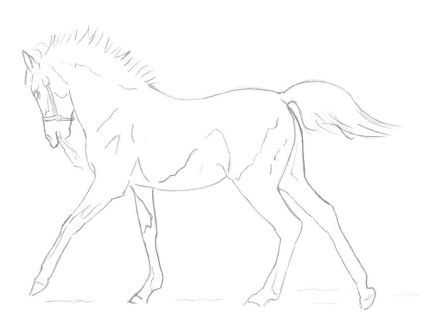

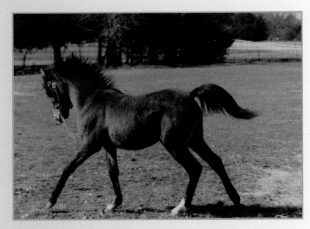

Reference Photo

94

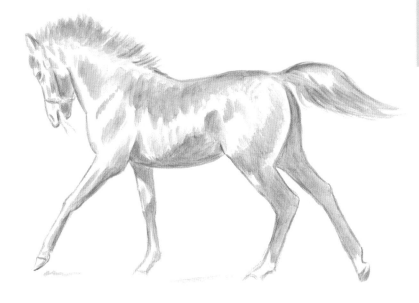

TIP

To make a small correction, such as painting too far over a line, use a moistened, clean no. 4 round to remove the paint while it is still wet.

1 Establish the Form

Draw or trace your sketch onto the panel with a no. 2 pencil. With Burnt Umber thinned with water and a no. 4 round, paint the main lines and shadowed areas of the filly. For broader areas, use a no. 6 filbert.

2 Paint the Darkest Values

Create a warm black mix with Burnt Umber and Ultramarine Blue. Paint the darkest areas with a no. 4 round, using a no. 6 filbert for the broader areas. For good coverage, paint a second coat after the first has dried.

Mix a blue-gray for the horse's shadow on the ground with Titanium White, Ultramarine Blue and Burnt Umber. Paint with a no. 6 filbert with sketchy strokes.

95

3 Paint the Middle Values

Create the reddish brown mix with Burnt Sienna, Burnt Umber, Yellow Oxide and Titanium White. Paint with a no. 6 filbert, blending with the warm black and a separate no. 6 filbert.

Mix the bluish shadow color with a portion of the blue-gray plus Titanium White. Paint the bluish highlights on the black areas of the coat, mane and tail with a no. 6 filbert, switching to a separate no. 6 filbert to blend with the adjacent color. Use no. 4 rounds for smaller areas such as the head. Use smooth strokes that follow the body contours.

4 Paint the Lighter Values and Background

Create the warm tan color with Titanium White, Yellow Oxide, Burnt Sienna and Raw Sienna. Paint with a no. 6 filbert, blending with a separate no. 6 filbert and the adjacent color. Use no. 4 rounds for smaller areas.

Create a hoof color with a little of the warm tan plus a little Ultramarine Blue. Use no. 4 rounds to paint the hooves with warm black for the shadowed parts and hoof color for the lighter areas. Blend where the two colors meet.

Make a medium brown halter color with a little of the warm tan plus Burnt Umber. Paint the halter with a no. 4 round, using a separate no. 4 round and warm black to refine and add shadows.

Mix a smoky gray background color with Titanium White, Cerulean Blue and Burnt Sienna. Begin to paint the background with a no. 4 filbert, using dabbing, semicircular strokes.

Paint around the filly's outline with a no. 6 filbert, using smooth, careful strokes, then blend outward with dabbing strokes. Use a no. 4 round for tighter areas, such as between the legs.

TIP

If you need only a small amount of paint on your brush, such as for the halter, dip your brush in the paint, then touch it lightly to a paper towel. You will learn how to get just the right amount of paint to do the job.

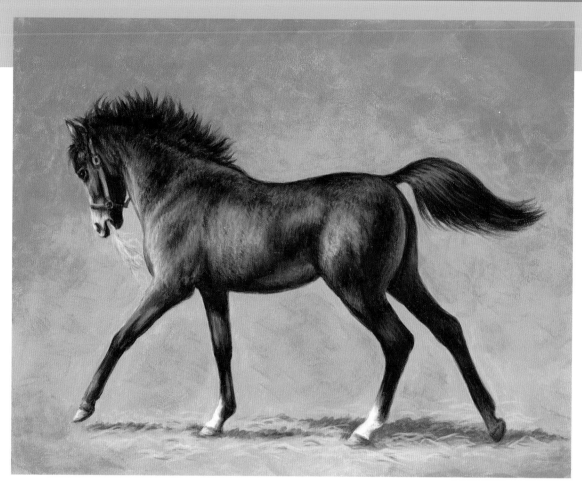

Poey the Prancer
Acrylic on Gessobord
8" × 10" (20cm × 25cm)

5 Finish the Background and Add Detail to the Filly

Mix a dark smoky gray background color (use the Step 4 colors with less Titanium White). Paint the top part of the painting with a no. 4 filbert, using a separate no. 4 filbert to blend with the smoky gray. Use dry brushing to blend the edges of the colors. Use the same technique to add some darker smoky gray to the other parts of the background with a light pressure on your brush, blending with the smoky gray using dabbing strokes.

Re-establish the filly's outline with a no. 4 round and the appropriate color. Re-establish the filly's shadow on the ground with the blue-gray and a no. 6 filbert. Blend the edges with smoky gray and a separate no. 6 filbert.

Mix warm white with Titanium White and a small amount of Yellow Oxide. Use no. 4 rounds to paint the filly's socks on the right front and left rear legs, blending with the bluish shadow color and warm black.

Use warm black to add detail to the bluish shadow and reddish brown areas of the coat with a no. 4 round with small parallel strokes. Blend with the adjacent color. Use no. 4 rounds to add detail to the warm tan areas with reddish brown. Add detail to warm black areas with the bluish shadow color.

Paint flowing lines from the mane and tail with warm black and a no. 4 round. With a no. 1 round and the bluish shadow color, paint a highlight in the eye. Add highlights to the muzzle, ear and chest with warm white and a no. 4 round. Switch to a no. 1 round to add highlights to the hooves, except for the hoof in shadow. Blend all highlights with the adjacent colors.

Create a golden color for the wisp of hay in the filly's mouth with Titanium White and Yellow Oxide. Paint with a no. 1 round. Use medium brown to paint a few strands in shadow. Paint a few strokes of hay on the ground around the filly's shadow, using the blue-gray to paint shadows in the hay.

Friesian Stallion

The subject of this drawing was a Friesian stallion named Frieske, who was at the Kentucky Horse Park. The people who work at the park were very kind, giving me a private showing of this amazing horse. It was a real thrill to watch Frieske walk, trot and gallop around the field, his luxurious mane and tail flying in the wind. Several paintings and drawings have resulted from that visit.

MATERIALS

Surface

bristol paper

Pencils

no. 2 pencil
ebony pencil

Other Supplies

kneaded eraser
blending stumps
tracing paper

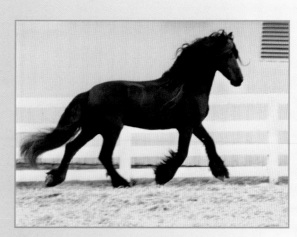

Reference Photo

1 Establish the Form

Draw or trace the image onto bristol paper with a no. 2 pencil. With a sharpened ebony pencil, lightly go over the lines and begin to shade in the darkest areas. Use parallel strokes that follow the horse's contours.

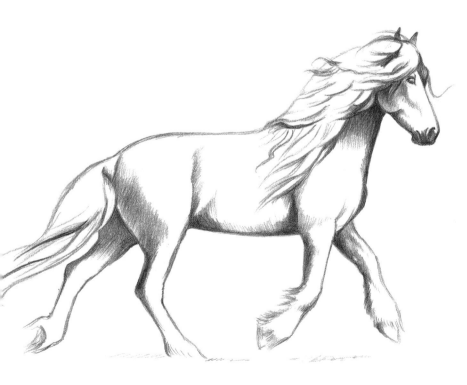

2 Shade in More Dark Areas

Continue to shade in the darkest areas with parallel strokes. Darken gradually, using crosshatching. Begin to block out the boundaries of the darker areas with light, parallel strokes.

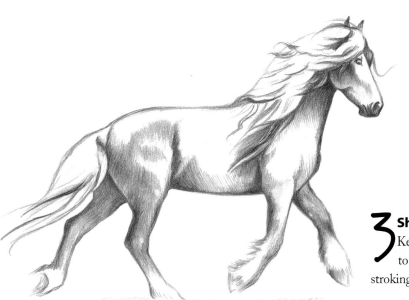

3 Shade the Dark and Middle Values
Keep shading the dark areas and begin to transition to some of the midvalue areas. Use a stump to blend, stroking in the same direction as the pencil lines.

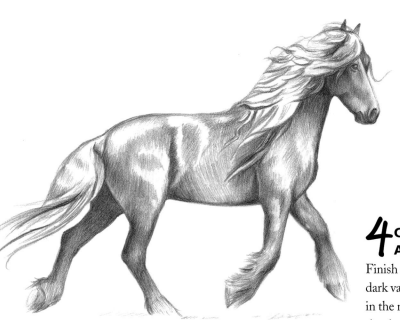

4 Continue Shading the Horse's Coat and Add Detail to the Mane and Tail
Finish defining the boundaries of the major areas of light and dark values in the coat. Sketch the shapes of the locks of hair in the mane and tail with flowing lines. Continue to darken the shadowed parts of the horse's coat.

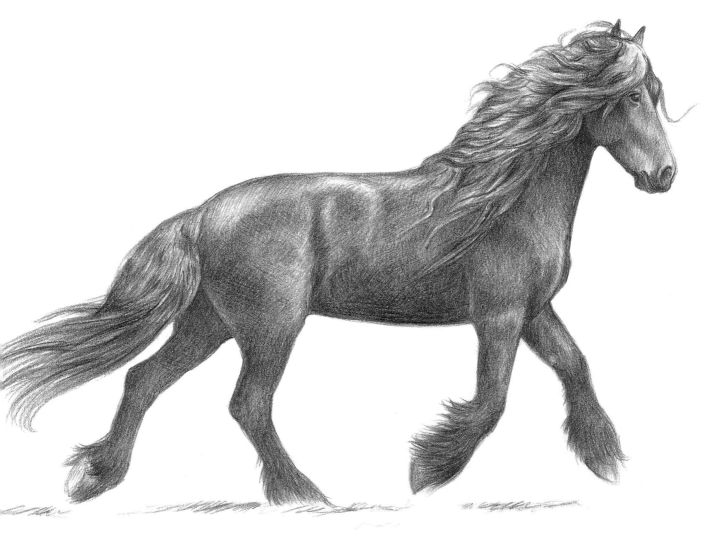

Amazing Trotter
Ebony pencil on bristol paper
8 " × 12 " (20cm × 30cm)

5 Finish the Drawing

Finish darkening the belly, neck, legs and hindquarters, using crosshatching and blending with a stump. Darken and add detail to the mane and tail. Use a kneaded eraser to lighten dark areas or to make corrections. Draw more lines in the tail with sweeping, curved strokes. Draw the horse's shadow with short, sketchy, slanted strokes. Blend with a stump.

Project 19

Arabian Gelding

The model for this painting was my Arabian horse Shammar. I acquired Shammar when he was at least fifteen years old (a horse's age can be determined from looking at its teeth up to the age of fifteen, but after that, the horse's age cannot be told with any accuracy). I had Shammar for the next nineteen years, so he was at least thirty-four years old when he passed away. Shammar was down on his luck before he came to live with us. His owners had left him at a stockyard, where he had been sold at auction to a horse dealer, who in turn sold him to the dealer I got him from. Shammar was very nervous and jumpy when he first came to our farm, but he gradually settled down. I miss him. He was a good horse, and I'm glad I was able to provide a secure and permanent home for him, where he could live out his life in peace and comfort.

MATERIALS

Surface

Gessobord panel
8" × 10" (20cm × 25cm)

Acrylic Pigments

Burnt Sienna

Burnt Umber

Cadmium Orange

Hansa Yellow Light

Hooker's Green

Titanium White

Ultramarine Blue

Yellow Oxide

Brushes

no. 1, 4 and 6 rounds
no. 4, 10 filberts

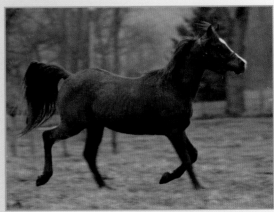

Reference Photo

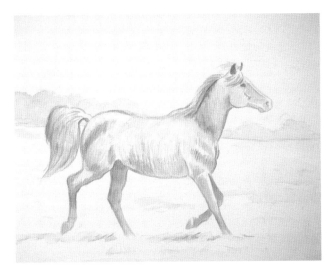

The reference photo was taken on a drab, overcast day, so the horse's color appears darker than normal. It is helpful to refer to other photos taken under better lighting conditions that show the rich red color of the coat.

1 Establish the Form

Lightly trace or sketch the horse and background onto the panel with a no. 2 pencil. Use Burnt Umber thinned with water and a no. 4 round to paint the main lines and contours of the horse and background.

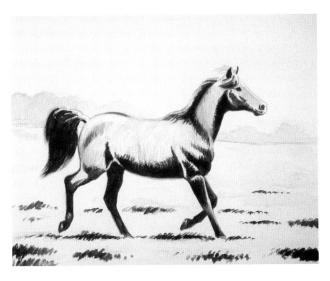

2 Paint the Dark Values

Mix the dark brown for the shadowed parts of the horse's coat with Burnt Umber, Burnt Sienna and Ultramarine Blue. Paint the broader areas with a no. 6 round, switching to a no. 4 round for more detailed areas. Mix the dark green for the grass shadows with Hooker's Green, Burnt Umber, Cadmium Orange and Ultramarine Blue. Paint with a no. 6 round, using dabbing parallel strokes.

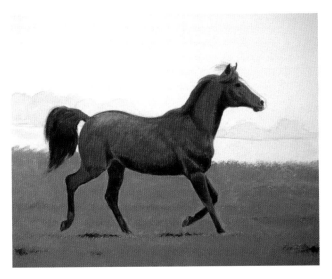

3 Paint the Middle Values and Begin the Background

Mix the red chestnut color for the horse's coat with Burnt Sienna and Cadmium Orange. Paint with a no. 6 round, using strokes that follow the horse's contours. For good coverage, add a second coat when the first is dry. Begin to re-establish the dark value areas with a no. 4 round and the dark brown from Step 2.

Mix the basic grass color with Hooker's Green, Cadmium Orange, Yellow Oxide, Titanium White and a small amount of Hansa Yellow Light. Paint with a no. 4 filbert, using dabbing strokes, about three-quarters of the way up to the horizon. Use a no. 4 round to paint around the horse.

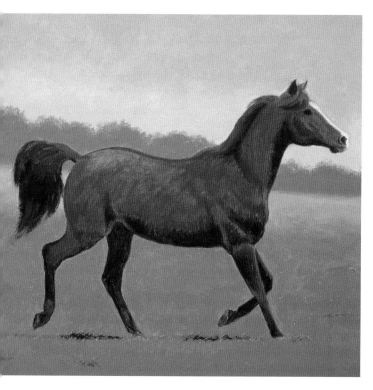

4 Paint the Sky and the Remainder of the Field

Make a light green for the upper fourth of the field with the basic grass color mixed with Titanium White, Yellow Oxide and Hansa Yellow Light. Paint with a no. 4 filbert, using a second brush to blend.

Mix blue-green for the trees with Titanium White, Hooker's Green Permanent, Ultramarine Blue, Cadmium Orange, Yellow Oxide and a little Hansa Yellow Light. Paint dabbing strokes with a no. 10 filbert, switching to a no. 6 round to paint around the horse. Blend where the horizon meets the tree line with a no. 4 round.

Mix the blue sky color with Titanium White, Ultramarine Blue and a little Yellow Oxide. Make a light blue for the lower quarter of the sky by adding more Titanium White and a little Yellow Oxide. Paint with separate no. 4 filberts for each color, blending where they meet, using semicircular dabbing strokes. With a no. 4 round and the blue-green color, paint feathery strokes from the tops of the trees overlapping the sky.

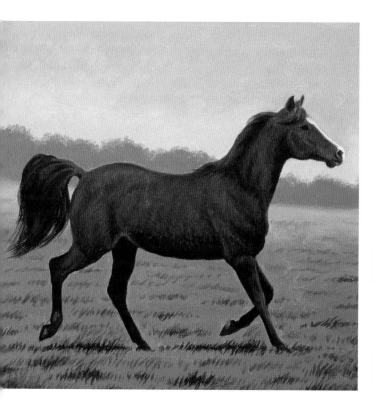

5 Add Detail to the Horse and Grass

Strengthen the horse's dark areas and the midvalue red chestnut color with no. 6 rounds. Paint more detail in the coat and blend the edges of the dark areas with the dark brown color and a no. 6 round, using light-pressured, parallel strokes that follow the horse's contours.

Paint dark detail areas in the grass with a no. 6 round and the dark green color from Step 3, using roughly vertical strokes in varying directions. Use a light pressure on the brush, and make the shadows smaller and lighter as you go back into the landscape.

TIP

By varying the amount of paint on your brush, you can control the darkness of the detail and make it more realistic. Use less paint for the clumps of grass in the background and for grass detail in between the main grass shadows in the foreground.

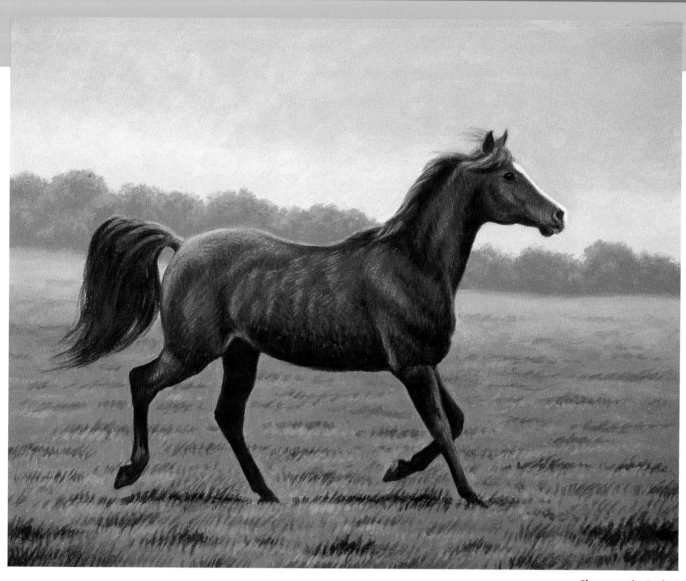

Shammar in Action
Acrylic on Gessobord
8" × 10" (20cm × 25cm)

6 Paint the Light Values and Finishing Details

Mix a highlight color for the horse with Titanium White, Hansa Yellow Light and Cadmium Orange. Paint the highlights with a no. 4 round, blending down into the red chestnut color with the dry-brush technique. Paint the highlights on the belly and flank with light parallel strokes. Tone down and blend the highlights with a separate no. 4 round and the red chestnut color.

Mix warm white with Titanium White and a touch of Hansa Yellow Light for the horse's white blaze. Paint with a no. 4 round. Paint a highlight in the eye with a little of the light blue sky color from Step 4 and a no. 1 round.

Mix a highlight color for the grass with a portion of the light green grass color from Step 4 mixed with some Cadmium Orange and Hansa Yellow Light. Paint with a no. 4 round, using dabbing, vertical strokes. Mix a warm brown with a bit of this color and a bit of the red chestnut color, and paint dabbing strokes in the grass with a no. 4 round. This will integrate the horse with the background and add realism to the field.

Mix a highlight color for the trees with some of the blue-green tree color from Step 4 and a portion of the light green grass color. Paint with a no. 4 round using dabbing strokes, blending with a separate no. 4 round and the blue-green color.

5 Cattle

I was introduced to cows on a family trip to Ideal Farms in New Jersey, where they raised dairy cattle. I remember being surprised at how big they were when I first saw them up close!

After I was married, my husband and I often walked on my husband's family farm in Kentucky, and I always enjoyed seeing the cows. There is something very peaceful about a field full of cattle, especially when it is dusk and they are settling down for the night. In the springtime, the calves are fun to watch as they scamper and play together. In the winter, I like seeing their wooly coats and their warm breath in the cold air.

Now that we have our own farm, we have our own cattle. Some of these cows we brought back from a three-year stay in Texas, and others came from Kentucky, so we have a mixture of longhorn, Brahman, Hereford and Angus. Eleven of these cows have names and are permanent residents. I never tire of sketching, photographing or just observing them in their daily lives.

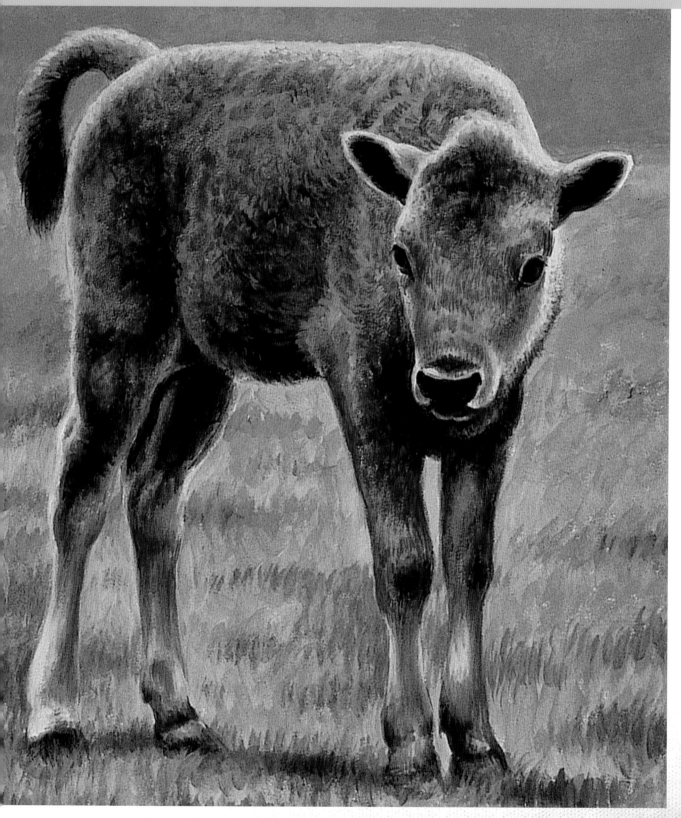

Project 20

Calf

Last spring, this pretty calf was born to our part-longhorn cow, Aster. We named her Astrid. Her reddish coloring and white markings make her an attractive subject to paint.

MATERIALS

Paints

Burnt Sienna

Burnt Umber

Cadmium Orange

Cadmium Red Medium

Raw Sienna

Titanium White

Ultramarine Blue

Yellow Oxide

Brushes

no. 1, 3 and 5 rounds

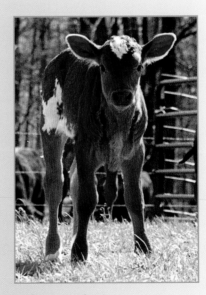

Reference Photo

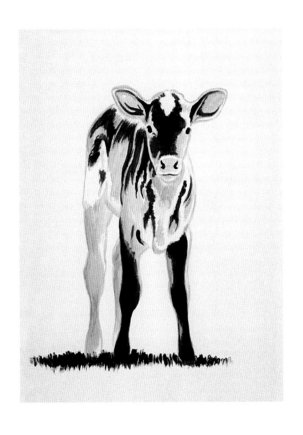

1 Establish the Form and the Dark Values

With your pencil, lightly draw the calf onto the panel, using a kneaded eraser to lighten lines or make corrections. Use Burnt Umber thinned with water and a no. 3 round to paint the main lines of the calf.

Create a dark brown for the shadows using Burnt Umber, Burnt Sienna and Ultramarine Blue. Paint the dark parts of the calf with a no. 5 round, u sing a no. 1 round for the eyes and nostrils. Paint with smooth strokes that follow the calf's contours. Dab the paint onto the forehead for the calf's curly hair.

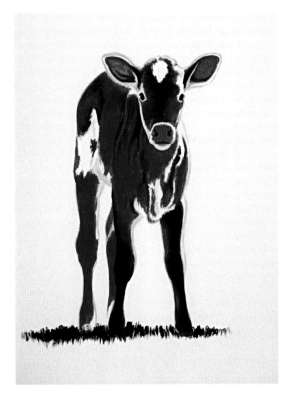

2 Paint the Middle Values

Mix a red for the coat with Burnt Sienna, Cadmium Orange and a small amount of Titanium White. Paint with a no. 5 round, switching to a no. 3 round for smaller areas.

Mix a pinkish color for inside the ears with Cadmium Red Medium, Cadmium Orange, Burnt Sienna and a small amount of Titanium White. Paint with a no. 5 round.

Mix a gray for the nose with Titanium White, Burnt Umber and Ultramarine Blue. Paint with a no. 3 round.

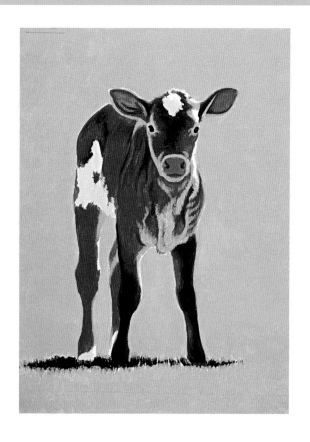

3 Paint the Light Values

Mix a buff color for the lighter parts of the calf with Titanium White, Raw Sienna and a small amount of Cadmium Orange. Paint with a no. 3 round, using strokes that follow the hair pattern.

For the shadows in the calf's white markings, you'll need a lighter, slightly bluish gray. Mix Titanium White and small amounts of Ultramarine Blue and Yellow Oxide. Paint with a no. 3 round, using dabbing strokes.

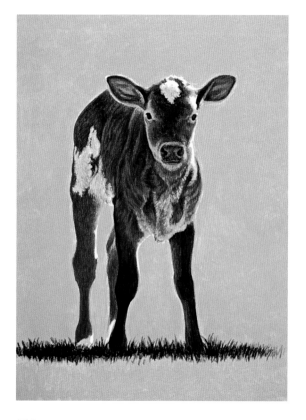

4 Paint Detail in the Coat

Transfer some of the dark brown from Step 1, some of the red from Step 2 and some of the buff from Step 3 to a dry wax paper palette. Use a no. 3 round and the dark brown to detail the coat with small, parallel brushstrokes that follow the hair pattern. Blend and soften with a separate no. 3 round and the red coat color. Use the same dark brown and brush to detail the buff-colored areas of the coat, then use a separate no. 3 round and the buff to blend.

Transfer a portion of the bluish gray from Step 3 to the dry palette. Mix a color for adding detail to the white areas of the coat with the bluish gray and small amounts of the dark brown and red. Paint with a no. 3 round.

Detail the nose with the dark brown and the gray from Step 2, using fresh no. 3 rounds for each.

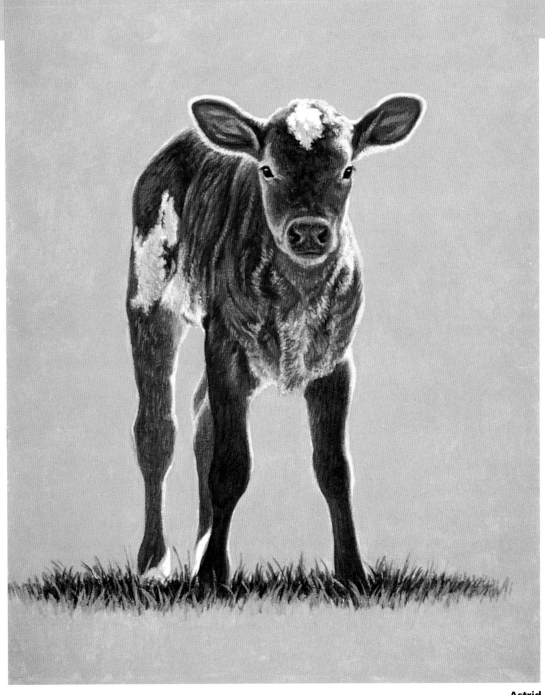

Astrid
Acrylic on Gessobord
10" × 8" (25cm × 20cm)

5 Add the Highlights and Finishing Details
On the dry palette, mix the highlight color for the calf with Titanium White and a bit of Yellow Oxide. Use a no. 3 round to paint with fairly thick strokes, then blend the edges with a separate no. 3 round and the red.

Use a no. 3 round and the red to add some lighter detail to the shadowed parts of the calf—the front legs, forehead, chest, etc. Use a moderately dry brush with light-pressured strokes. Using the same technique, paint some detail in the red areas of the coat with the buff color.

Paint the highlights in the eyes in small, curved arcs with a bit of the bluish gray and a no. 1 round. Use the same color and brush to paint highlights around the nostrils.

Project 21

Cow's Head

We lived in Kaufman County, Texas, for several years on a small farm with five cows. When we moved back to our family farm in Kentucky, we took the cows with us. Jessamine is a big, beautiful cow with dark eyelashes, large ears and horns, all part of her Brahman heritage.

MATERIALS

Paints

Burnt Sienna

Burnt Umber

Cadmium Orange

Cadmium Yellow Light

Payne's Gray

Raw Sienna

Titanium White

Ultramarine Blue

Yellow Oxide

Brushes

no. 0, 1, 3 and 4 rounds

no. 8 shader

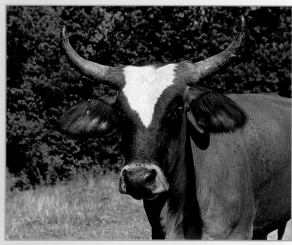

Reference Photo

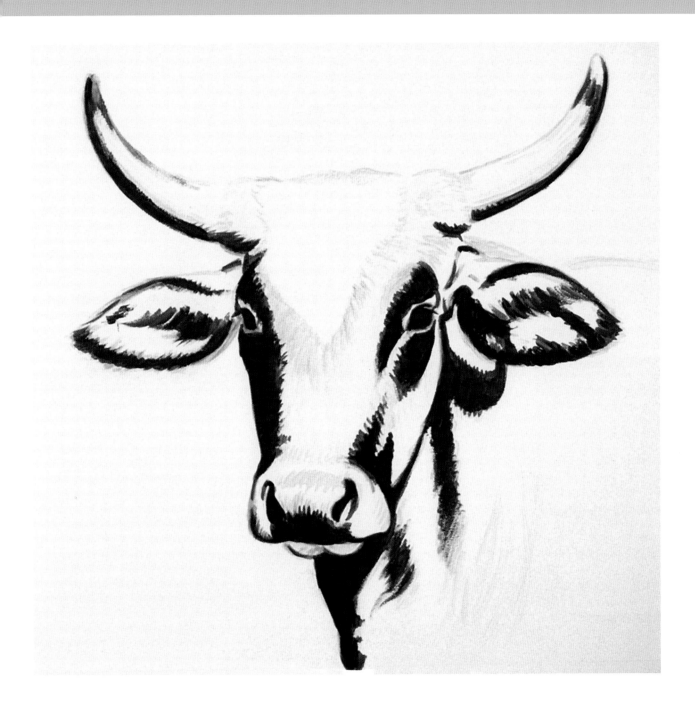

1 Establish the Form and the Dark Values

Draw the cow's head lightly in pencil, using your kneaded eraser to make corrections or lighten any lines that are too dark. With Payne's Gray thinned with water and a no. 3 round, establish the main lines and form. Switch to a no. 4 round for the broader areas.

Mix the warm black for the darkest areas on the face, ears and horns with Burnt Umber and Ultramarine Blue. Paint with a no. 3 round, switching to a no. 4 round for the broader areas. Mix Burnt Sienna and Ultramarine Blue for the dark brown shadows on the neck and paint with a no. 4 round.

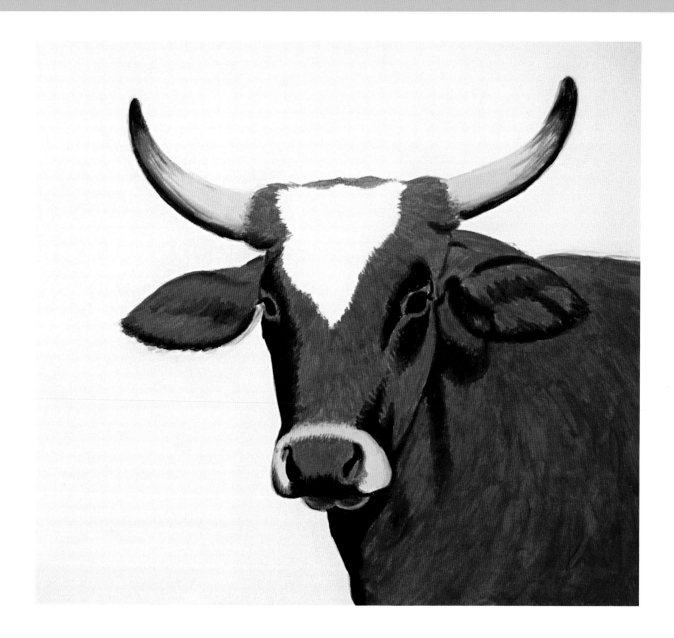

2 Paint the Middle Values

Mix a reddish color for the coat with Burnt Sienna and Cadmium Orange. Paint with a no. 3 round, switching to a no. 8 shader for broad areas. Use brushstrokes that follow the cow's shape. Once this dries, add another coat for good coverage.

Create a buff color for the muzzle and horns with Titanium White and Raw Sienna. Paint with a no. 4 round.

Mix the warm gray for the nose and horn detail with Titanium White, Burnt Umber and Ultramarine Blue. Paint these areas with a no. 3 round. Use the warm gray and a no. 0 round to paint under the eyes. For the chin, mix a little warm black with some of the warm gray. Paint the reflected light under the chin with a mixture of the warm gray and a little Titanium White and a no. 3 round.

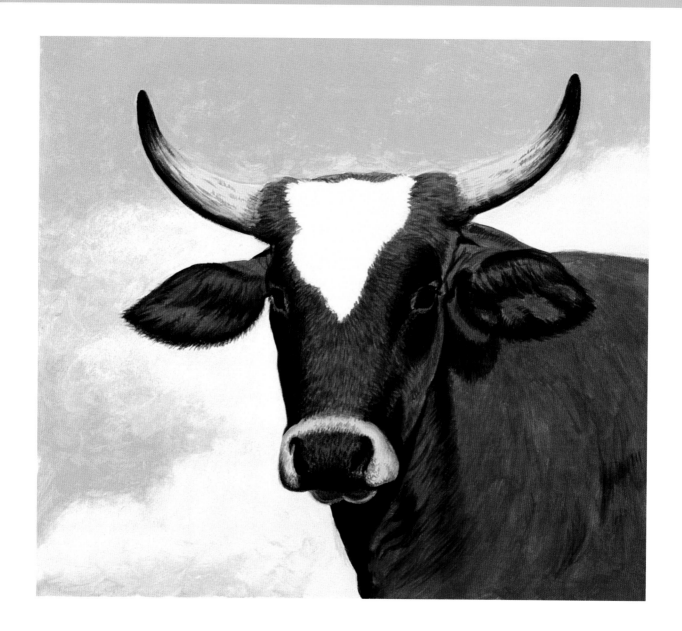

3 Begin Adding Detail

Mix some of the warm black with some Burnt Umber. With a no. 3 round, blend where the black areas meet the reddish areas, using small strokes that overlap the edges where the two colors meet. Paint hair detail in the reddish areas with strokes that follow the hair pattern. Make the edges of the ears fuzzy with small strokes and add detail to the nose and horns.

The only background I wanted for the cow's head was a cloudy sky. I started with a blue sky color, mixed from Titanium White, Ultramarine Blue and a small amount of Yellow Oxide. I mostly painted with a no. 8 shader, but switched to a no. 4 round to paint around the outline of the cow. I painted the clouds Titanium White, using a fresh no. 8 shader and blending the edges where the white met the blue while both colors were still wet.

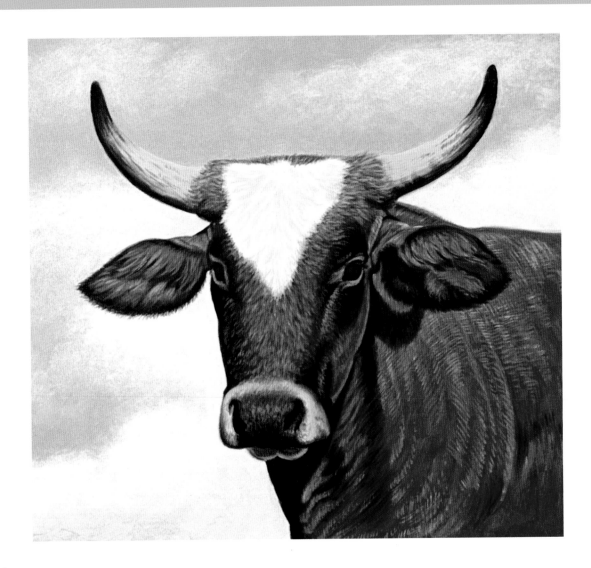

4 Paint the Blaze and the Coat Highlights

For the warm white of the blaze on the cow's forehead, mix Titanium White with a touch of Cadmium Yellow Light. Use a no. 4 round to paint with dabbing strokes. Overlap the edges of the blaze where it meets the reddish color with a no. 1 round, using small strokes that follow the hair pattern. To detail the white blaze, mix a light blue-gray from Titanium White with small amounts of Ultramarine Blue and Burnt Sienna. Paint with a no. 3 round, using slightly curved strokes. Blend with a separate no. 3 round and the warm white.

Mix the highlight color for the cow's coat with Titanium White, Cadmium Orange, Yellow Oxide and a small amount of Cadmium Yellow Light. Paint the highlights on the head and ears with a no. 3 round, using a small amount of paint and light-pressured strokes that follow the hair pattern. Paint small, slightly curved triangular tufts. Use a separate no. 3 round with the reddish color to soften and blend. Paint the highlights on the body using parallel brushstrokes that follow the general contours.

Reinforce the lower eyelids with a mixture of Titanium White, Ultramarine Blue and a bit of Burnt Sienna using a no. 1 round. Use a no. 3 round and the same color to paint muted highlights in the black points of the face, ears and nose. Blend the nose detail by alternately painting small strokes of the warm gray and small strokes of the buff.

I finished the sky using the same brushes and colors. I simply reinforced the blue and added more clouds, blending while wet, then drybrushing the edges of the clouds

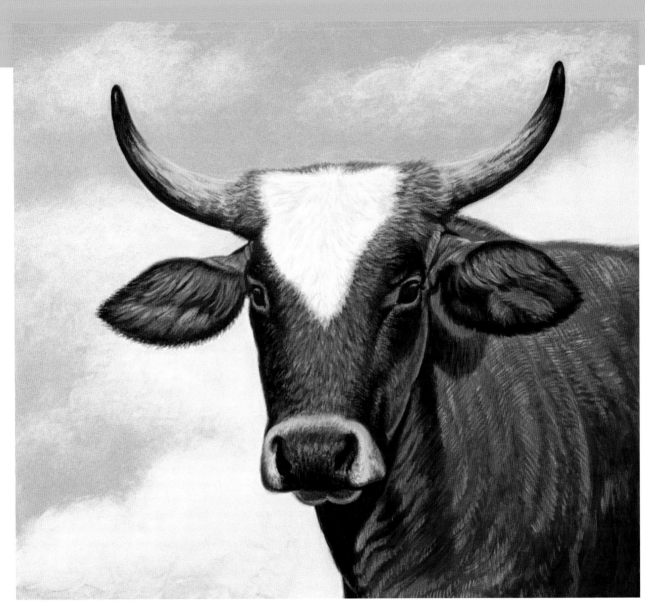

Jessamine
Acrylic on Gessobord
9" × 10" (23cm × 25cm)

5 Add the Finishing Details

Add some Burnt Umber and Ultramarine Blue to a bit of the reddish coat color. Paint the shadowed area of the belly using a no. 4 round, with strokes that follow the contours. Mix some of the coat's highlight color with a little Cadmium Orange and Burnt Sienna to paint a few details over the shadowed area with a no. 4 round.

Add more detail to the horns with a no. 3 round. Paint a glaze of Burnt Sienna over the horns, then add some staggered, broken lines with the warm black.

Blend the edges of the blaze using a no. 1 round and the warm white. Paint small strokes out from the edges to overlap the reddish color.

Add highlights to the eyes with two no. 1 rounds. Use the first one to paint the highlight with the light blue-gray from Step 4. Using the second brush, quickly blend the highlight's edges with the dark eye color.

Strengthen the black ear fringes with the warm black and a no. 3 round. Soften the sharp outlines with a no. 1 round and a small amount of the reddish coat color.

TIP

Make the cow's left ear stand out more by toning down the shadow of the ear on the body. Use a no. 3 round and a mixture of the highlight color and a little Burnt Sienna. Paint with light-pressured, semi-dry strokes.

Project 22

Holstein

This cow belongs to some neighbors of ours who run a small dairy farm. The whole family very kindly helped me get the cow into a good pose, repeatedly herding her away from a muddy puddle she wanted to wade in to cool off!

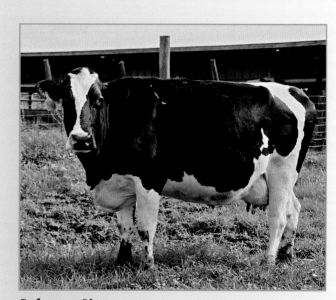

Reference Photo

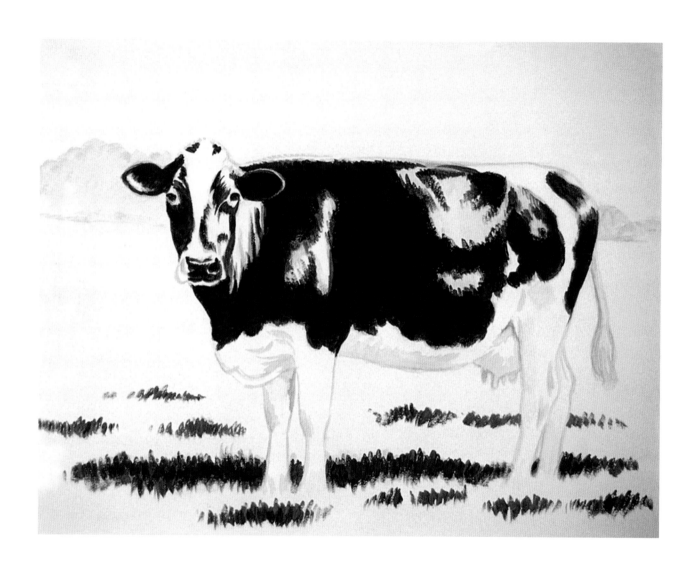

1 Establish the Form and the Dark Values

Draw the cow lightly in pencil. With Payne's Gray thinned with water and a no. 5 round, paint the main lines and form of the cow.

For the warm black of the cow's coat, mix Burnt Umber and Ultramarine Blue. Paint with a no. 7 round with dabbing strokes that follow the cow's contours. As the paint dries, add more layers until the black is rich and dense.

TIP

Although the cow's tail doesn't show in the main reference photo, adding the tail gives more life to the pose, as if the cow had just flicked away a fly.

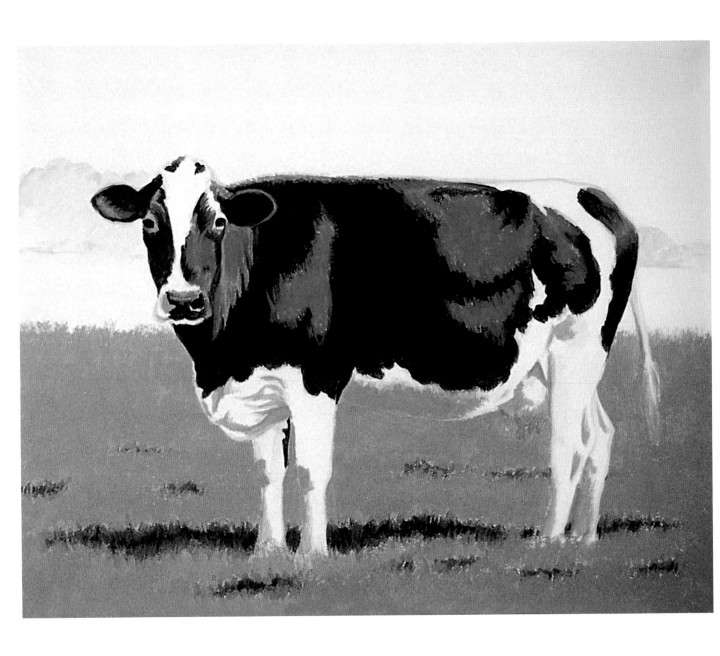

2 Paint the Middle Values

Mix a grayish highlight color for the black areas of the coat with Titanium White, Burnt Umber and Ultramarine Blue. Paint with a no. 5 round.

Mix a warm shadow color for the cow's chest, belly, udder, legs and tail with Titanium White, Yellow Oxide, Raw Sienna and Ultramarine Blue. Paint with a no. 5 round.

Mix a pink for the nose and udder with Titanium White, Cadmium Red Medium and Yellow Oxide. Paint with a no. 3 round.

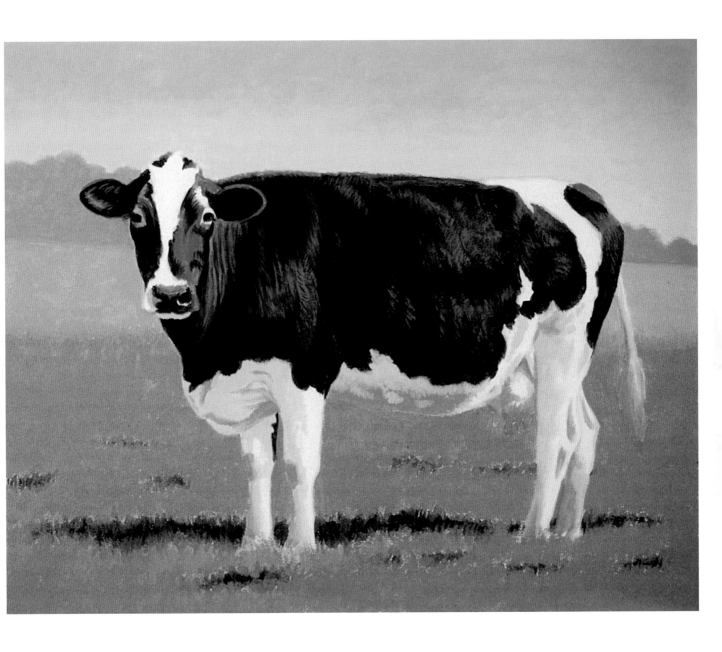

3 Paint the Lighter Values

Mix a bluish shadow color for the white areas of the cow with Titanium White, a small amount of Ultramarine Blue and a touch of Burnt Umber. Paint with a no. 5 round.

Blend the grayish highlight color with the warm black of the cow's coat using separate no. 3 rounds for the two colors. Use a fairly dry brush to paint small strokes of black over the highlighted areas, then blend with the grayish color.

Drybrush more grayish highlights over the black areas.

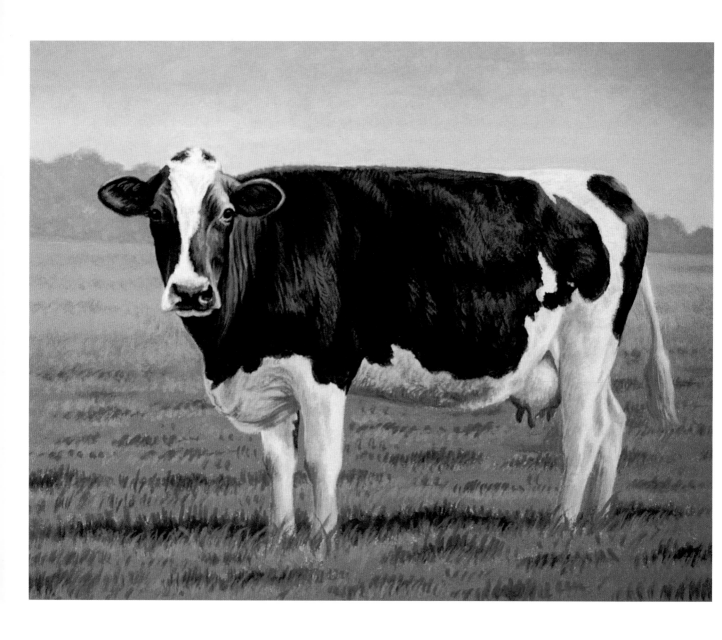

4 Paint the Lightest Values and Add Detail

Mix a lighter gray highlight color with a bit of the grayish highlight color from Step 2 and Titanium White. Paint the highlights on the head and ears with a no. 3 round.

Mix a warm white for the cow's coat with Titanium White and a touch of Cadmium Yellow Light. Paint with a no. 3 round, with small, dabbing strokes.

Mix a darker shadow color for the cow's chest, belly, udder, legs and tail with a portion of the warm shadow color from Step 2 mixed with Burnt Umber and a small amount of the warm black from Step 1. Paint with a no. 3 round using a fresh no. 3 round to blend it with the neighboring color.

With separate no. 3 rounds for the bluish shadow color, the warm shadow color and the warm white color, blend where those colors meet.

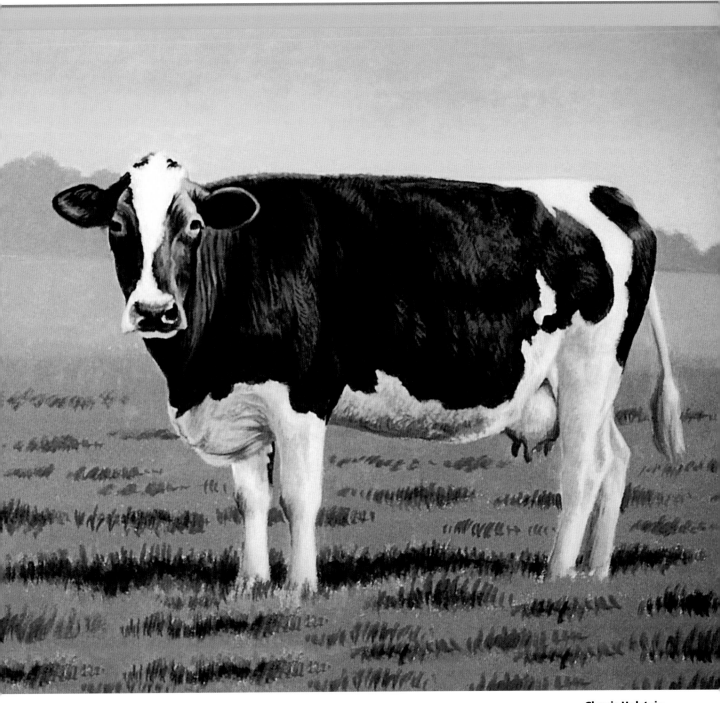

5 Add the Finishing Details

With a no. 3 round and the grayish highlight color from Step 2, add some hair detail to the inside of the left ear. Use a no. 1 round to refine the cow's muzzle and nostrils.

With the lighter version of the warm shadow color and a no. 3 round, paint detail in the cow's white face marking and flank. Blend with a fresh no. 3 round and the warm white.

Use a no. 1 round to refine the shape of the eyes. For the highlights in the eyes, mix a bit of the grayish highlight color with a touch of the warm black from Step 1. Paint with a no. 1 round.

6 Barnyard Animals

One of my earliest paintings was done while I was in high school, at the request of my grandmother, who wanted a barnyard scene. The painting depicts two white ducks by a farm pond, with a cow and a red farm house in the background. I still enjoy sketching, painting and interacting with farm animals.

When I was growing up, my family raised a dozen chickens—eleven hens and a rooster. I was fascinated with the chickens and spent hours watching them. They all had names and distinct personalities, and were so tame that the hens would lay their eggs in my hand! I've gotten to know pigs on my husband's family farm, and have had pet goats and rabbits, but I would still like to know other farm animals such as sheep, donkeys, llamas, ducks and geese. So many animals, so little time! But even if I can't find the time to take care of all these animals, I can still enjoy doing paintings of them!

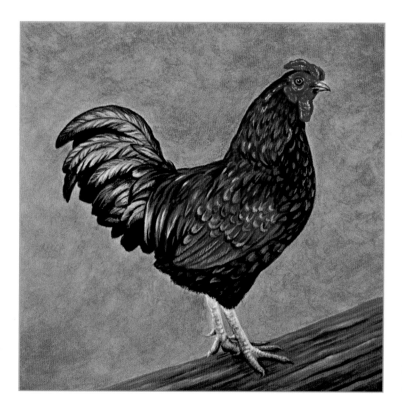

Chicks

Since I planned to paint some baby chicks for this book, I bought Casa and Blanca from a local farm supply store. I had been wanting to get a couple of chickens, and this was a perfect excuse! They grew rapidly and are now beautiful white chickens with red combs.

MATERIALS

Paints

Burnt Sienna

Burnt Umber

Cadmium Orange

Cadmium Red Medium

Cadmium Yellow Light

Raw Sienna

Titanium White

Ultramarine Blue

Brushes

no. 1, 3 and 5 rounds

Reference Photo

1 Establish the Form and the Darker Values

With a pencil, lightly draw the chicks onto your panel. Use Burnt Umber thinned with water and a no. 5 round to paint the main darks and lights, switching to a no. 3 round for details.

Mix the dark brown for the eyes and the dark shadows on the feet and legs with Burnt Umber, Raw Sienna and Cadmium Red Medium. Paint with a no. 3 round.

2 Paint the Middle Values

Mix a red-gold for the shadows on the chicks with Cadmium Orange, Raw Sienna and Cadmium Yellow Light. Paint with a no. 5 round with parallel strokes, following the pattern of the down.

Mix a pink for the legs, feet and beaks with Titanium White, Cadmium Orange, Cadmium Red Medium, Cadmium Yellow Light and a touch of Raw Sienna. Paint with a no. 3 round. Then take a portion of this color and mix it with Burnt Umber and Burnt Sienna. Use this color with a no. 3 round to accent the feet, legs and around the beaks.

Mix the blue-gray with Titanium White, Ultramarine Blue and a touch of Cadmium Orange. Paint this mixture on the left side with a no. 5 round.

Mix the yellow for the chicks' down with Titanium White, Cadmium Yellow Light and a touch of Raw Sienna. Paint with a no. 3 round. Begin to blend where the yellow meets the red-gold with a no. 3 round, using small, parallel strokes.

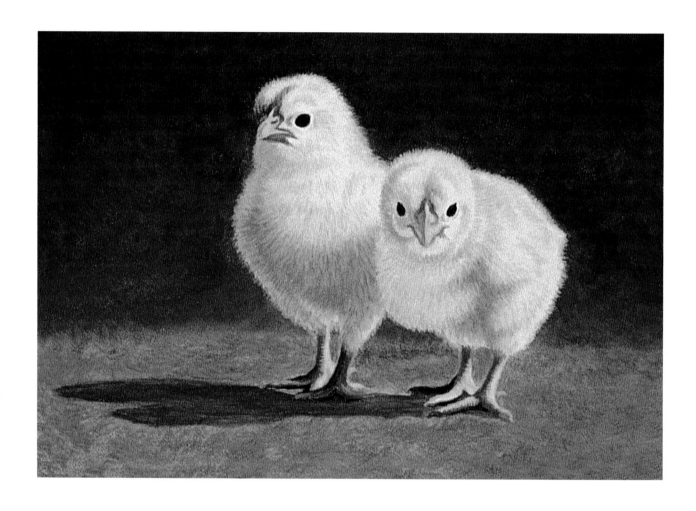

3 Paint the Light Values and Details

Mix a warm white for the highlighted parts of the chicks with Titanium White and a small amount of Cadmium Yellow Light. Paint with a no. 5 round, switching to a no. 3 round for details.

You'll need a detail color for the highlighted areas. For this, mix a portion of the yellow with some of the red-gold from Step 2. Use a no. 3 round to paint parallel strokes, then blend.

Mix a light pink for the highlighted parts of the beaks, legs and feet with a portion of the pink from Step 2 mixed with Titanium White. Paint with a no. 3 round. Add detail to the beaks, feet and legs using separate no. 3 rounds for the different colors. Add highlights with a bit of the warm white mixed with the yellow. Add dark detail to the beaks with some of the pink mixed with some of the dark brown.

128

Casa and Blanca
Acrylic on Gessobord
5½" × 8" (14cm × 20cm)

4 Paint the Finishing Details

Mix a slate blue for shadowing on the chicks with Titanium White, Ultramarine Blue, Burnt Umber and Raw Sienna. Paint thin, parallel strokes with a no. 3 round, then blend and soften with the adjacent color.

Transfer some of the warm white to a dry wax paper palette so the paint will become thicker. With a no. 1 round, add more detail to the downy coats.

Paint highlights in the eyes with some of the blue-gray, using a no. 1 round to paint small, curved arcs. Refine the beak of the chick on the left with a no. 3 round for each color.

Project 24

Ducks

One of my favorite places for photography and sketching is the Lexington Cemetery in Lexington, Kentucky. Founded in 1848, it is a beautiful place with large, old trees, sunken gardens, flowers and secluded ponds. Many animals live there, including chipmunks, squirrels, rabbits and birds. This is where I encountered these attractive white ducks. Graceful swimmers, they seemed to glide effortlessly across the water.

MATERIALS

Paints

Burnt Umber

Cadmium Orange

Cadmium Yellow Light

Payne's Gray

Raw Sienna

Titanium White

Ultramarine Blue

Viridian

Yellow Oxide

Brushes

no. 1, 3, 5 and 7 rounds

no. 10 shader

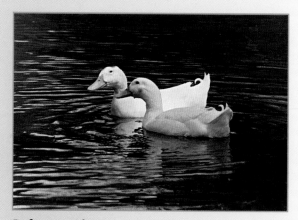

Reference Photo

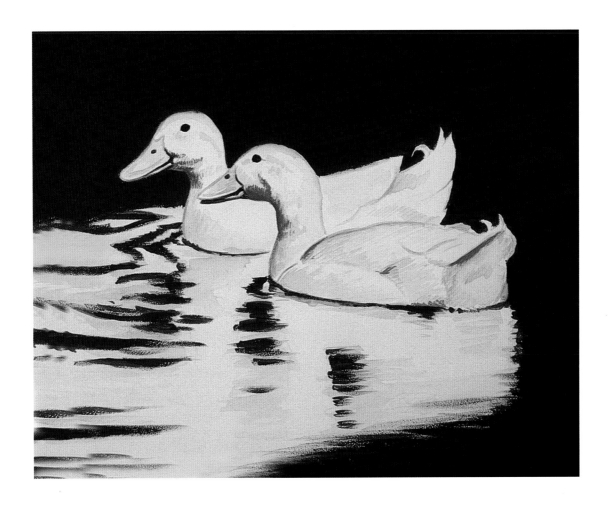

1 Establish the Form and the Dark Values

Draw the ducks lightly in pencil, using your kneaded eraser for any corrections. Use Payne's Gray thinned with water and a no. 3 round to paint the basic lines, lights and darks. Use a no. 7 round for the broader areas and for the water.

Mix the dark brown for the ducks' eyes and bills with Burnt Umber and Ultramarine Blue. Paint with a no. 3 round.

For the dark shadowed parts of the feathered areas, mix a gray with Titanium White, Ultramarine Blue, Burnt Umber and a small amount of Raw Sienna. Paint with a no. 3 round, using parallel strokes.

I mixed the dark green for the water with Viridian, Burnt Umber, Ultramarine Blue and a small amount of Cadmium Orange. I painted with a no. 5 round with smooth, horizontal strokes. For the broad expanses of water, I switched to a no. 10 shader, painting carefully around the ducks' outlines with a no. 5 round. When everything was dry, I added another coat.

I mixed the blue-green reflection base color for the water from Titanium White, Viridian, Ultramarine Blue and Burnt Umber. I painted with a no. 7 round with long, smooth, horizontal strokes.

I created the greenish water color from Viridian, Titanium White, Ultramarine Blue and Burnt Umber. I painted these areas with a no. 7 round, using smooth strokes that followed the ripple pattern.

2 Paint the Middle Values

For the ducks' bills, mix an orange with Cadmium Orange, Titanium White, Yellow Oxide and a small amount of Raw Sienna. Paint with a no. 3 round. Mix a darker shadow color for the bill with the orange, Burnt Umber and more Cadmium Orange and Raw Sienna. Paint with a no. 3 round. Re-establish the line of the mouths, nostrils and darker shadows on their bills with a no. 3 round and the dark brown from Step 1.

Mix a light blue for the ducks' shadows with Titanium White, Ultramarine Blue and small amounts of Yellow Oxide and Burnt Umber. Paint with a no. 5 round.

TIP

For lighter value detail, mix a little of the light blue into a bit of the gray.

3 Paint the Light Values

With Titanium White and small amounts of Ultramarine Blue and Cadmium Yellow Light, mix an even lighter value blue for the highlighted parts of the forefront duck. Paint with a no. 5 round. Use a no. 3 round and the light blue from Step 2 to blend where the two colors meet, using small, parallel strokes. With a separate no. 3 round and the gray from Step 1, blend where this color meets the light blue. Begin to add some detail with the gray.

Use a no. 5 round and the light blue to add detail to the shadowed parts of the duck with light-pressured strokes.

Mix the warm white for the highlighted parts of the background duck with Titanium White and a touch of

Cadmium Yellow Light. Paint the broad areas with a no. 5 round, switching to a no. 3 round for the smaller detail areas, such as the head and tail. Blend the light blue with the warm white and the gray.

Mix a highlight color for the bill of the far duck with Titanium White and touches of Cadmium Yellow Light and the orange from Step 2. For the near duck, add a little more of the orange for a darker highlight color. Paint with no. 3 rounds, blending with the adjacent color and a separate no. 3 round.

With a no. 5 round and the greenish water color from Step 1, I added ripple marks to the water with slightly curved, sweeping strokes.

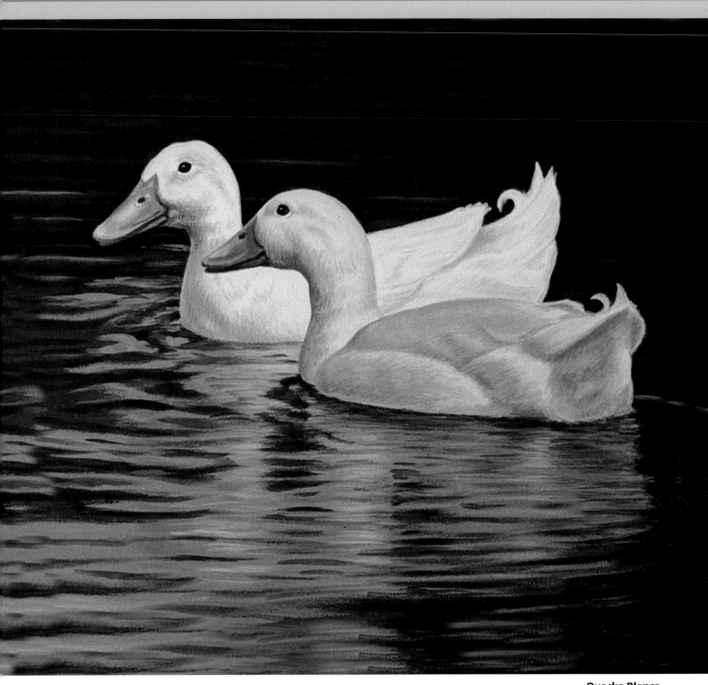

Quacka Blanca
Acrylic on Gessobord
8" × 10" (20cm × 25cm)

4 Paint the Finishing Details

Use no. 3 rounds to add more detail to the ducks' feathers, blending with the neighboring colors. Re-establish the shapes of the eyes as needed with a no. 1 round and the dark brown color. Paint highlights in the eyes with the lightest value blue and a no. 1 round.

I continued to paint ripples in the water with the greenish color and a no. 5 round. I used the light bluish color from Step 2 and a no. 5 round to paint the ducks' reflections with horizontal strokes.

I painted some orange reflections in the water from the ducks' bills with the orange bill color from Step 2 and a no. 5 round.

133

Project 25

Pig

While I was driving along the back roads of Jessamine County, Kentucky, I stopped when I caught sight of this pig. She shared a field with a white goat. I was struck by her happy and contented expression, and I just had to sketch and photograph her for future reference.

MATERIALS

Paints

Burnt Sienna

Burnt Umber

Cadmium Orange

Raw Sienna

Scarlet Red

Titanium White

Ultramarine Blue

Yellow Oxide

Brushes

no. 1, 3, 5 and 7 rounds

no. 10 shader

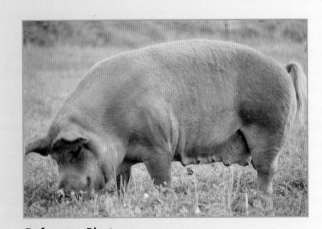

Reference Photo

1 Establish the Form and the Dark Values

With a no. 3 round and Burnt Umber thinned with water, paint the main lines and form of the pig.

Mix a dark brown with Burnt Umber, Burnt Sienna and Ultramarine Blue for the dark-valued areas. Paint with a no. 5 round.

2 Paint the Middle Values

Mix a golden brown middle value for the pig's coat with Raw Sienna, Burnt Sienna, Burnt Umber and a small amount of Titanium White. Paint with a no. 5 round.

3 Paint the Lighter Values

Mix the pig's basic color with Titanium White, Raw Sienna, Cadmium Orange and Yellow Oxide. Paint with a no. 10 shader for the broad areas, using dabbing strokes. Switch to a no. 7 round for the smaller areas. Blend into the edges where it meets the neighboring color with small strokes.

Mix a pink for the pig's udder with Titanium White, Scarlet Red, Cadmium Orange and a small amount of Raw Sienna. Paint with a no. 7 round.

For the ears and snout, mix a warm gray with Titanium White, Burnt Umber and small amounts of Ultramarine Blue and Raw Sienna. Paint with a no. 3 round.

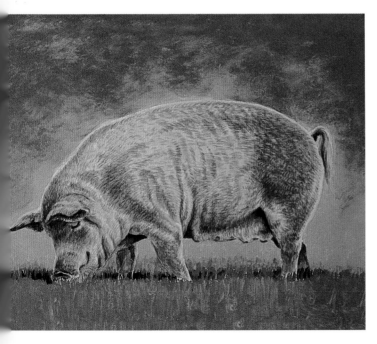

4 Add Detail to the Pig

Add detail to the lighter parts of the coat with the golden brown from Step 2. Use a no. 3 round, painting small parallel strokes that follow the hair pattern. For lighter value detail, use a little more water and a lighter pressure on your brush.

To mix a dark gray for detail on the snout and ears, combine some of the dark brown from Step 1 with Titanium White. Use a separate no. 3 round with the warm gray from Step 3 to blend where the two colors meet. Reinforce the dark parts of the ears and snout with a no. 3 round and the dark brown. For lighter details over the broad dark areas of the pig's coat, take a portion of the basic color from Step 3 and mix in small amounts of Yellow Oxide and Cadmium Orange. Paint with small strokes. Add some lighter colored hairs to the tail with flowing strokes.

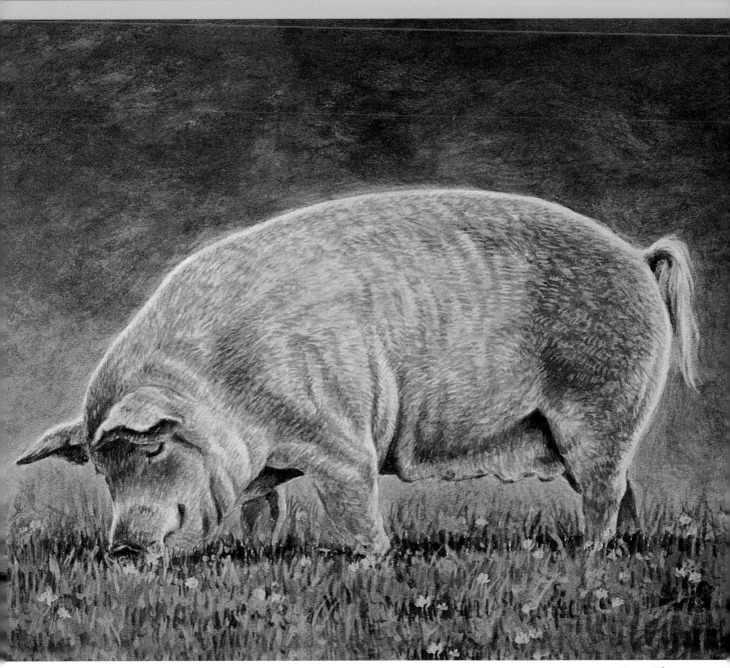

Happy Pig
Acrylic on Gessobord
8" × 10" (20cm × 25cm)

5 Refine the Pig's Coat

Warm and soften the pig's coat by painting a glaze of the golden brown mixture and water over the entire body with a no. 7 round. Mix a highlight color for the pig with Titanium White and a small amount of Yellow Oxide. Use a no. 1 round to paint a smooth line around the pig's outline, then blend inward with small strokes.

137

Project 26

Rooster

Last fall, on a visit to my parents' home, I went for a drive with them in the country. At a farm with a roadside stand, we stopped to look at the goats, sheep and chickens they had on display. This fine looking rooster caught my eye as he seemed to pose for his portrait.

Reference Photo

1 Establish the Form and the Dark Values

With a no. 3 round and Burnt Umber thinned with water, paint the outline and main tail feathers of the rooster. Use a no. 5 round to paint the Burnt Umber wash in the main shadow areas.

To create a black for the dark parts of the head and body, combine Burnt Umber and Ultramarine Blue. Paint with a no. 5 round. Apply a second coat when the first dries. Use a no. 3 round to paint the eye and beak.

For the green tail feathers, create a dark green mixture with Burnt Umber, Ultramarine Blue and Viridian. Paint with a no. 5 round, switching to a no. 3 round for details.

2 Paint the Middle Values

For the reddish feathers, mix a red-brown with Burnt Sienna and Cadmium Orange. Paint in smooth strokes with a no. 5 round.

Mix a blue-green for the tail feathers with Titanium White, Viridian, Ultramarine Blue and a touch of Burnt Umber. Paint with a no. 5 round with smooth strokes following the feather contours.

Mix a red for the rooster's comb with Cadmium Red Medium and small amounts of Titanium White and Burnt Umber. Paint with a no. 3 round.

Mix the eye color with Yellow Oxide and Cadmium Orange. Paint with a no. 1 round.

3 Paint the Dark Feather Detail

Paint the dark feather detail with a no. 3 round and the black mixture, using light-pressured strokes and a small amount of paint with just enough water so the paint flows. Switch to a no. 1 round to reinforce the dark line around the eye, pupil and beak. Paint cracks in the log and darken shadowed parts of the feet with a no. 3 round.

4 Paint Light Values and More Detail

Mix Titanium White, Ultramarine Blue, Burnt Umber, Burnt Sienna and a touch of Raw Sienna to create a dark gray. Add more Titanium White to a portion of this for a lighter gray. Using the lighter gray and a no. 3 round, paint the beak, legs and feet. Using the black, dark gray and light gray (and a separate no. 3 round for each), blend the dark shadows on the toes into the lighter gray. Define the beak and detail the beak, feet and legs with a no. 1 round and a mixture of the black and dark gray. Use the neighboring color to make corrections to the shape if needed.

Add some reddish feather detail to the black areas of the rooster's body with some of the red-brown mixed with Cadmium Orange. Use a no. 3 round.

Mix a color for greenish feather detail on the wings, chest, back and lower neck with a portion of blue-green and a small amount of the dark green. Paint with a no. 3 round. Add a little of the red-brown to the tail feathers with a fresh no. 3 round.

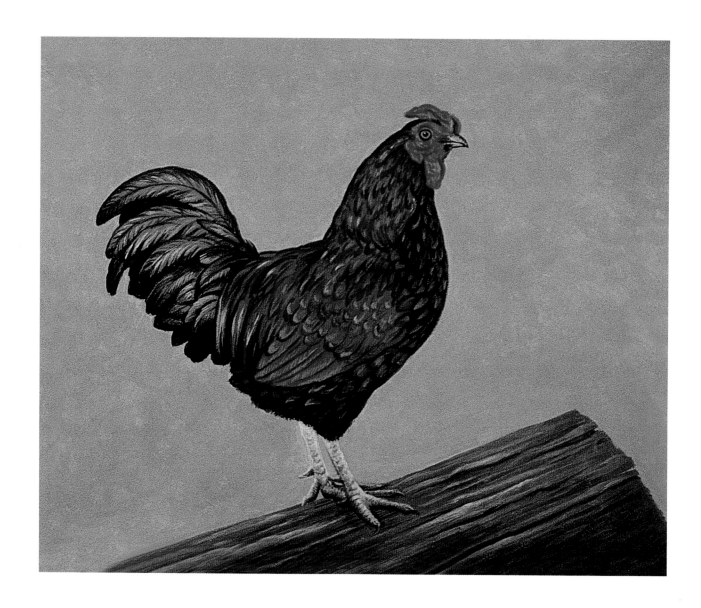

5 Add Highlights and Details

Mix a highlight color with Titanium White and a bit of Yellow Oxide. Paint highlights on the tail feathers, legs and some of the body feathers with a no. 3 round. Once you re-establish the eye color and pupil, paint a highlight in the eye with a no. 1 round and the highlight color. Use this color to paint detail in the comb, then blend with a separate no. 1 round and the red comb color.

Add lighter detail to the reddish wing feathers with some of the red-brown mixed with a bit of Yellow Oxide and Titanium White. Lightly paint parallel lines over the feathers.

Mix a highlight color for the blue-green feathers with some blue-green and a touch of Titanium White and Yellow Oxide. Paint with a no. 3 round with small, parallel strokes.

Combine a little of the red comb color and Titanium White with a touch of Yellow Oxide to create a pink for parts of the legs and feet. Paint with a no. 1 round. Mix a bit of the red comb color with Burnt Umber and use a no. 1 round to paint darker detail in the comb.

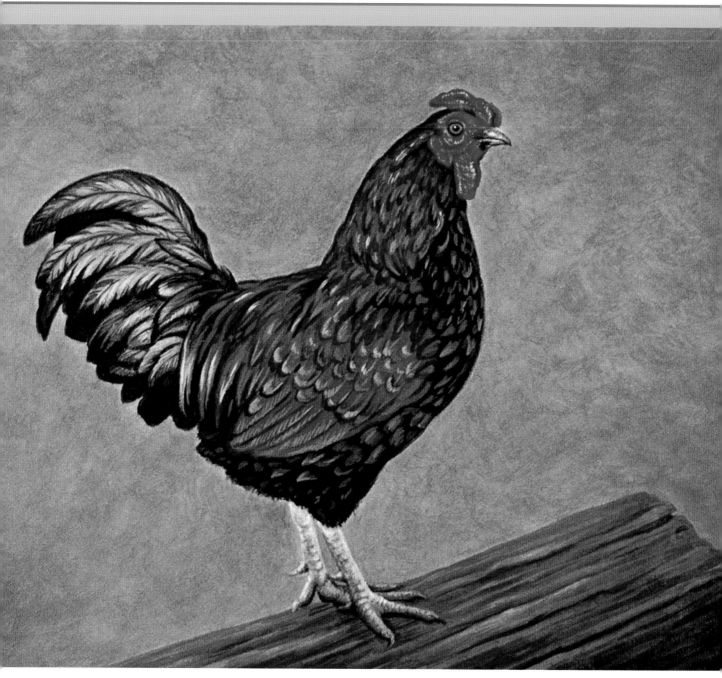

Fancy Rooster
Acrylic on Gessobord
8" × 10" (20cm × 25cm)

6 Add the Finishing Touches

Use a no. 3 round to paint a thin glaze of Burnt Sienna on the comb, beak, legs and feet.

Brighten the highlights on the legs, feet, beak and tail with a no. 3 round and Titanium White mixed with a touch of Cadmium Yellow Light.

7 Rabbits

Just about everyone is familiar with rabbits, whether it's the cottontail you occasionally see in your backyard, a rabbit kept as a family pet or rabbits being shown at a county fair or petting zoo. If you live or have traveled in the West, you may also be familiar with the jackrabbit, which is a member of the hare family. Both rabbits and hares have long ears, large eyes, small tails and large hind feet. There are also some important differences. Hares are usually larger than rabbits and have longer ears and hind legs. Hares live in a more open habitat and escape from danger by running long distances, while rabbits seek safety by running into brush or underground burrows. Hares live alone or in loose groups; rabbits live in very organized family groups. In this chapter, I've demonstrations for the dutch rabbit and cottontail rabbit in two different viewpoints.

Dutch Rabbit

There are between fifty and one hundred breeds of domestic rabbit—it depends on who you talk to—from dwarf rabbits weighing as little as two pounds to giant rabbits weighing as much as fifteen pounds. Dutch rabbits are of small to medium size. They are popular as both pets and painting subjects!

MATERIALS

Paints

- Burnt Sienna
- Burnt Umber
- Cadmium Red Light
- Payne's Gray
- Titanium White
- Ultramarine Blue
- Yellow Ochre

Brushes

no. 0 and 1 rounds
no. 2 and 4 filberts

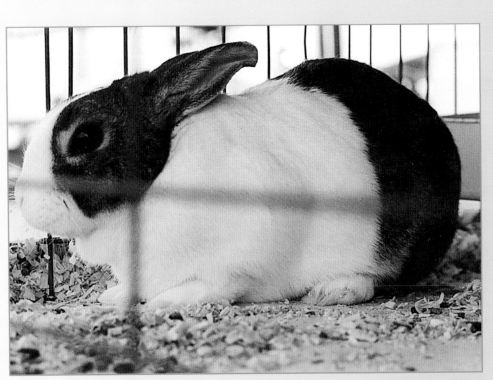

Reference Photo

1 Establish the Lights, Darks and Basic Form

Lightly sketch the rabbit with pencil. Use Payne's Gray and a no. 1 round to paint the basic lights and darks. Use a no. 2 filbert for the broader areas.

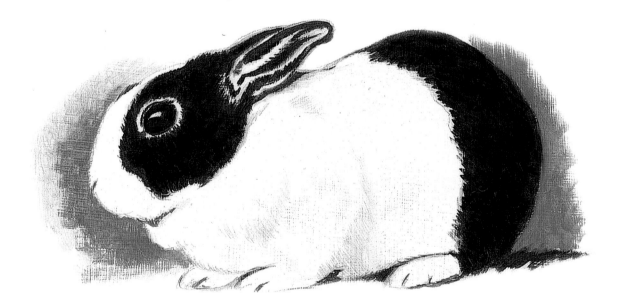

2 Paint the Darker Values

For the black fur, mix Burnt Umber and Ultramarine Blue, and paint with a no. 4 filbert. Use short brushstrokes in the direction of fur growth. Use a no. 1 round for the smaller details, such as the ears. Paint the eye with some of the black mixture with more Burnt Umber added.

To paint the shadows under the belly, between the toes and under the neck, use Burnt Umber and a no. 1 round. Dip your brush in Liquin only when the paint seems too thick.

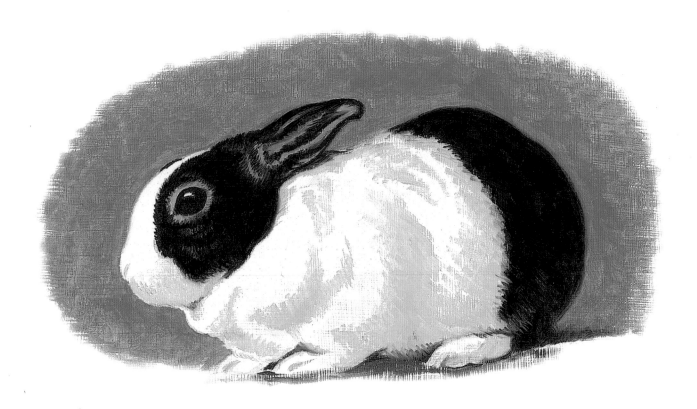

3 Paint the Shadows and Begin the Details

For whatever background you choose, be sure to soften the edges of the dark fur color against it using a no. 2 filbert. Next mix the bluish shadow color for the white part of the fur with Titanium White, Ultramarine Blue and a small amount of Burnt Sienna. With a no. 4 filbert, paint with brushstrokes that follow the hair growth. For the bluish shadows in the black fur, add a little Burnt Umber to some of the color you just mixed. With a no. 1 round, paint around the eye and begin painting detail in the fur of the ear and other areas.

TIP

When painting fur, use parallel brushstrokes that follow the direction of the hair growth. Be sure to vary your strokes—make some slightly longer and some a little shorter—and vary the direction of the strokes a little. This will make the fur look more natural, and you'll avoid the "blow-dried" look.

Dutch Rabbit
Oil on gesso-primed Masonite
8" × 10" (20cm × 25cm)

4 Paint Lightest Values, Create Fur and Add Details

Paint over the areas of fur where you left the white of the panel showing with Titanium White and a no. 4 filbert, using brushstrokes that overlap the bluish shadow areas with individual strokes to create a furry look. Follow the rabbit's hair pattern. Use separate no. 1 rounds, one for the bluish shadow color and one for the black fur color, to blend the edges where the white and black fur meet.

For the pinkish nose, mix Cadmium Red Light, Yellow Ochre, Titanium White and a bit of Burnt Umber. Paint with a no. 0 round. Tone it down with a little Titanium White and a no. 1 round if needed. Paint the whiskers with Titanium White using a no. 0 round. To integrate the rabbit with its surroundings (in this example, straw), reflect a little of the straw color up onto the bluish shadows on the rabbit with a few brushstrokes. (I wiped most of the paint off on a paper towel first so I wouldn't overdo it).

Cottontail Rabbit (Front View)

This young cottontail was one of three orphans raised by an acquaintance who is a wildlife rehabilitator. To photograph them, I put them into an empty fish tank with a cover and placed it outside. This way I could get down to their level for a great view without fear they would escape. They would be released into the wild later when they grew old enough to fend for themselves.

MATERIALS

Paints

Burnt Sienna
Burnt Umber
Cadmium Orange
Cadmium Red Medium
Hansa Yellow Light
Hooker's Green Permanent
Naples Yellow
Raw Sienna
Titanium White
Ultramarine Blue

Brushes

no. 3 and 10 rounds
no. 10 bright

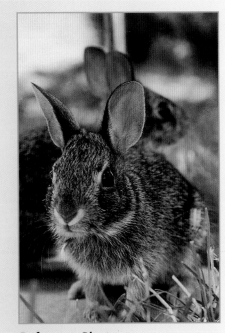

Reference Photo

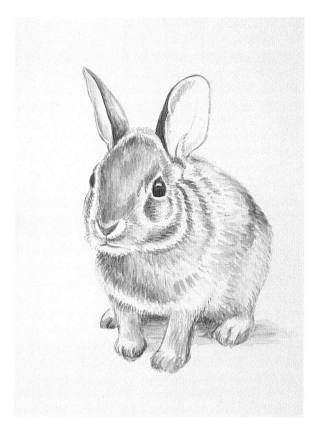

1 Establish the Form

With a pencil, lightly draw the rabbit, using a kneaded eraser for corrections or to lighten lines. Paint the main lines and shading with diluted Burnt Umber and a no. 10 round.

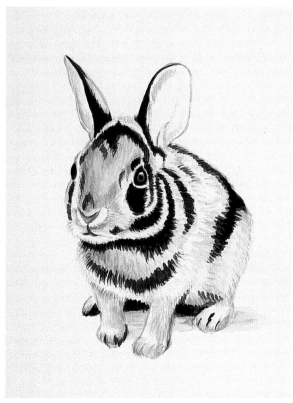

2 Paint the Dark Values

Mix dark brown with Burnt Umber and Ultramarine Blue. Paint strokes that follow the fur growth pattern using a no. 10 round. Switch to a no. 3 round for the eyes and mouth.

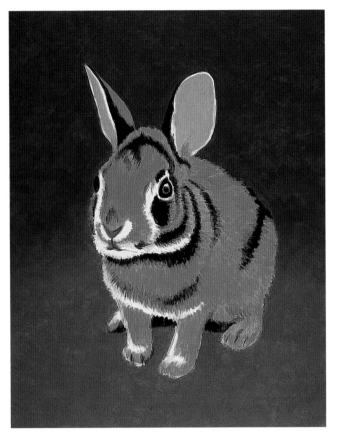

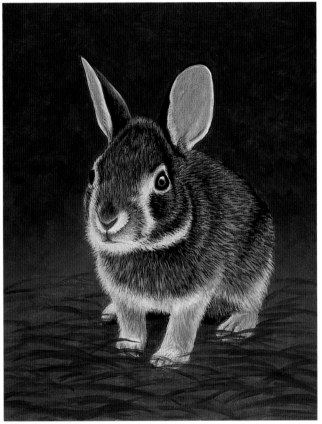

3 Paint the Middle Values

Mix a medium brown for the coat with Titanium White, Raw Sienna and Cadmium Orange. Paint strokes following the fur pattern with a no. 10 round.

Mix a grass green color for the upper part of the background with Hooker's Green Permanent, Cadmium Orange, Burnt Umber, Ultramarine Blue and Titanium White. Paint dabbing strokes with a no. 10 bright and use a no. 10 round around the rabbit's outline. When dry, add another layer of paint.

Mix a lighter grass green color for the lower part of the painting with Hooker's Green Permanent, Cadmium Orange, Hansa Yellow Light and Titanium White. Paint with a no. 10 bright and use a no. 10 round around the rabbit's outline.

Blend where the two greens meet using a separate brush for each color. Mix pink for inside the ears with Titanium White, Cadmium Red Medium, Raw Sienna and Cadmium Orange. Paint with a no. 10 round using smooth, vertical strokes. Mix a pink nose color with a portion of pink, plus Cadmium Red Medium, Burnt Umber and Raw Sienna.

4 Paint Light Values and Begin to Add Detail

Transfer portions of the dark brown and medium brown to a dry palette. Paint fur detail using a separate no. 10 round for each color, overlapping the medium brown areas with dark brown detail and the dark areas with medium brown detail. Use strokes that follow the fur pattern.

Mix a buff color for the lighter value areas of the coat with Titanium White, Naples Yellow, Cadmium Orange and Raw Sienna. Paint with a no. 10 round.

With a no. 10 round, paint a glaze of Burnt Sienna and water over the rabbit. Mix a fur detail color with a portion of medium brown, Burnt Sienna and Raw Sienna. With a no. 3 round, paint fur detail with small strokes using it to integrate the dark shadows in the fur with the medium brown areas. Also, use this color to blend where the dark areas meet the light value areas. Add more buff detail with a no. 3 round. Use the fur detail color and a no. 3 round to add more detail to the buff areas. With sweeping strokes, paint some blades of grass with the lighter grass green color and a no. 10 round.

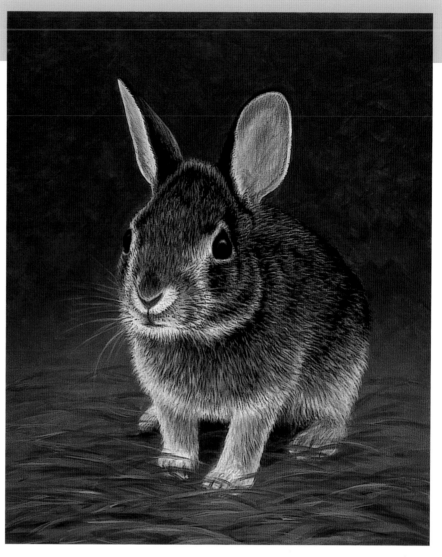

Bunny Business
Acrylic on Gessobord
10" × 8" (25cm × 20cm)

TIP

It's better not to paint the background color too solid. Leave some thinner areas where the panel shows through the paint to allow the background to breathe and to have depth.

5 Paint the Finishing Details

Mix a brown eye color with Burnt Sienna, Burnt Umber, Raw Sienna and Titanium White. Paint with a no. 3 round, blending with dark brown and a separate no. 3 round. Mix the eye highlight color with Titanium White and a touch of Ultramarine Blue. Paint the highlight with a no. 3 round, blending the edges with the brown eye color.

Blend the dark outline of the eye with the medium brown. Paint a small, vertical arc of the brown eye color in the right eye, then paint a small highlight in the upper part of the eye. Darken and soften the eyes by painting a glaze of Burnt Umber and water over the brown part of the eyes.

Add more detail to the fur using the brown eye color and a no. 3 round. Paint with small, thin strokes. Add more detail with the buff color. Mix a pink ear detail color with Titanium White, Cadmium Red Medium, Cadmium Orange and Burnt Umber, then paint veins in the left ear with light-pressured strokes using a no. 3 round. Paint shaded areas in the left ear with parallel strokes, blending with the pink. Create an ear shadow color with some of the fur detail color mixed with some of the brown eye color. Paint shadows inside the ears with a no. 10 round, using parallel strokes.

Mix a grass shadow color with a portion of the grass green color, Burnt Umber and Ultramarine Blue, then paint a shadow under the rabbit with a no. 10 round. Paint some strokes in the grass, then paint some slightly curved, horizontal strokes with the fur detail color. Add a few strokes of buff to the grass, blending with the fur detail color.

Paint the whiskers with a no. 3 round, using dark brown for the base of the whiskers and buff for the rest. Paint lightly, with long, thin, curving strokes. Tone down as needed with the adjacent color.

153

Cottontail Rabbit (Side View)

The cottontail is the most common breed of rabbit in North America and lives primarily in the wild. Check to see if there's a local wildlife rescue in your area you might visit to sketch and photograph some cottontails for painting reference.

Paints

Burnt Sienna

Burnt Umber

Payne's Gray

Raw Sienna

Raw Umber

Scarlet Red

Titanium White

Ultramarine Blue

Brushes

no. 1 and 3 rounds

no. 2, 4 and 6 filberts

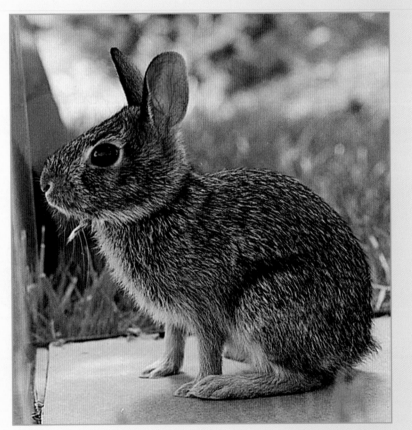

Reference Photo

1 Establish the Form and the Dark Values

Over a light sketch, use Payne's Gray thinned with water and a no. 1 round to paint the basic darks and lights. Use a no. 6 filbert for the broader areas. For the dark color of the rabbit's coat and eye, mix Burnt Umber and Ultramarine Blue. Paint the eye with a no. 1 round, leaving a white space for the highlight. (If you paint over the highlight by mistake, you can always add it later.)

Use a no. 1 round (for details) and a no. 4 filbert (for the broader areas) to begin painting the darkest shadowed areas around the neck, haunch, under the eye, etc. Use brushstrokes that follow the way the hair grows. It will take more than one layer of paint to cover the dark areas. As soon as one layer is dry, you can darken it by adding another layer.

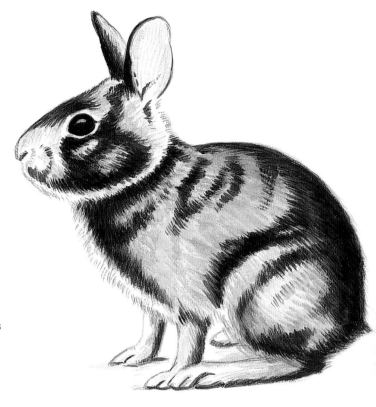

2 Paint the Middle Value

For the brownish middle value color, mix Raw Sienna, Burnt Sienna and Titanium White. Apply with a no. 4 filbert. First dip the tip of your brush in water, then in the paint. Paint right up to the dark areas, overlapping with short, uneven brushstrokes at the edges where the two colors meet.

3 Begin the Fur Details

With the dark fur color and a no. 1 round, begin painting fur detail over the middle value color, following the fur pattern. Mix a lighter fur color using Titanium White and Raw Umber. With a no. 3 round, begin painting the chest fur against your background, and begin adding lighter hairs around the eye, head, shoulders and haunches. Use the same color and brush to paint the lighter parts of the legs and feet. For the pink color inside the ear, mix Scarlet Red, Burnt Umber, Titanium White and a little Ultramarine Blue. Apply with a no. 2 filbert.

TIP

- Make fur more realistic by painting some tufts of fur—triangular in shape with the top end open. Some artists make the mistake of painting fur as if it were just a series of thin lines all going in the same direction.

- Tone down any areas of light-colored fur that look too bright or stand out too much with a thin glaze of Burnt Umber and water.

Eastern Cottontail Rabbit
Acrylic on illustration board
8" × 10" (20cm × 25cm)

4 Finish the Details

Add more dark hairs with a no. 1 round and the dark value you mixed in Step 2. Vary your brushstrokes so they aren't all in the same direction. Use a no. 1 round and the light fur color to continue the fur. Integrate the areas where the light and dark fur meet by stroking one color into the other at the edges, using separate brushes for each.

Paint a highlight on the edge of the closest ear with a no. 1 round and some of the light fur mixture. For areas where this mixture would be too light, mix a little of the light and middle value fur colors together. Use short strokes on the head and slightly longer strokes on the body. Mix a little

Titanium White with Ultramarine Blue and paint the eye highlight with a no. 1 round, then blend the edges.

Use a no. 1 round and a mixture of Scarlet Red, Burnt Umber and Titanium White to paint the veins inside the ear. Use some of the pinkish ear color mixture from Step 3 (thinned with water) and a no. 1 round to tone them down. Paint the shadows inside the ear with a mixture of the pinkish ear color and Burnt Umber, then blend.

With a no. 1 round, paint the whiskers with some of the light fur color and enough water so the paint flows. Use a no. 1 round and some of your background color to tone them down as needed.

8 Squirrels

It is important for the artist to know that within a species, individual animals may vary greatly in color. They may also vary in color depending on the time of year. For example, gray squirrels are usually gray to brownish gray with white underparts, but sometimes they are brownish underneath. In the summer, they may be more tawny colored than gray, and there are some "gray" squirrels that are actually all black or all white! They are all individuals, which only makes them more interesting subjects for your artwork.

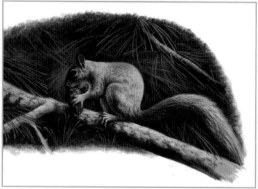

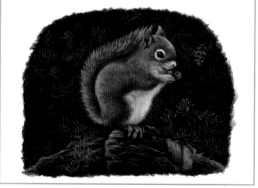

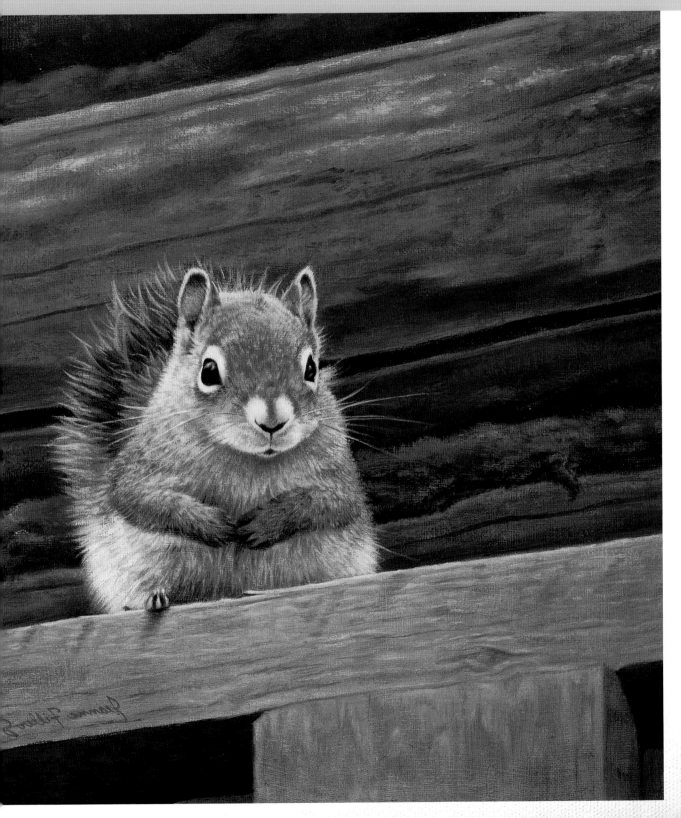

Project 30

Gray Squirrel

Gray squirrels are common in North America and are predominantly gray in color. They appear brownish or tawny in the summer and have white underbellies.

MATERIALS

Paints

Burnt Sienna

Burnt Umber

Cadmium Orange

Cadmium Red Light

Cadmium Yellow Light

Payne's Gray

Raw Sienna

Titanium White

Ultramarine Blue

Brushes

no. 0, 1, 3 and 5 rounds

no. 2 filbert

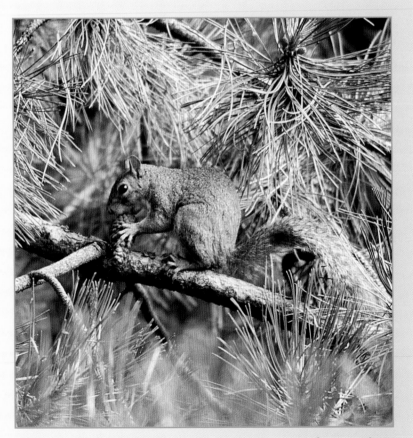

Reference Photo

160

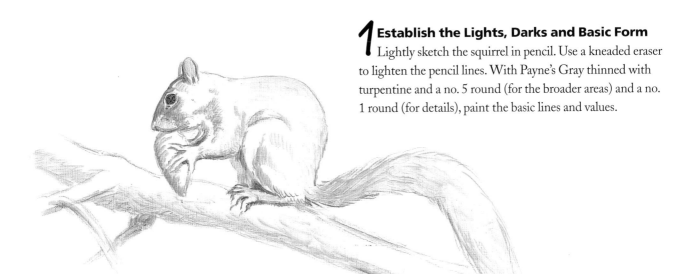

1 Establish the Lights, Darks and Basic Form

Lightly sketch the squirrel in pencil. Use a kneaded eraser to lighten the pencil lines. With Payne's Gray thinned with turpentine and a no. 5 round (for the broader areas) and a no. 1 round (for details), paint the basic lines and values.

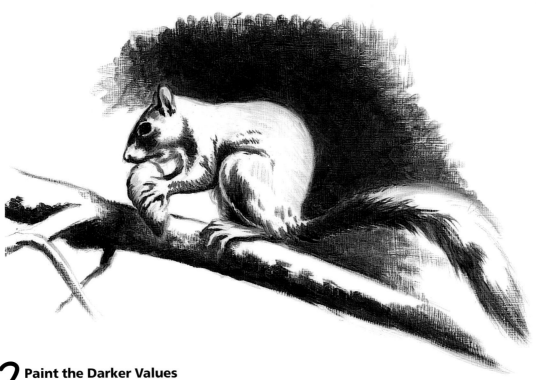

2 Paint the Darker Values

For the darker values, mix Burnt Umber, Burnt Sienna and a small amount of Ultramarine Blue. Paint the darks with a no. 5 round. With a clean no. 2 filbert, soften the line at the edge of the squirrel's back where it meets your background.

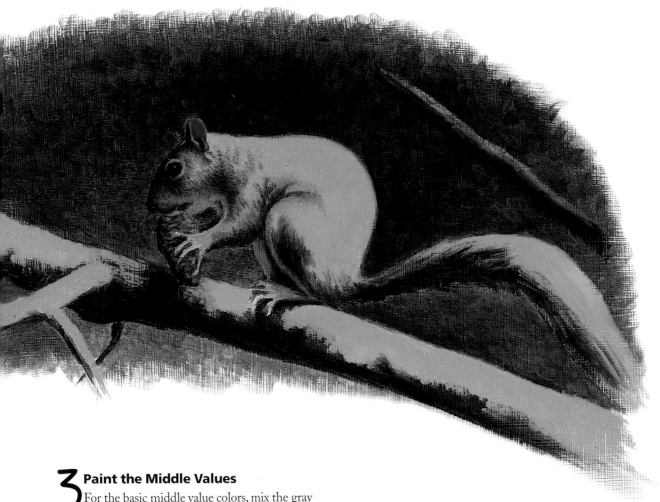

3 Paint the Middle Values

For the basic middle value colors, mix the gray using Titanium White, Ultramarine Blue, Raw Sienna and Burnt Umber. Mix the tawny color for the face, feet and haunches with Titanium White, Raw Sienna, Cadmium Orange and Burnt Sienna. Use no. 3 rounds to paint these colors. Be sure to use brushstrokes that follow the way the hair grows.

For the pinkish inside of the ear, mix Cadmium Red Light, Titanium White and Burnt Umber. Use a no. 1 round. With a separate no. 1 round, get a little Burnt Umber on your brush and paint the dark area inside the ear, blending up into the pinkish color. Take the brush with the pinkish color and blend into the Burnt Umber, too, until you have a good blend between the two colors. Allow the painting to dry overnight.

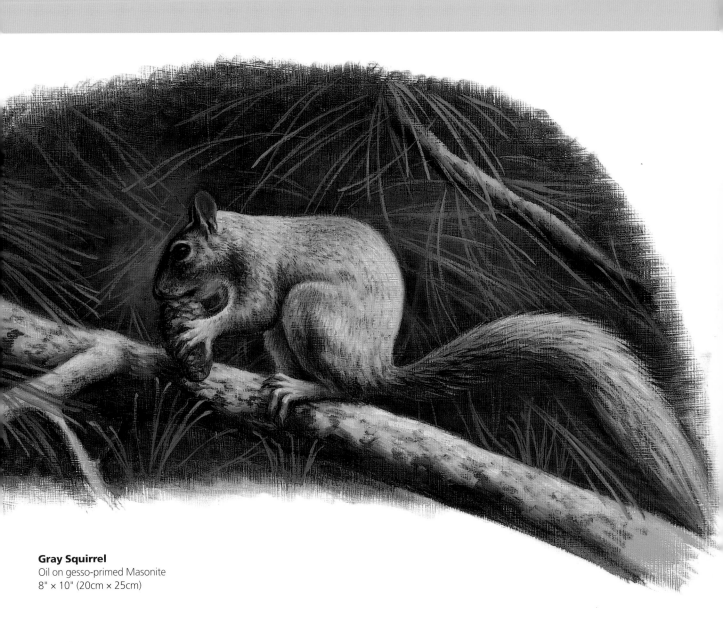

Gray Squirrel
Oil on gesso-primed Masonite
8" × 10" (20cm × 25cm)

4 Paint the Lighter Values and Fur Detail

Mix the color for the darker fur detail with Burnt Umber, Burnt Sienna, Ultramarine Blue and Raw Sienna. Use a no. 0 round to paint some hair texture. Blend with a no. 3 round and some of the gray mixture or tawny mixture from Step 3. Blend just enough so that the fur looks natural.

For the highlights, mix Titanium White, a little Raw Sienna and a touch of Cadmium Yellow Light for warmth. Use a no. 0 round to paint small dabs, allowing the paint to be a little thicker in these areas. This will make the squirrel stand out against your background.

163

Project 31

Red Squirrel

Red squirrels are another common tree squirrel found in North America. They are sometimes referred to as pine squirrels or chicarees. The red squirrel has a red tail bordered with black, a white underbelly and tufted ears.

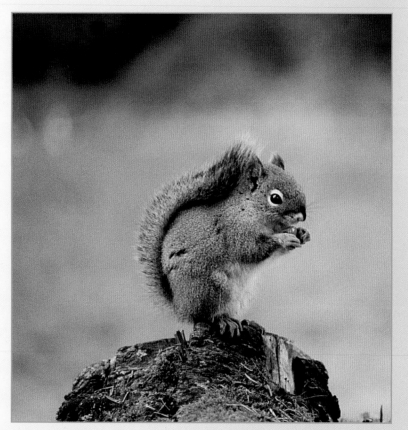

Reference Photo

1 Paint the Dark Values

Lightly sketch the squirrel in pencil. Paint the basic form of the squirrel with a no. 3 round and Burnt Umber thinned with water. Mix Burnt Umber, a smaller amount of Burnt Sienna and a little Ultramarine Blue for the dark value. Paint these darks with a no. 3 round. Use water to thin your paint to the right consistency. Use brushstrokes that follow the way the hair grows.

Mix Titanium White, Burnt Sienna, Acra Red and Cadmium Orange for the base color of the squirrel. Begin to paint this using a no. 3 round.

2 Paint the Basic Colors

Continue painting the reddish base color of the squirrel's body. Dip just the tip of your brush in the water, then in the paint mixture to get the correct amount of water and paint on your brush. When this is dry, add a second coat to completely cover the surface.

Mix Burnt Umber, Burnt Sienna and a small amount of Ultramarine Blue. Begin overlapping the edges of the shadowed areas into the reddish base color. Use short strokes with a no. 3 round. Mix the bluish shadow color for the white underbelly with Titanium White, Ultramarine Blue and a touch of Burnt Sienna for warmth. Paint with a no. 3 round, overlapping the edges of the adjacent color with uneven strokes.

Mix the basic color for the paws and feet with Titanium White, Cadmium Orange and Raw Sienna, and paint with a no. 1 round. Use the same color to begin adding the fur highlights with a no. 3 round along the back line where it meets the tail.

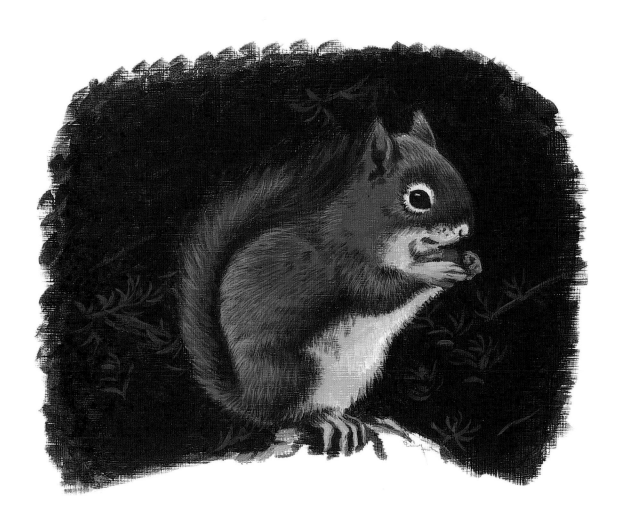

3 Add the Fur Detail

Continue adding detail to the fur. Use just enough water so the paint flows. Add dark hair patterns with the color you mixed in Step 1, followed by the lighter value you mixed in Step 2, using no. 1 rounds. Paint with small overlapping strokes. For detail in the bluish shadow areas, dip a no. 1 round into the bluish mixture from Step 2, then into some Burnt Umber, and mix on the palette. Apply with small strokes, and overlap the edges with strokes of the bluish mixture.

For highlights in the fur, use some of the color mixture from Step 2 that you mixed for the paws and feet. Begin to paint these highlights with a no. 1 round, including the edge of the tail where it meets your background.

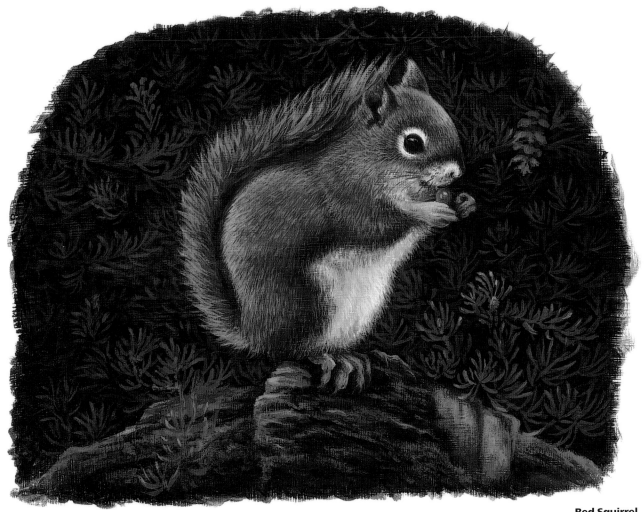

Red Squirrel
Acrylic on gesso-primed Masonite
8" × 10" (20cm × 25cm)

4 Finish the Details

Keep overlapping the three basic fur colors alternately, using the reddish value to tone down and soften brushstrokes that appear too sharp. Use Titanium White with a touch of Yellow Ochre to soften and blend the white lines around the eye. With two brushes—a no. 1 round for Titanium White and another no. 1 round for the bluish shadow color—add highlights to the underbelly, then blend the edges with the bluish color.

Use your background color to paint around the toes to refine the shape of the feet and paws. Use the paw and foot color mixture to redefine the shape. Using a no. 1 round, glaze the feet with a thin wash of Burnt Umber. Then, using a no. 1 round and some of the foot color mixed with Titanium White, paint highlights on the toes. You don't need to glaze the paws with a darker color since the paws are not in shadow. Highlight the paws in the same way as the feet.

Paint the whiskers with a no. 0 round and a very small amount of Burnt Umber thinned with water. Blot your brush lightly on a paper towel before applying the paint. Be careful not to make the whiskers too dark. Paint the eye highlight with a no. 0 round and a small amount of Titanium White mixed with a touch of Ultramarine Blue. Use the dark eye color to refine the shape, and redefine the highlight with the highlight color.

Project 32

Columbian Ground Squirrel

On a family trip to Banff National Park in Alberta, Canada, one of our most enjoyable experiences was meeting the Columbian ground squirrels. In one area, the squirrels were so trusting and accustomed to being fed peanuts, that if you sat down on the ground very still, they would climb onto your lap!

Paints

Burnt Sienna

Burnt Umber

Cadmium Orange

Cadmium Red Medium

Hansa Yellow Light

Hooker's Green Permanent

Raw Sienna

Titanium White

Ultramarine Blue

Brushes

no. 3 and 10 round

no. 10 bright

Reference Photo

1 Establish the Form
Draw the squirrel lightly in pencil, using a kneaded eraser to lighten lines or make corrections. With Burnt Umber thinned with water and a no. 10 round, paint the basic lines and shadows. For the shadows on the squirrel, mix dark brown with Burnt Umber and Ultramarine Blue. Paint with a no. 10 round.

2 Paint the Dark Values
Continue painting the dark areas of the squirrel with dark brown. Mix dark green for the squirrel's ground shadow with Hooker's Green Permanent, Cadmium Orange, Burnt Umber and Ultramarine Blue. Paint with a no. 10 round.

3 Paint the Middle Values and Begin Painting the Background

Mix a light rufous color for the squirrel's coat with Burnt Sienna, Cadmium Orange and Titanium White. Paint short, parallel strokes in the direction of fur growth with a no. 10 round.

Mix blue-gray for the squirrel's belly, back and head with Titanium White, Ultramarine Blue and a small amount of Burnt Umber. Paint with a no. 10 round.

Mix pink for the nose with Titanium White, Cadmium Red Medium, Burnt Sienna and Cadmium Orange. Paint with a no. 10 round.

Mix a field green background color with Hooker's Green Permanent, Cadmium Orange, Titanium White and Raw Sienna. Paint with a no. 10 bright, using dabbing strokes. Switch to a no. 10 round to paint around the squirrel's outline.

4 Finish the Background Color and Paint the Light Values

Finish painting the background using the field green. Mix a highlight color for the squirrel with Titanium White and small amounts of Raw Sienna and Hansa Yellow Light. Using a no. 10 round, paint parallel strokes that follow the fur pattern. Paint the mottled checkerboard pattern on the back over the blue-gray with small, parallel strokes. Overlap where the highlight meets the adjacent color with thin strokes of the highlight color. Vary the length of the strokes—longer on the body and shorter on the head and paws.

TIP

Create an impression of light and depth in the background by varying the amount of paint used on the panel. Allow it to show through more in some areas than in others.

TIP

To make the squirrel's fur stand out against the background, transfer a portion of the highlight color to a dry palette. As the paint dries, it will become thicker and more opaque. Paint the edges of the highlighted side of the squirrel with a no. 10 round. If the paint becomes too dry, use a spray bottle to moisten it.

To make the shadowed side of the squirrel stand out, use some blue-gray mixed with Titanium White. For the chest, use light rufous mixed with Titanium White.

5 Paint the Detail

Paint dark detail on the squirrel's back with dark brown and a no. 10 round, using short strokes. Soften and blend with a separate no. 10 round and blue-gray. Add dark fur detail to the belly and chest with longer strokes, softening with the adjacent color. Add detail to the highlighted areas with the rufous, using fine strokes and a small amount of paint.

Begin to paint dark blades of grass with the dark green shadow color and a no. 10 round.

172

The Sentry
Acrylic on Gessobord
10" × 8" (25cm × 20cm)

6 Paint the Finishing Detail

On a dry palette, create the light blue fur softening color with a portion of blue-gray and some of the highlight color. With a no. 3 round, paint thin strokes over the mottled pattern on the back to soften it. Reinforce the outline of the back with the highlight color. Add some of the rufous to the back with a no. 3 round, using thin strokes.

Mix a highlight color for the eye with Titanium White and a bit of blue-gray. Use separate no. 3 rounds to paint the highlight, blending with dark brown. Reinforce the highlight with a touch of pure Titanium White.

Mix a whisker color with some dark brown and blue-gray. Paint thin, light strokes with a no. 3 round. Tone down the whiskers with the adjacent color if they come out too dark.

Paint more blades of grass with dark green and a no. 10 round. Make the strokes smaller and lighter and use less paint as you work into the background behind the squirrel. Tone down any blades that stand out too much with the field green color. Paint some blades with rufous to give the grass a more natural look.

9 Foxes

There are four species of foxes in North America: the red fox, the gray fox, the kit fox and the arctic fox. The most widespread are the red and gray foxes. Red foxes have a slender build, long slim legs, large ears and a bushy, white-tipped tail. They may vary greatly in color. Some red foxes are a pale yellowish red, while others are a deep red on the upper parts of the body. They are usually white underneath, have a white-tipped tail and have black lower legs and ear tips. However, there are all-black "red" foxes as well as silver "red" foxes!

The gray fox is a little smaller and doesn't appear as long and slim as the red fox. It has a grizzled gray coat with rusty colored patches on the neck, belly, legs and tail. The muzzle is black, and the cheeks and throat are white. The tail has a black stripe down its length with a black tip. One interesting characteristic is that the gray fox, unlike the red fox, will climb trees, both to escape from enemies and to look for food.

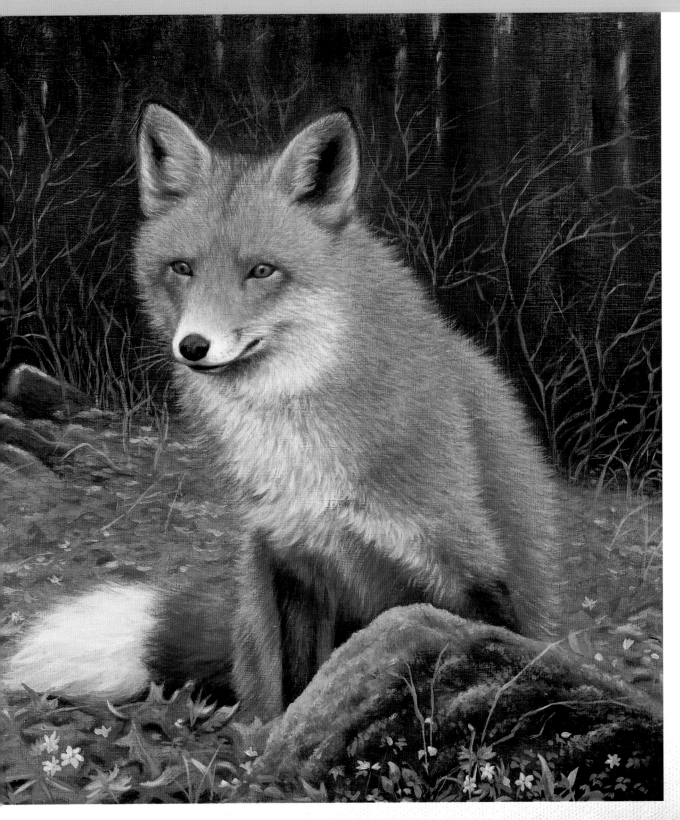

Red Fox

Red foxes have a reddish coat, white-tipped tail, white neck and chest, and black legs and feet. Female foxes are called vixens.

MATERIALS

Paints

Burnt Sienna

Burnt Umber

Cadmium Yellow Deep

Spectrum Yellow

Ultramarine Blue

Yellow Ochre

Zinc White

Brushes

no. 1, 3 and 5 rounds

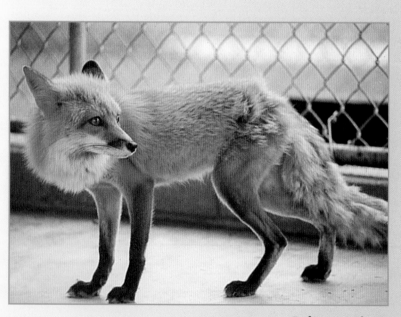

Reference Photo

1 Establish the Form and Begin Painting the Dark Values

Lightly sketch the fox in pencil. Using a small amount of Burnt Umber thinned with water, sketch out the main lines of the fox with a no. 5 round. Mix the color for the black parts of the fox's coat with Burnt Umber and Ultramarine Blue. Paint with a no. 3 round. (From now on, use a small to moderate amount of water as you paint.) Mix the darkest value of the reddish coat color with Burnt Umber, Burnt Sienna and Zinc White. With a no. 3 round, paint these areas using fairly short, parallel brushstrokes that follow the contours of the fox's form, keeping in mind the way the hair grows.

2 Continue Painting the Basic Coat Color

Continue painting the basic reddish coat color using a no. 5 round for the broader areas. Use brushstrokes going in the direction of hair growth.

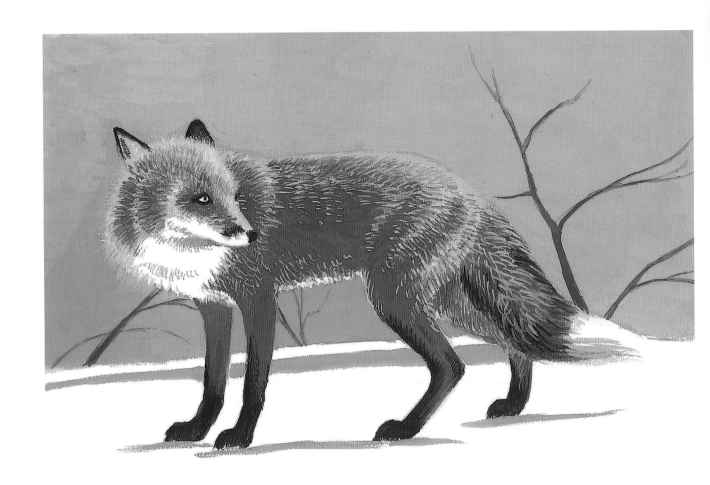

3 Paint the Lighter-Values

Mix the lighter-value fur color with Zinc White, Cadmium Yellow Deep and Yellow Ochre. Paint with a no. 5 round, overlapping the edges where the lighter and darker fur meet with short, parallel strokes.

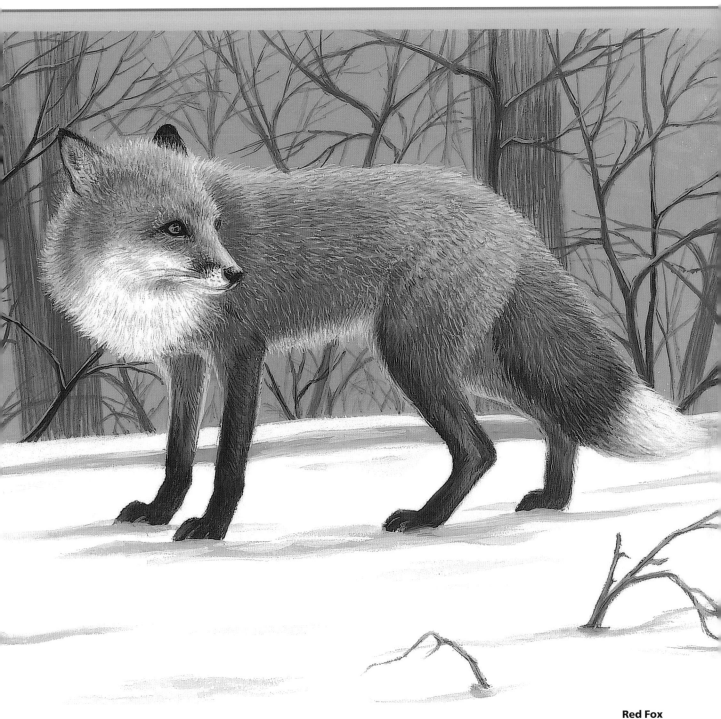

Red Fox
Gouache on illustration board
8" × 10" (20cm × 25xcm)

4 Add the Finishing Details

Paint hair detail in the areas of darker reddish fur using a no. 3 round and some of the lighter fur color you. Use short, thin brushstrokes that follow the hair pattern. With a separate no. 3 round and the dark reddish fur color, add some hair detail on top of the lighter fur color. Hold both brushes in your hand at the same time so you can work back and forth on these areas. Soften and integrate the lighter fur detail

using a no. 3 round and a small amount of the dark reddish fur color mixed with enough water to make a glaze. Paint over the lighter fur detail so that it shows through the glaze, using quick, light brushstrokes.

Mix a little Spectrum Yellow with Zinc White and use a no. 1 round to warm and intensify some of the highlighted areas on the fox's coat. Add small details such as the eyes, nose, whiskers and fine fur detail with a no. 1 round.

Gray Fox

The gray fox has white cheeks and throat, and a black-tipped tail. It has strong hooked claws that enable it to climb trees to escape predators.

MATERIALS

Paints

Burnt Sienna

Burnt Umber

Cadmium Orange

Cadmium Red Light

Cadmium Yellow Light

Payne's Gray

Titanium White

Ultramarine Blue

Brushes

no. 0, 1 and 3 rounds

no. 2 filbert

Reference Photo

1 Establish the Main Lines and Begin the Coat

Lightly sketch the fox in pencil. Paint the main lines over this sketch using Payne's Gray thinned with turpentine and a no. 3 round. For smaller details use a no. 1 round. Mix the darkest shadows for the gray part of the coat with Burnt Umber and Ultramarine Blue. Paint with a no. 2 filbert, using dabbing strokes that follow the hair pattern. For details, such as the hair tufts at the end of the tail and facial features, use a no. 3 round.

2 Continue the Coat

For the rust-colored parts, mix Titanium White, Burnt Sienna and Cadmium Orange. (You'll use this color in Step 3.) Transfer some of this color to a clean spot on your palette and mix with some Burnt Umber and a little Ultramarine Blue for the dark shadows in the rusty areas. Use a no. 3 round. In places such as the dark shadow along the belly and under the ruff around the neck, you'll paint the dark rusty red adjacent to and overlapping the edges of the dark shadowed areas you painted in the first step.

3 Paint the Middle Values

Paint the rusty red part of the fox's coat with a no. 3 round. Use another no. 3 round and some of the blackish color from Step 1 to blend the edges of the rusty red areas where the two colors meet. For the blue-gray middle value of the coat, mix Titanium White, Ultramarine Blue and Burnt Umber. Paint with a no. 3 round and follow the hair growth pattern.

Use separate no. 3 rounds for the rusty red middle value and the dark value, and blend the edges where the two colors meet. Use short brushstrokes to create the look of fur. If a brush gets too much of the other color on it, wipe it on a paper towel, then dip into the correct color again.

Mix the pinkish color for the inside of the ears with Cadmium Red Light, Burnt Umber, Burnt Sienna and Titanium White.

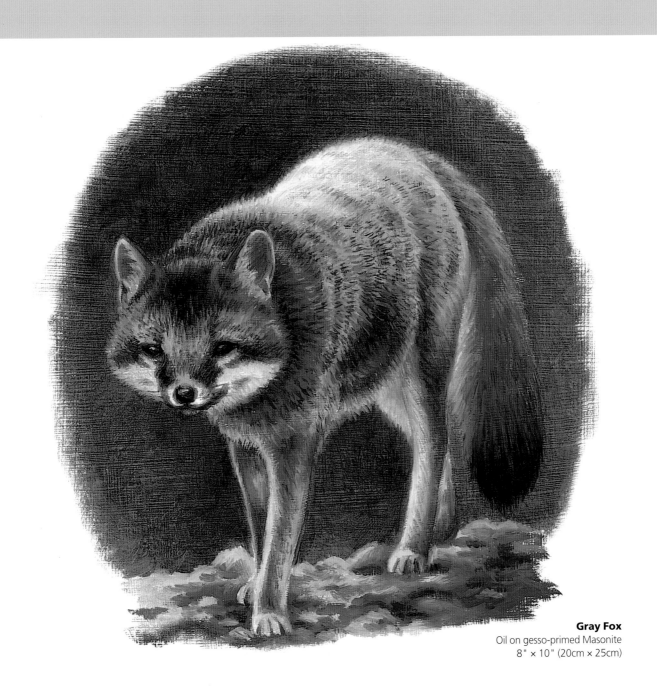

Gray Fox
Oil on gesso-primed Masonite
8" × 10" (20cm × 25cm)

4 Add the Highlights and Details

Mix the color for the warm highlights along the tail, upper legs and chest with Titanium White, Cadmium Yellow Light, Cadmium Orange and a bit of Burnt Sienna. Paint with a no. 3 round. Use a clean no. 3 round to blend the highlight color into the surrounding color. For the brightest highlights along the fox's back, ears, lower legs and feet, muzzle and cheeks, mix Titanium White and a small amount of Cadmium Yellow Light and use a no. 3 round.

When dry, add some fur detail over the blue-gray middle-value fur with a no. 0 round and some of the dark color mixture from Step 1. Use another no. 0 round and some of the blue-gray color from Step 3 to tone down and blend the dark hairs with the surrounding color.

Paint the eyes with a no. 0 round and the dark shadow color from Step 1. Use a separate no. 0 round and a mixture of Titanium White and a bit of Ultramarine Blue to carefully paint the eye highlights.

Project 35

Fox Cub

This pretty little red fox cub had been orphaned and was in the care of a wildlife rehabilitator. I was impressed by the alertness and intelligence in the cub's eyes as well as the quickness and agility present in such a young animal. I imagined how the fox would look after he had been released into the woods.

MATERIALS

Paints

Burnt Sienna

Burnt Umber

Cadmium Orange

Hansa Yellow Light

Hooker's Green Permanent

Naples Yellow

Raw Sienna

Titanium White

Ultramarine Blue

Brushes

no. 3 and 10 rounds

no. 8 and 10 brights

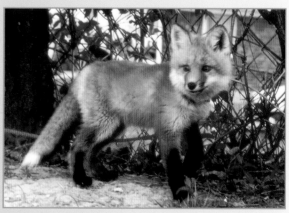

Reference Photo

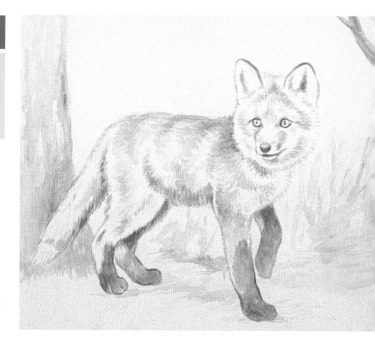

1 Establish the Form

Lightly draw the fox cub onto the panel with a pencil, using a kneaded eraser to make corrections or lighten lines. Use diluted Burnt Umber and a no. 10 round to establish the main lines and the form.

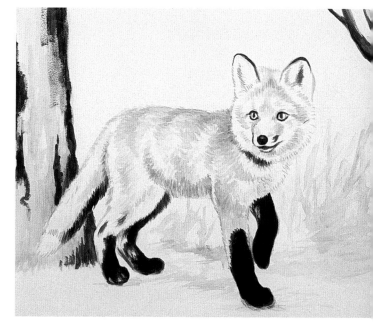

2 Paint the Dark Values

Mix a black for the cub's darkest parts—legs, nose, mouth and the outline around the eyes and ears—with Burnt Umber and Ultramarine Blue. Paint with a no. 10 round, switching to a no. 3 round for the face and ears.

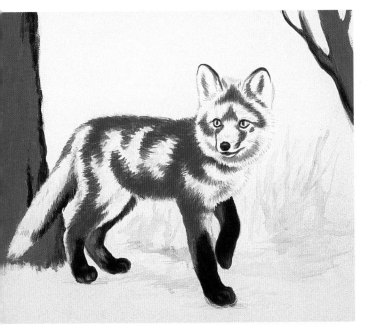

3 Paint the Middle Values

Mix a rufous color with Burnt Sienna, Cadmium Orange and Titanium White. Paint the fur with a no. 10 round, using strokes that follow the hair pattern.

Mix a blue shadow color with Titanium White, Ultramarine Blue and Burnt Umber. Paint the shadows in the ears, under the neck and chest ruff, and on the legs with a no. 10 round.

Mix a warm gray for the tree trunk with Titanium White, Burnt Umber and Ultramarine Blue. Paint vertical strokes with a no. 10 round.

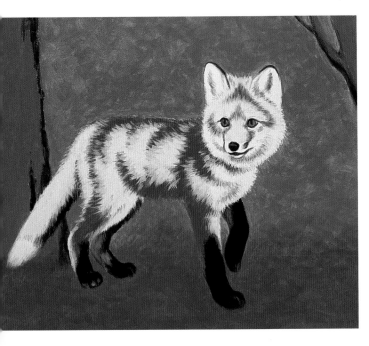

4 Paint the Light Values and Background

Mix an earth green color with Naples Yellow and Ultramarine Blue. Paint the background with a no. 10 bright. Switch to a no. 10 round for around the cub's outline. Use dabbing, semicircular strokes.

Mix a brown leaf color for the ground with Titanium White, Raw Sienna and Burnt Umber. Paint with a no. 10 bright, using dabbing, horizontal strokes. Switch to a no. 10 round for around the cub's legs and feet. Blend into the green background using the dry-brush technique.

Mix a blond highlight color with Titanium White and small amounts of Hansa Yellow Light and Cadmium Orange. With a no. 10 round, use tuft-shaped strokes following the fur pattern.

Mix a warm white for the ears, ruff, chest and tip of the tail with Titanium White and a touch of Hansa Yellow Light. Paint with a no. 10 round.

Mix a warm brown eye color with Cadmium Orange, Raw Sienna and Titanium White. Paint the eye with a no. 3 round. Use some of the blue shadow color for the corner of the left eye.

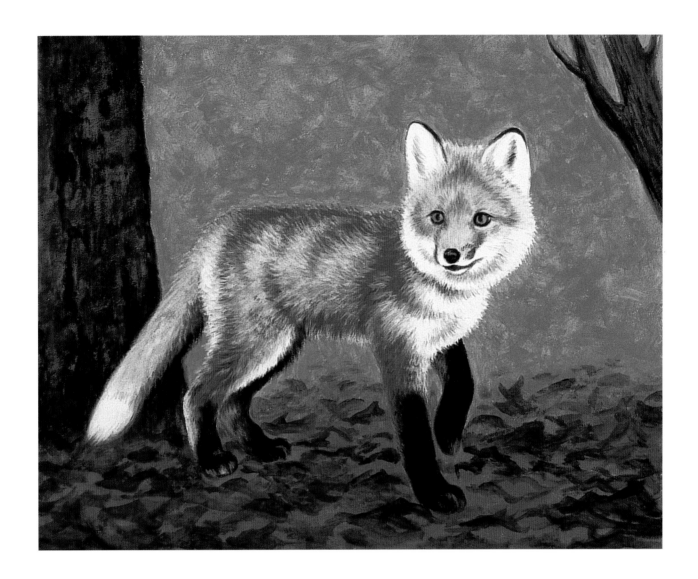

5 Add Detail

Paint a thin glaze over the blond areas of the coat with rufous and water, using a no. 10 round. Add detail to the coat with a no. 10 round and rufous. Add dark detail with black, blending with rufous.

Use the dry-brush technique to paint texture on the tree trunk using black and a no. 8 bright. Use black and a no. 10 round for fallen leaf detail on the ground.

Blend into the earth green background color with smaller, lighter value detail.

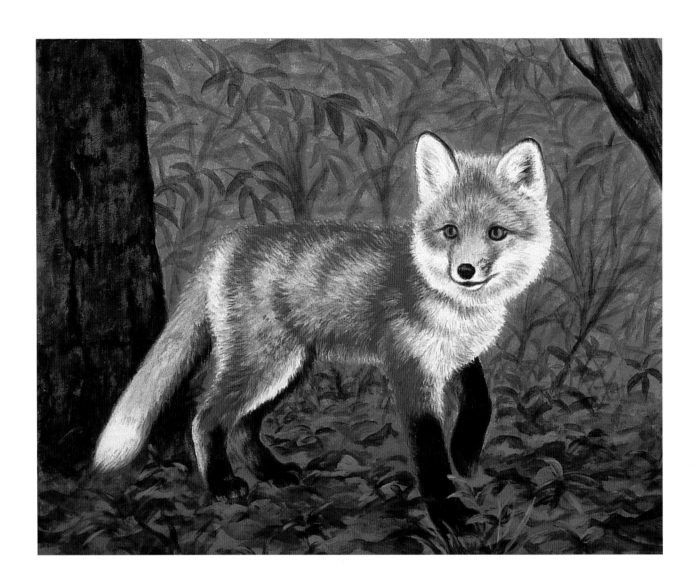

6 Add More Detail to the Cub and Background

Continue to add detail to the fur with no. 3 rounds, blending with the adjacent color or with a clean, damp brush. Add blue shadow color detail to the white areas of the fur, blending with warm white. For lighter value detail, add some Titanium White to the blue shadow color.

Mix a leaf highlight color with warm white and some of the brown leaf color. Paint highlights with a no. 10 round.

Mix dark green with Hooker's Green Permanent, Cadmium Orange, Burnt Umber and Ultramarine Blue. Use a no. 10 round on the small woodland plants. Mix a green highlight color with a portion of earth green and Titanium White and Hansa Yellow Light. Paint highlights with a no. 10 round. Paint some tree leaves in the background with dark green thinned with a small amount of water. Paint some of the leaves with less paint to create a sense of distance. With diluted black, paint a few saplings in the background.

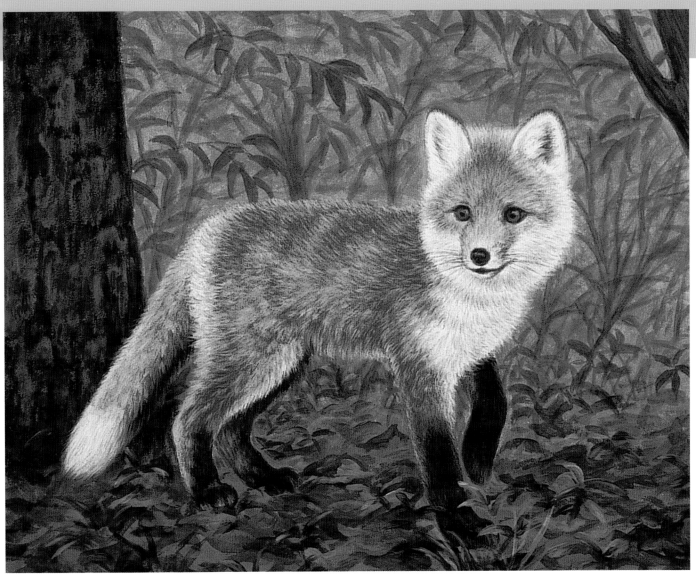

The Young Fox
Acrylic on Gessobord
8" × 10" (20cm × 25cm)

7 Paint the Finishing Details

With a no. 3 round and the blond highlight color, continue to add detail to the fur. Soften the outline of the ears with a small amount of earth green and a no. 3 round. Paint some dark detail in the tail with black and a no. 3 round. Add lighter detail with the blond highlight color, then blend and soften with warm white. Add some very light strokes of rufous to the blue shadowed areas of the ruff, chest and tail.

Use a no. 10 round to restore color and integrate the reddish parts of the coat with a thin glaze of rufous and water. Re-establish highlights as needed.

Using black, the eye color and separate no. 3 rounds, blend where the dark pupils and the outline of the eye meet the warm brown eye color. Mix a highlight color for the eye with Titanium White and the blue shadow. Use a no. 3 round. Paint the corner of the left eye with blue shadow color.

Soften the outline of the nose with the blue shadow color and a no. 3 round. Paint the whiskers with diluted black and a no. 3 round, using light, feathery strokes. Tone down as needed with warm white.

To help integrate the fox with the background, add some touches of rufous with a no. 10 round using small, dabbing strokes on randomly selected lighter value leaves.

10 Raccoons & Woodchucks

Raccoons are intelligent animals that can adapt to a variety of environments, including urban areas. Their most striking feature is the black mask, which is surrounded by white fur. The animal's fur color ranges from gray to black, with black and white banded guard hairs and short grayish or brownish underfur. The raccoon appears in Native American folklore as a trickster who can outsmart his enemies and use his hands like a human.

Also called the groundhog or whistle pig because of its habit of whistling shrilly when alarmed, the woodchuck is actually an oversized squirrel belonging to the marmot family. Commonly seen in farm fields where they enjoy sunbathing outside their burrows after a meal, woodchucks are also often seen feeding by roadsides. It has a bushy tail of medium length and strong claws used for digging.

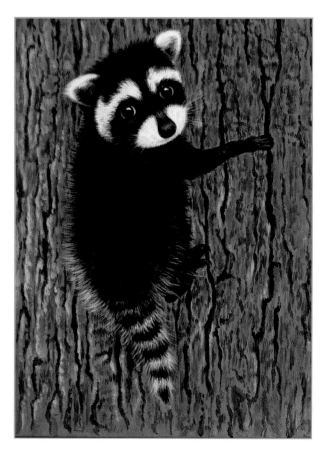

Project 36

Raccoon

Raccoons are medium-sized animals and native to North America. They have a black mask, pointed nose, broad head and between 4 and 7 rings on their bushy tails.

Reference Photo

1 Establish the Main Lines and Paint the Darkest Value

Lightly sketch the raccoon in pencil. Use Burnt Umber thinned with turpentine and a no. 3 round to roughly paint the basic lines. For the black mask and tail rings, mix Burnt Umber and Ultramarine Blue. Paint the tail rings with a no. 4 filbert. Paint the mask, eyes and nose with a no. 1 round.

2 Paint the Darker Value of Coat

Mix the brownish shadow color for the raccoon's coat with Burnt Umber and a smaller amount of Ultramarine Blue than you used to mix the black in Step 1, plus a very small amount of Titanium White. In areas of fur that are a confusing mixture of dark fur overlaid with very small, lighter colored hairs, such as the left foreleg, first paint the area dark. Later on you can paint the lighter hairs over the dark fur.

3 Paint the Middle Values

Mix the grayish brown middle value coat color with Titanium White, Burnt Umber and a smaller amount of Raw Sienna. Paint with a no. 3 round, using short, parallel brushstrokes following the fur pattern. With a separate no. 3 round and the dark value color you mixed in Step 2, begin to blend the edges where the two colors meet.

For the bluish shadow color on the lower part of the muzzle, around the edges of the ears and for the top of the lower part of the right leg, mix Titanium White, Ultramarine Blue and a small amount of Burnt Umber.

TIP

If you make a mistake when painting a detail, such as the eye, and you need to change the shape, use the tip of a craft knife to scrape the paint away. If you want to remove the paint completely, use a cotton swab dipped in turpentine to rub the paint carefully away. In this way, you can make corrections without disturbing the other parts you've already painted.

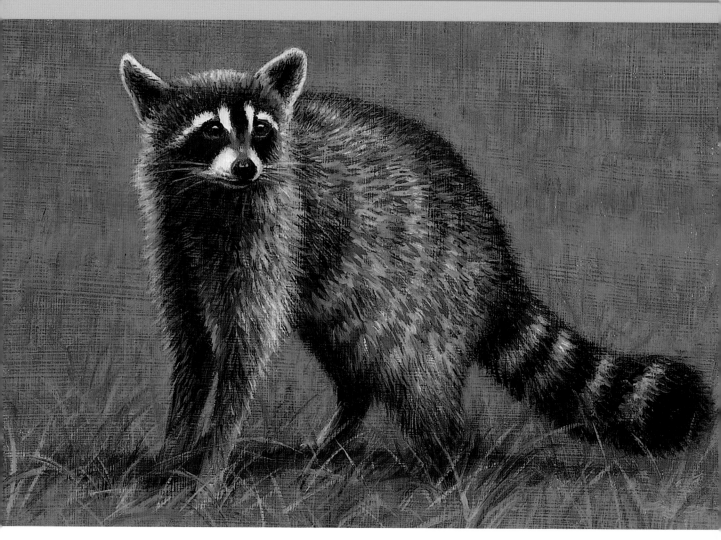

Raccoon
Oil on gesso-primed Masonite
8" × 10" (20cm × 25cm)

4 Add the Details

Continue blending the dark and middle values of the fur using separate no. 3 rounds. Wipe the brushes on a paper towel when they get too much of the opposite color on them, then redip them first in Liquin, then in the correct color. For the brownish color on either side of the dark band between the eyes and down the length of the muzzle, use a no. 1 round with a bit of the middle value color mixed with Burnt Umber and Burnt Sienna. Use a no. 0 round with Titanium White and a small amount of Yellow Ochre for the white fur on the muzzle, above the eyes and outlining the ears. Use a no. 1 round with the brownish color to blend the edges. Get some of the bluish shadow color on your brush and blend where the white meets the bluish color.

When dry to the touch, mix a little of the dark value brownish color from Step 2 with a little of the middle value color from Step 3. Use a no. 1 round to paint fur detail over the light and dark parts of the coat. Paint clumps of fur rather than individual hairs; make them roughly triangular in shape. With separate no. 1 rounds for the dark and middle values, blend and add fur detail. Re-establish darks where needed. Paint a few brownish hairs over the black tail bands and the mask so they will integrate with the rest of the coat.

Mix the wheaten coat highlights with Titanium White and a touch of Yellow Ochre. With a no. 1 round, high-light the clumps of fur. Use separate brushes with the other fur colors to blend the edges where the colors meet. With a no. 0 round, take some of the bluish color mixture from Step 3 and mix with some Titanium White to paint the eye highlights. Paint the whiskers with a no. 0 round and the Titanium White–Yellow Ochre mixture. Add a few tufts of the wheaten color to the raccoon's coat using a no. 1 round. Putting some of your background color into the coat will integrate the animal with its surroundings.

Woodchuck

Woodchucks, also known as groundhogs, are large rodents that belong to the marmot group. They are excellent diggers and hibernate in the winter by burrowing underground. Woodchucks have small ears, a frosted brown coat, dark feet, long claws on the front feet and lighter coloring around the nose.

MATERIALS

Paints

Burnt Sienna

Burnt Umber

Raw Sienna

Titanium White

Ultramarine Blue

Yellow Oxide

Brushes

no. 0, 1 and 3 rounds

no. 2 filbert

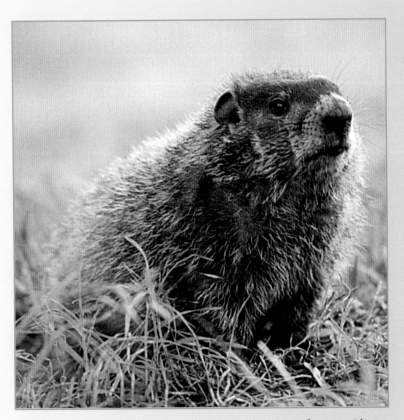

Reference Photo

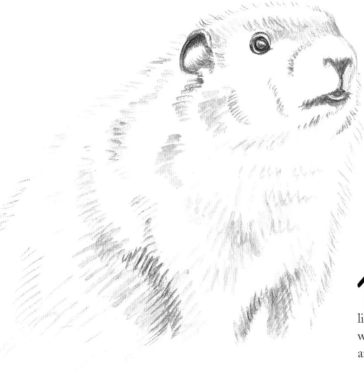

1 Establish the Form

Sketch the woodchuck lightly in pencil. Paint the main lines and form with a no. 3 round and Burnt Umber thinned with water. (From now on, paint with a small to moderate amount of water on your brush, unless otherwise indicated.)

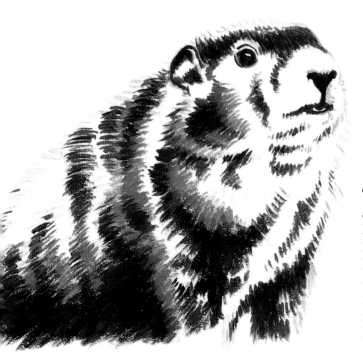

2 Paint the Darkest Values and Begin the Middle Values

Mix the dark brown for the darkest parts of the coat with Burnt Umber and a moderate amount of Ultramarine Blue. Paint with a no. 3 round. Paint the nose, mouth, inside the ear and the shadowed areas of fur, following the direction the fur grows. Paint the eye with a no. 1 round. Mix the brownish middle value color with Titanium White, Raw Sienna and Burnt Sienna. Begin to paint this color with a no. 2 filbert.

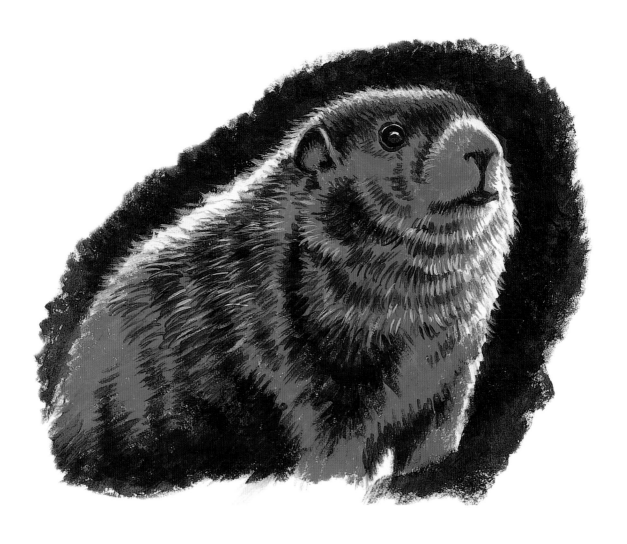

3 Paint the Middle Values and Begin the Highlights

Continue painting the middle value with the no. 2 filbert, switching to a no. 3 round for the smaller areas around the eye, nose and mouth. Leave the lightest, highlighted parts of the coat white. As the paint dries, add more layers of paint until the surface is well covered. Then use a no. 3 round to begin stroking some of the dark brown you mixed in Step 2 from the dark areas out into the middle value areas. Use the same brush and dark brown color to start adding smaller areas of dark fur over the brownish middle value color.

Mix the bluish color for inside the ear, the top of the nose and the brow line with Titanium White, Ultramarine Blue and Burnt Umber. Paint with a no. 1 round, then use a separate no. 1 round and the dark brown color to stroke the edges, integrating the two colors. Mix the highlight color with Titanium White and a small amount of Yellow Oxide. Begin to paint highlights along the chest, head and front leg with a no. 1 round.

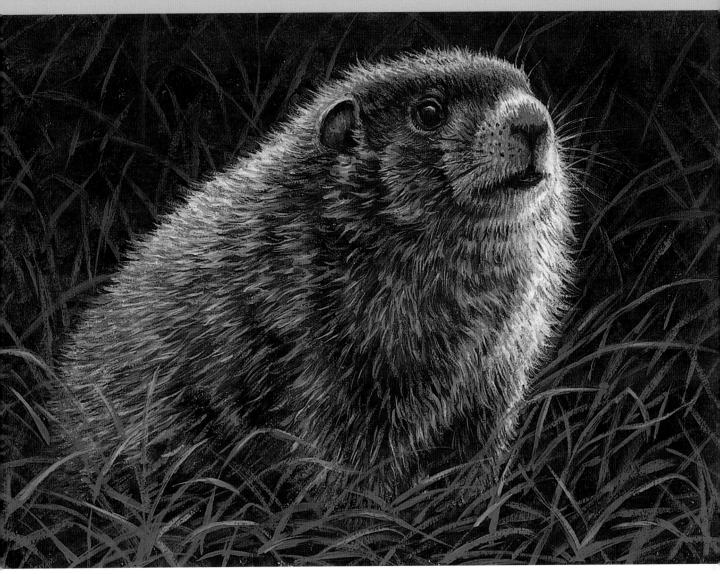

Woodchuck
Acrylic on illustration board
8" × 10" (20cm × 25cm)

4 Paint the Details

Continue to paint dark brown fur detail with a no. 1 round. Woodchucks have a brown coat that is sprinkled with light-colored hairs. Paint these hairs over the brown so that the brown coat underneath shows through between the brushstrokes. With a no. 1 round, paint the highlight color you mixed in Step 3 along the woodchuck's back, fading gradually into the body. In the broad areas of dark brown, use a no. 1 round to paint hair detail with the brownish middle value you mixed in Step 2. Then, with a separate no. 1 round, paint some of the highlight-colored hairs that are sprinkled over the coat. If they appear too bright, use the no. 1 round

with some of the brownish middle value color thinned with water to glaze over them.

Paint the eye highlight with a no. 1 round using a mixture of Titanium White and a touch of Ultramarine Blue. Make a small, curving brushstroke to show the roundness of the eyeball. Paint the whiskers overlapping the body (on the right side) with the dark brown color mixture from Step 2 and a no. 0 round. Paint the whiskers overlapping your background with the highlight color and a separate no. 0 round, using enough water so the paint flows easily. Make corrections as needed by painting over a whisker with your surrounding color, then repainting.

199

Project 38

Raccoon Baby

This orphaned baby raccoon was taken in by a veterinary clinic in Lexington, Kentucky, where they care for wildlife in need. This baby was irresistible with his wide-eyed, intelligent, yet naïve expression. He definitely needed help, and I'm glad he was able to get it.

MATERIALS

Paints

Burnt Umber

Cadmium Orange

Hansa Yellow Light

Hooker's Green Permanent

Raw Sienna

Titanium White

Ultramarine Blue

Brushes

no. 3 and 10 rounds

no. 10 bright

Reference Photo

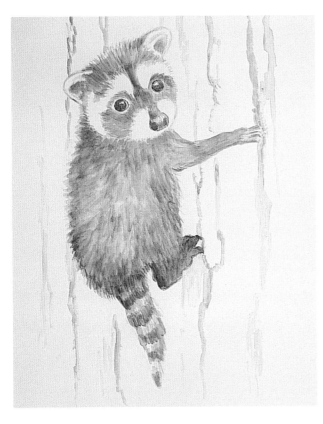

1 Establish the Form

Draw the raccoon lightly in pencil, using a kneaded eraser for corrections or to lighten lines. Use diluted Burnt Umber and a no. 10 round to paint the main lines and the form.

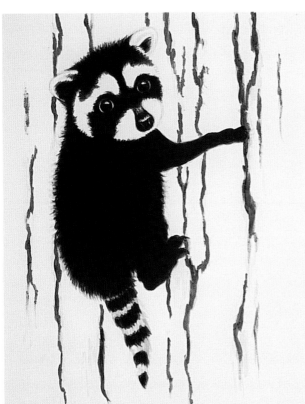

2 Paint the Dark Values

Mix warm black with Burnt Umber and Ultramarine Blue. Paint the black parts of the raccoon with a no. 10 round, using parallel strokes that follow the hair growth pattern.

When painting the eyes, leave the highlighted parts unpainted. For good, dark coverage, paint more layers after the first layer has dried. Paint cracks in the tree bark with the same brush and color.

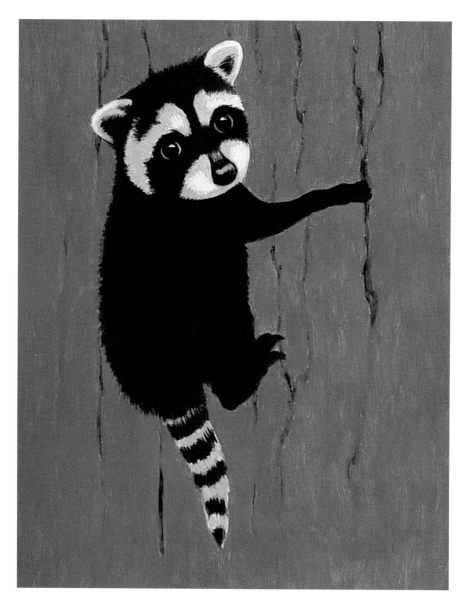

3 Paint the Middle Values

Mix warm gray for the tree trunk with Titanium White, Burnt Umber and Ultramarine Blue. Paint the trunk using vertical strokes with a no. 10 bright. Use a no. 10 round to paint around the raccoon's outline.

Mix a buff color with Titanium White, Raw Sienna and a touch of Cadmium Orange. Paint the shaded areas of the mask and ears and the light tail rings with a no. 10 round.

Mix a blue shadow color with Titanium White, Ultramarine Blue and a small amount of Burnt Umber. Paint the lower muzzle, inside the ears and the nose highlight with a no. 10 round. Use a no. 3 round to paint the whites of the eyes using the same color.

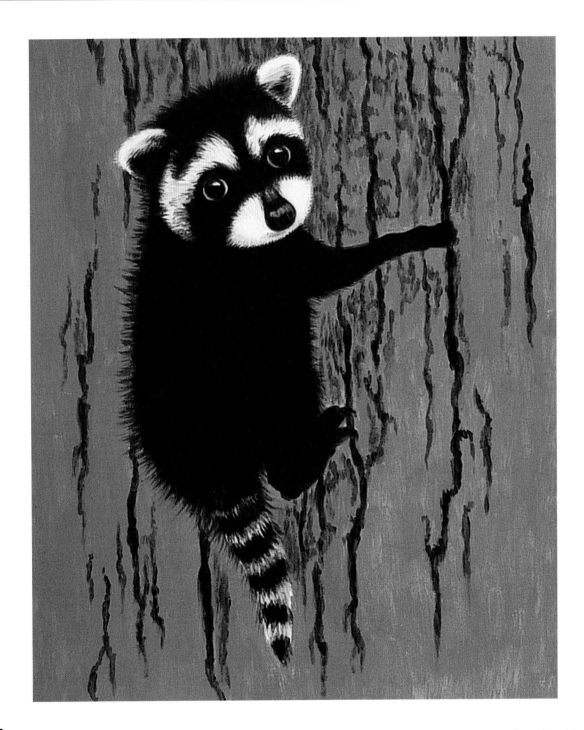

4 Paint the Light Values

Mix a white fur color with Titanium White and a touch of Hansa Yellow Light. Paint the white parts of the face and ears with a no. 10 round. Use overlapping strokes that follow the fur pattern.

With warm black and a no. 10 round, paint the longer hairs along the back, head, belly and tail using slightly curving strokes. Paint shorter strokes at the edges where the white fur meets the black fur.

Reinforce the cracks in the tree bark and add detail to the warm gray areas using a no. 10 round with less paint while applying lighter pressure on the brush. Paint bark details with short vertical strokes. Add secondary cracks that are long, but thinner than the main cracks.

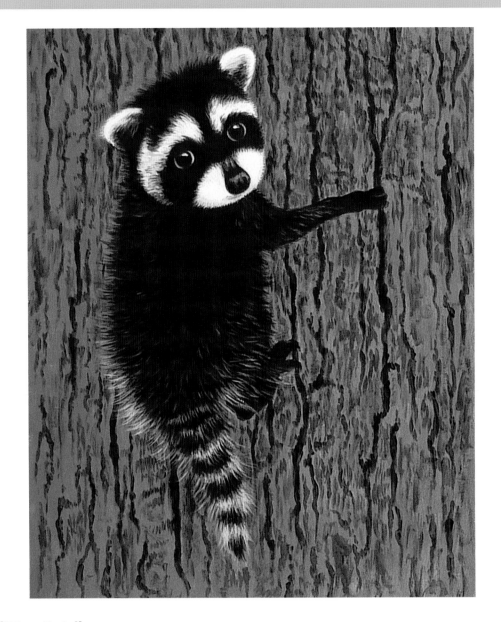

5 Add More Detail

Continue to paint detail in the tree bark with warm black. With a no. 3 round and the blue shadow color, paint fur detail inside the ears. With separate no. 3 rounds for warm black and the buff color, paint long hairs along the outline of the back, tail, belly and haunch. Paint light-pressured, slightly curved strokes, blending the buff colored hairs where needed with warm black.

Mix a dark buff color with a portion of the buff color and Raw Sienna. Using the same stroke with the longer hairs, paint shorter hairs on the body and at the edges of the facial mask, blending with the warm black. Re-establish the dark outline of the body with warm black and a no. 3 round with strokes that follow the fur pattern.

TIP

When painting subtle hair detail in the darkest areas with the dark buff color, lightly wipe the brush on a paper towel after dipping it into the color. This will give you the correct amount of paint on the brush.

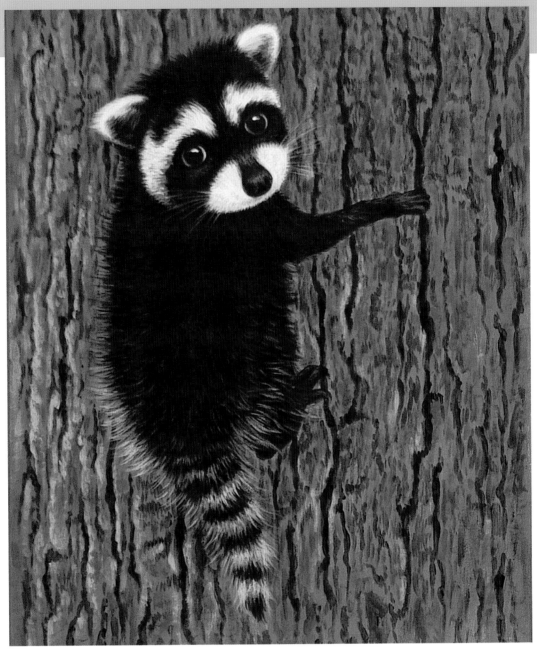

Bright Eyed and Curious
Acrylic on Gessobord
10" × 8" (25cm × 20cm)

6 Paint the Finishing Details

Continue to paint dark buff detail in the black areas of the coat. Use a separate no. 3 round with warm black to tone down and blend. Mix a dark blue shadow color by adding more Ultramarine Blue and Burnt Umber to a portion of the blue shadow color. Paint detail around the eyes and on the nose and paw.

Reinforce and brighten the tail rings with a no. 3 round and the dark buff color. Add highlights to the tree bark with the buff color and a no. 10 round.

Using separate no. 3 rounds, add more detail to the muzzle with the blue shadow and buff colors. Blend with the white fur color. Lightly paint the whiskers with the white fur color and a no. 3 round, toning them down with warm black as needed. Paint highlights on the toes with the dark blue shadow color and a no. 3 round, blending with warm black.

Mix a mossy green for the tree trunk with Burnt Umber, Hooker's Green Permanent and Titanium White. Paint some moss on the bark with a no. 10 round, using the dry-brush technique.

11 Ferrets & Otters

Ferrets and otters are playful, fun-loving animals. Both are members of the weasel family and have long, low-slung bodies, short legs and small, rounded ears. This family also includes mink, sables, badgers, wolverines, martens and skunks.

The ferret is the only domesticated member of the weasel family. Originally, ferrets were used to control rats and mice in granaries, but now many are kept as pets. Ferrets love to play and are very sociable. They have an undercoat of fine, soft, short hair and an outer layer of longer, coarser guard hairs. They come in various colors, but most have a raccoon-like mask and legs, tails and ears that are darker than the rest of the body.

The North American river otter is one of thirteen species of otters worldwide. It amuses itself either alone or in groups by rolling, sliding down snow or mud banks, and frolicking in the water. The otter is an excellent swimmer, feeding mainly on fish. Its thick, velvety fur ranges in color from dark brown to reddish or grayish brown, with lighter, silvery-colored hair on the belly, throat and cheeks.

Project 39

Ferret

Ferrets are domesticated mammals that have a long and slender body (14 to 16 inches [36 to 41cm]) covered with brown, black, white or mixed fur. They have rounded ears and a pointed nose, and their tails are about 5 inches (13cm) long.

MATERIALS

Surface

illustration board

Pencils

no. 2 pencil
ebony pencils

Other Supplies

kneaded eraser

Color Reference

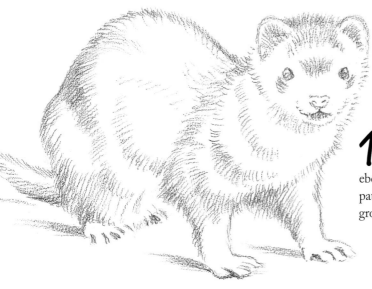

1 Establish the Form and Major Fur Patterns

Sketch the ferret lightly with a no. 2 pencil. With an ebony pencil sharpened to a fine point, sketch the main fur patterns, using parallel lines that go in the direction of fur growth. Use moderate pressure on the pencil.

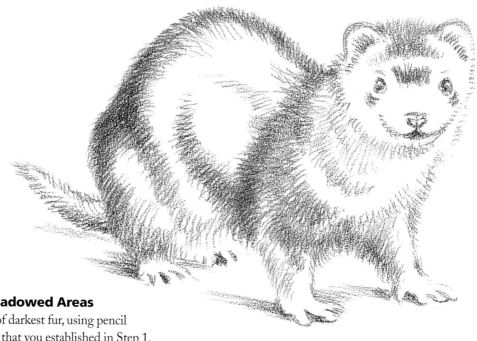

2 Begin Darkening Shadowed Areas

Begin to shade the areas of darkest fur, using pencil strokes that go in the direction that you established in Step 1. Gradually increase the pressure on your pencil as you shade. Gradual shading will allow you to make corrections more easily with your kneaded eraser as the drawing progresses and will give you smoother tones.

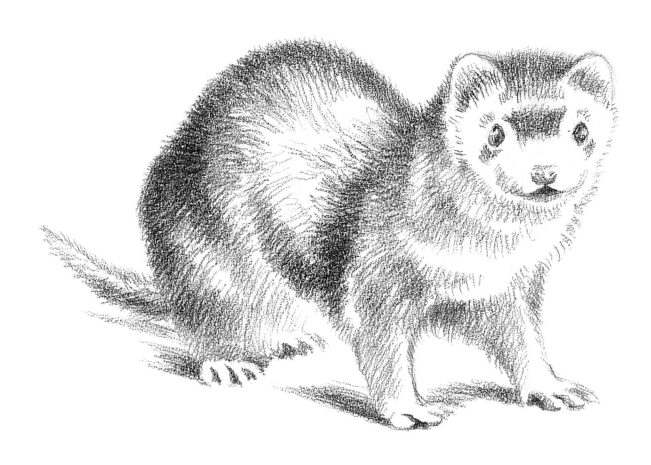

3 Continue Shading and Begin the Details
Continue to darken the shadowed and darker areas of fur, shading gradually to build up the dark value tones. Begin to add some fur detail in the lighter areas, using short, light-pressured pencil strokes.

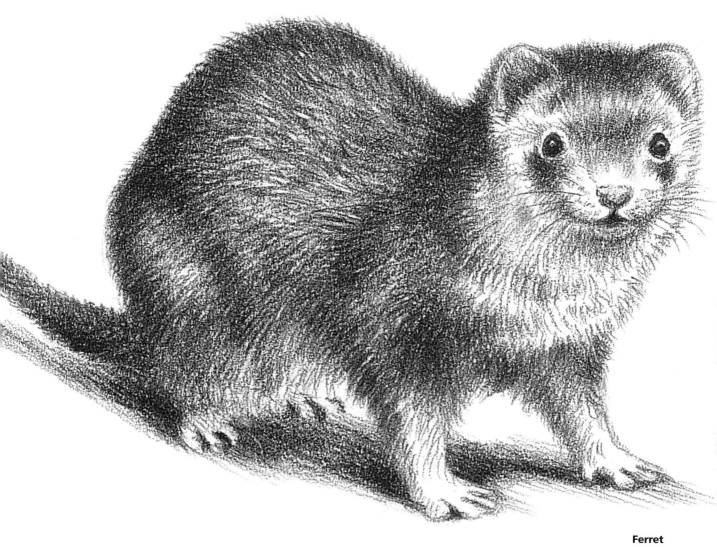

Ferret
Ebony pencil on illustration board
8" × 10" (20cm × 25cm)

4 Finish the Darkest Tones and Add the Finer Details

Keep shading the dark value areas to their final darkness. Begin to add the finer details. For the whiskers, use a sharp pencil and lightly draw a long, curving single line. (If a whisker comes out too dark, lighten it with your kneaded eraser. Form the kneaded eraser into a point and lightly press down on the line.) Continue to add fur detail to the lighter areas, using short, staggered strokes that are roughly parallel and follow the fur growth.

Otter

River otters are semiaquatic mammals common in North American waterways. They have webbed feet, long bodies (35 to 42 inches [89 to 107cm]) and long tails that are thick at the base, tapering to a point. The animals are versatile in the water and on land. They live in burrows close to the water's edge in rivers, lakes, swamps, coastal shorelines or estuaries.

MATERIALS

Paints

Burnt Sienna
Burnt Umber
Cadmium Orange
Cadmium Yellow Light
Raw Sienna
Titanium White
Ultramarine Blue

Brushes

no. 1 and 3 rounds
no. 2 filbert

Reference Photo

1 Establish the Form and the Basic Values

Sketch the otter lightly in pencil. With Burnt Umber thinned with turpentine and a no. 3 round, paint the main lines and the shadowed areas of the otter.

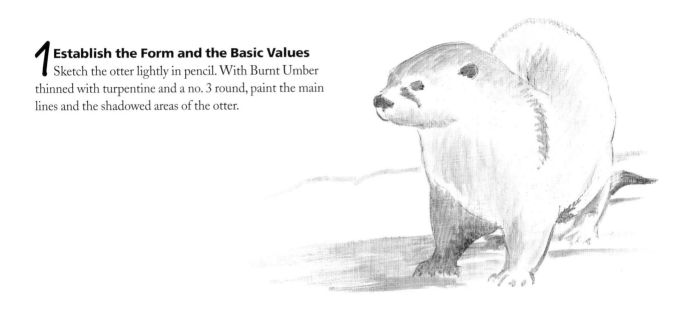

2 Paint the Dark and the Middle Value Brown Fur Colors

Mix the dark brown fur color with Burnt Umber, Burnt Sienna and Ultramarine Blue. With a no. 3 round, paint the darkest areas of fur. Use short, parallel brushstrokes that follow the general direction of fur growth.

Mix the middle value brown fur color with Burnt Sienna, Cadmium Orange, Titanium White and a moderate amount of Burnt Umber. Paint with a no. 3 round, using strokes that follow the fur pattern.

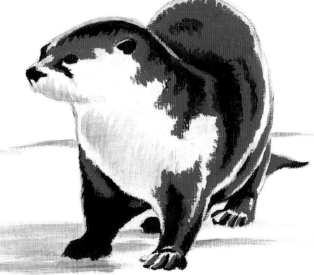

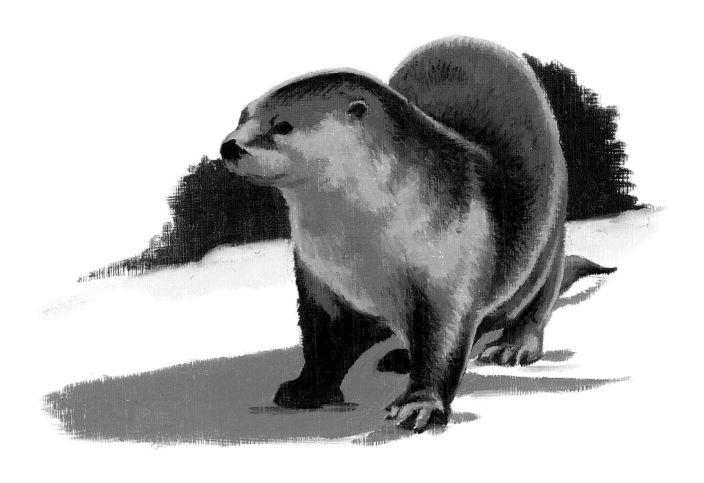

3 Paint the Lighter Colored Fur

Mix the bluish shadow color for the underside of the muzzle and the chest with Titanium White, Ultramarine Blue and Burnt Umber. Paint with a no. 3 round, switching to a no. 2 filbert for the broader areas of the chest. Mix the paler tan fur color for the highlighted areas, the chest and belly with Titanium White, Raw Sienna and a small amount of Cadmium Orange. Paint with a no. 3 round. Using separate brushes for each of the four fur colors you have already mixed (dark brown, middle value brown, bluish shadow color and tan color), begin to blend the edges where one color meets another. Hold all of your brushes while you work so you can easily switch from one to another. Blend with short, parallel strokes that follow the fur pattern.

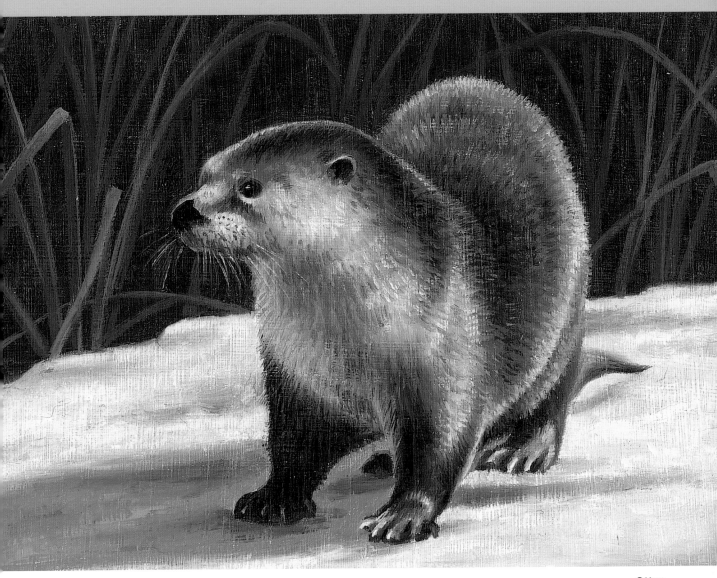

Otter
Oil on gesso-primed Masonite
8" × 10" (20cm × 25cm)

4 Blend and Add Detail

Add fur detail using separate no. 3 rounds for each color. Lightly paint short, parallel brushstrokes of dark brown over the bluish shadow on the chest. Use the same technique to add lighter fur detail by painting strokes of the tan color over the darker areas of fur, making sure to follow the hair pattern. Mix the fur highlight color with Titanium White and a touch of Cadmium Yellow Light. Paint the highlights around the top of the head and back with a no. 1 round, painting a smooth, fine line around the contour. Then use small, parallel strokes to blend the edges.

12 Woodland Animals

Living on a farm in Kentucky has given me the opportunity to see many kinds of wild animals that live in both open fields and wooded areas. White-tailed deer, chipmunks and black bears all are found in open woodlands and in fields bordered by trees. Sometimes these animals can also be found in more urban settings such as school campuses, golf courses, backyards and parks. For the black bear, I had to travel farther afield. I've observed and photographed black bears in parks, such as the Great Smoky Mountains National Park, and in zoos.

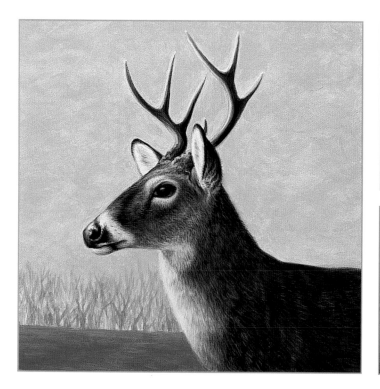

White-Tailed Deer

This young buck showed up on a thoroughbred horse farm in Midway, Kentucky. The deer had likely been raised by people since he had no fear of humans and would eat out of a horse bucket. The farm owners eventually gave him to a wild animal park to roam with a captive deer herd.

MATERIALS

Paints

Burnt Sienna

Burnt Umber

Cadmium Orange

Cadmium Red Medium

Hooker's Green Permanent

Naples Yellow

Titanium White

Ultramarine Blue

Brushes

no. 3, 4 and 10 rounds

no. 10 bright

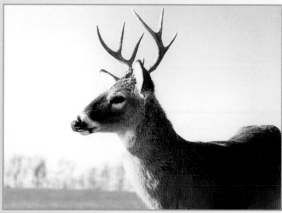

Reference Photo

1 Establish the Form

Lightly draw the deer in pencil on the panel, using a kneaded eraser to make corrections or lighten lines. Paint the basic lines and shading using a no. 10 round and Burnt Umber thinned with water.

2 Paint the Dark Values

Mix dark brown with Burnt Umber and Ultramarine Blue. Paint the darkest areas with a no. 10 round.

3 Paint the Middle Values

Mix a green field color with Hooker's Green Permanent, Burnt Umber, Cadmium Orange, Naples Yellow and Titanium White. Paint smooth, horizontal strokes with a no. 10 round.

To paint the deer's coat and antlers, mix medium brown with Burnt Umber, Burnt Sienna, Cadmium Orange and Titanium White. With a no. 10 round, use brushstrokes that follow the hair pattern.

219

4 Paint the Light Values

Mix pink with Titanium White, Naples Yellow, Cadmium Orange and small amounts of Cadmium Red Medium and Burnt Sienna. Paint parallel strokes inside the ears and around the nostril with a no. 10 round.

Mix a buff color for the highlighted areas of the coat with Titanium White, Cadmium Orange and Naples Yellow. Paint parallel strokes following the hair pattern with a no. 10 round. Blend the edges where colors meet with a separate no. 10 round and the adjacent color. Paint the antler highlights with buff and a no. 10 round.

Mix a blue shadow color with Titanium White and small amounts of Ultramarine Blue and Burnt Umber. Paint the shaded white areas (the muzzle, neck and base of the ear) with a no. 10 round, blending the edges with the adjacent color.

Mix a blue sky color with Titanium White, Ultramarine Blue and a small amount of Naples Yellow. Begin to paint with a no. 10 bright, using dabbing and semicircular strokes. Switch to a no. 10 round to paint around the deer's outline.

5 Finish the Sky, Add Highlights and Begin Detail

Mix a lighter sky color with a portion of the blue sky color and Titanium White. Paint the sky at the horizon line, blending upward with a separate no. 10 bright and the blue sky color.

Mix a warm white with Titanium White and a touch of Naples Yellow. Paint the highlights on the ears, head, neck and antlers with a no. 10 round. Blend the edges with the adjacent color.

Mix warm black with Burnt Umber and Ultramarine Blue. Add dark accents to the ears, antlers and muzzle, and darken the eye with a no. 10 round. Paint dark detail in the coat with a no. 10 round, using light pressured strokes that follow the hair pattern. Use medium brown to add detail to the buff and blue shadow color areas. Lightly blend with the adjacent color.

Nobility
Acrylic on Gessobord
8" × 10" (20cm × 25cm)

6 Paint the Finishing Details

Continue to add dark detail to the coat, blending and softening with the medium brown and a separate brush. Use medium brown to add detail to the reflective part of the neck, softening and blending with warm white. Add lighter detail with buff and a no. 10 round, blending and softening with a separate brush and medium brown.

Add knobby detail to the base of the antlers and strengthen highlights on the antlers' tines. Add detail to the muzzle and darken the underside of the chin. Paint a highlight in the eye with the blue sky color and a no. 3 round. Blend with warm black using a separate no. 3 round.

To paint the field's horizon, mix a light brown tree line color with Titanium White, Burnt Umber and a touch of Burnt Sienna. Paint with a no. 10 round, using light, sketchy strokes.

Mix a field highlight color with Titanium White, Hooker's Green Permanent, Cadmium Orange and Naples Yellow. Paint sketchy horizontal strokes over the grassy field. Add a few light touches of medium brown and blend with the green field.

Project 42

Chipmunk

Chipmunks are delightful creatures. They are also very difficult to photograph! I saw this chipmunk at the University of Kentucky campus where they are used to people feeding them and walking close by. It took a great deal of patience to get close enough to capture the elusive little animal on film.

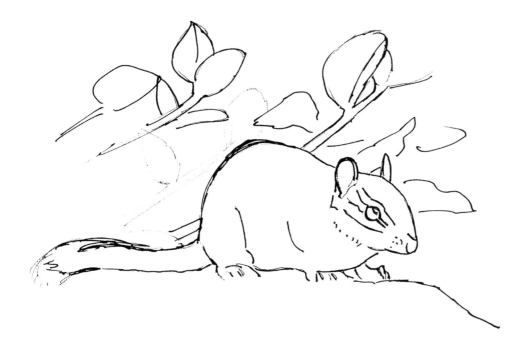

MATERIALS

Paints

Burnt Sienna

Burnt Umber

Cadmium Orange

Hansa Yellow Light

Hooker's Green Permanent

Naples Yellow

Raw Sienna

Titanium White

Ultramarine Blue

Brushes

no. 3 and 10 rounds

no. 2, 6 and 10 brights

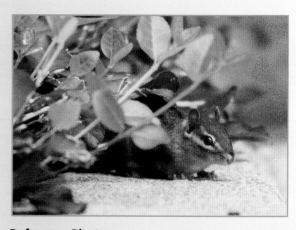

Reference Photo

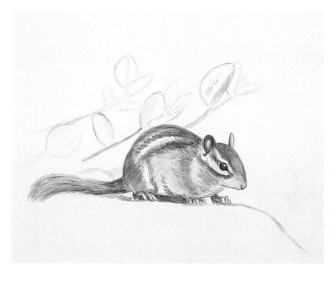

1 Establish the Form

Use a pencil to lightly draw the chipmunk, rock and plants onto the panel, using a kneaded eraser for corrections or to lighten lines. Use a no. 10 round and diluted Burnt Umber to paint the main lines. Switch to a no. 3 round for the smaller details.

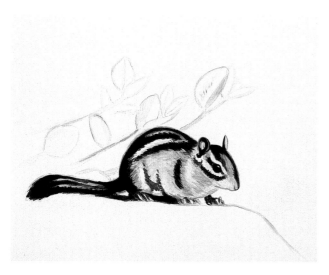

2 Paint the Dark Values

Mix warm black with Burnt Umber and Ultramarine Blue. Paint the back, tail and shadows of the chipmunk with a no. 10 round. Use a no. 3 round to paint the eyes, ears and other small details.

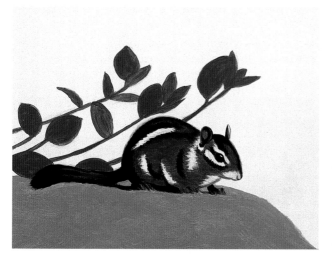

3 Paint the Middle Valus

Mix a reddish coat color with Burnt Sienna, Cadmium Orange and Burnt Umber. Paint with a no. 10 round, blending with warm black and a separate no. 10 round. Use strokes that follow the fur pattern.

Mix a green plant color with Hooker's Green Permanent, Cadmium Orange, Hansa Yellow Light and Titanium White. Paint the plants with a no. 10 round.

Mix a rock color with Titanium White, Raw Sienna and Burnt Umber. Paint the rock with dabbing strokes, using a no. 10 bright. Switch to a no. 10 round for around the chipmunk's feet and tail.

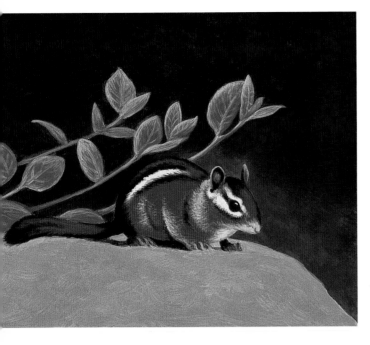

4 Paint the Light Values and the Background Color and Add Detail

Mix a dark green background color with Hooker's Green Permanent, Burnt Umber, Cadmium Orange and Ultramarine Blue. Mix a lighter green for the lower part of the painting by adding Titanium White to a portion of dark green. Paint with no. 10 brights, blending where one color meets the other and using dabbing strokes. Use no. 10 rounds for painting around the chipmunk and plants.

Mix a buff color for the lighter parts of the chipmunk's coat with Titanium White, Naples Yellow, Cadmium Orange and Raw Sienna. Using a no. 10 round, paint strokes that follow the fur pattern, then switch to a no. 3 round for the smaller details.

Mix a cream color for the lightest parts of the chipmunk with a portion of the buff color and Titanium White. Paint the white stripes on the body's side and around the eye with a no. 3 round.

Mix yellow-green for the highlights on the plants with some of the green plant color mixed with Titanium White, Hansa Yellow Light and a touch of Cadmium Orange. Using a no. 10 round, paint highlights and details with smooth strokes, blending with the green plant color.

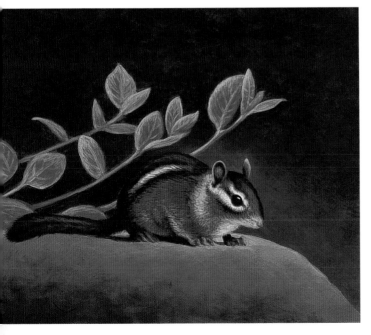

5 Add Detail to the Rock and Fur

Mix a medium rock shadow color with Titanium White, Raw Sienna and Burnt Umber. With dabbing strokes and a no. 10 bright, paint the lower part of the rock, leaving the upper part and the right edge the original color. Use a separate no. 10 bright and the rock color to blend where the two colors meet.

Mix a dark rock shadow color with a portion of the medium rock shadow color, Burnt Umber and Ultramarine Blue. Paint the lower edge of the rock with a no. 10 bright, blending up into the medium rock shadow color. Re-establish the rock color where needed, blending into the adjacent color with the dry-brush technique.

Using no. 3 rounds, add detail to the fur with warm black and the reddish and buff colors, blending with the adjacent color.

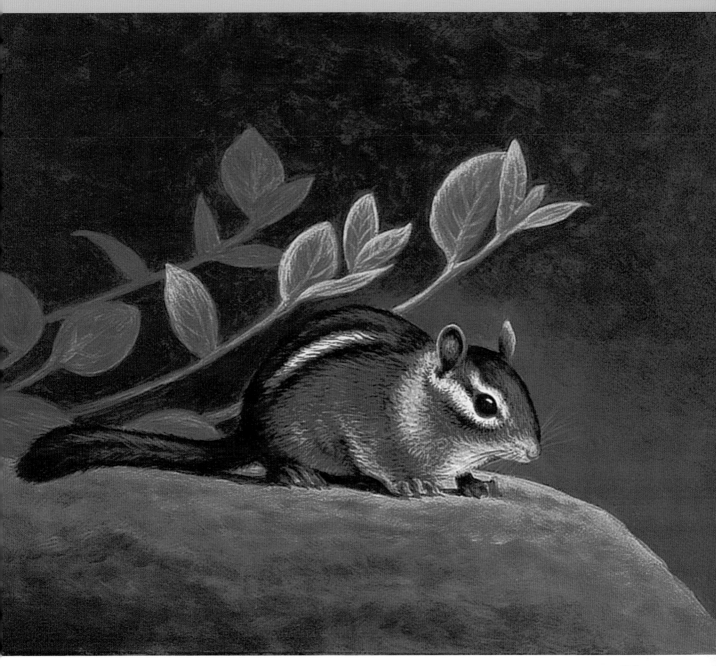

Chipper
Acrylic on Gessobord
8" × 10" (20cm × 25cm)

6 Paint the Finishing Details

Paint a thin glaze of the reddish color mixed with water over the plants with a no. 10 round. This will help integrate the chipmunk and background.

Use a no. 10 round to paint a glaze of dark green and water over the plants farthest in the background. Smooth the plants out by lightly painting over them with the lighter green and a no. 10 round. Re-establish highlights as needed with yellow-green.

Mix a rock detail color with some of the rock shadow and reddish colors. With a small amount of semi-dry paint on a no. 6 bright, use broken, dabbing strokes to create texture and shadow detail. With a no. 2 bright and the rock color, paint highlights using the same technique.

Paint the whiskers with very thin, slightly curving strokes, using a small amount of buff and a no. 3 round. For the portion of the whiskers that overlap the muzzle, use the rock detail color.

Black Bear

This black bear lived in an outdoor enclosure at the Arizona Sonora Desert Museum in Tucson, Arizona. I've seen wild black bears in the U.S. and Canada, but I have never been able to get a good reference photo in their natural habitat. Eventually, this bear struck a relaxed pose that I wanted to paint.

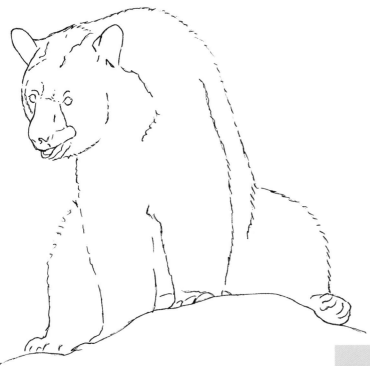

MATERIALS

Paints

Burnt Umber

Cadmium Orange

Cadmium Red Medium

Cerulean Blue

Hooker's Green Permanent

Naples Yellow

Raw Sienna

Titanium White

Ultramarine Blue

Brushes

no. 3 and 10 rounds
no. 5, 6, 8 and 10 brights

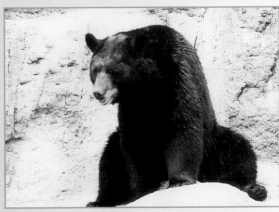

Reference Photo

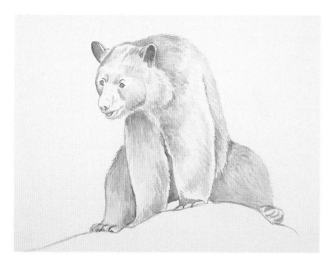

1 Establish the Form

Draw the bear lightly in pencil, using a kneaded eraser for corrections or to lighten lines. With diluted Burnt Umber and a no. 10 round, paint the main lines and the form of the bear.

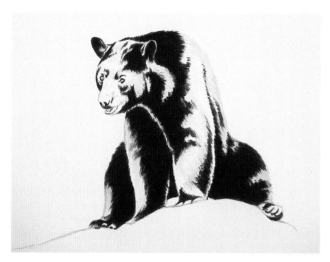

2 Paint the Dark Values

Mix a black fur color for the bear's coat with Burnt Umber and Ultramarine Blue. Paint the darkest parts of the coat with a no. 10 round, using strokes that follow the fur growth pattern. Switch to a no. 3 round for facial details. For darkest coverage, keep adding layers of paint after the first layer has dried.

3 Paint the Middle Values

Mix a slate blue fur color with Titanium White, Ultramarine Blue and Burnt Umber. Paint with a no. 10 round. Mix a grayish brown for the rock with Titanium White, Burnt Umber and Ultramarine Blue, and use a no. 10 bright.

Mix tan for the muzzle with Titanium White and Raw Sienna. Paint with a no. 10 round. Mix pink for the tongue with Titanium White, Cadmium Red Medium and Naples Yellow, and paint with a no. 3 round. Mix a lighter pink for the bear's lip by adding more Titanium White to the mixture.

Mix a brown eye color with Raw Sienna and Burnt Umber. With a no. 3 round, paint the eyes and define the mouth.

4 Paint the Background Color and Begin to Add Detail

Add warmth to the bear and rock by painting a thin (but not soupy) glaze of Burnt Umber over the entire area with a no. 6 bright. Paint thinly so that the original colors show through the glaze. When dry, add more glazes as needed.

With a no. 10 round and the black fur color, add detail to the lighter areas of the coat using strokes that follow the fur pattern. When adding detail to the muzzle, paint with very light-pressured strokes. Paint the highlighted part of the nose with the slate blue color, blending with the black fur color.

Mix a forest green color with Hooker's Green Permanent, Burnt Umber, Cerulean Blue and a small amount of Titanium White. To paint the background, use dabbing strokes with a no. 5 bright.

5 Add More Detail

Mix a dark slate blue fur color with a portion of the slate blue fur color, Burnt Umber and Ultramarine Blue. Lightly paint fur detail in the dark areas of the coat with a no. 10 round.

Mix a light highlight color with Titanium White and a touch of the slate blue fur color. Paint highlights in the coat sparingly with a no. 3 round, as well as in the eyes and on the face.

Mix a dark mossy green for the rock with a portion of forest green mixed with Burnt Umber and Ultramarine Blue. Use a no. 6 bright to paint broken, dabbing strokes.

Mix a pine branch color with Hooker's Green Permanent, Burnt Umber, Titanium White and Naples Yellow. Paint a few sketchy branches in the background using a no. 10 round.

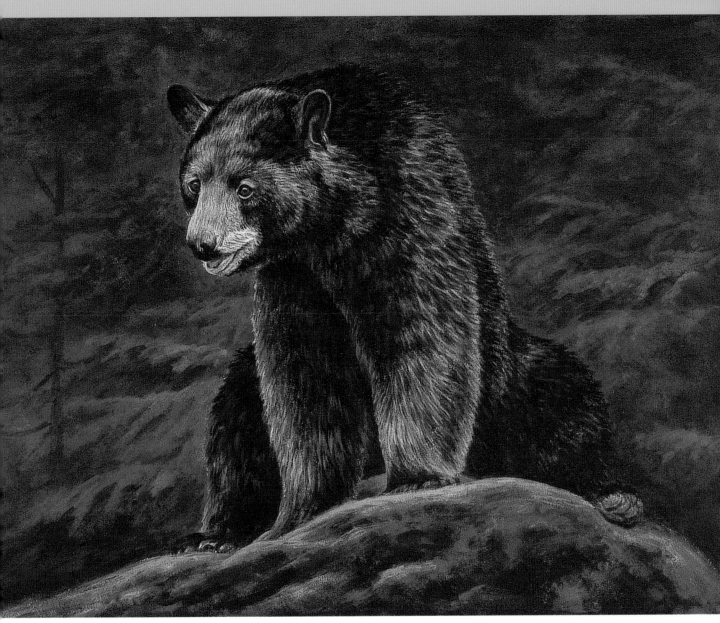

Rock Sitter
Acrylic on Gessobord
9" × 12" (23cm × 30cm)

6 Paint the Finishing Details

Mix a medium mossy green for the rock with Hooker's Green Permanent, Naples Yellow, Burnt Umber, Cadmium Orange and a small amount of Ultramarine Blue. Paint with a no. 6 bright, using a clean no. 6 bright for the dark mossy green. Paint with dabbing strokes, roughly blending where the two colors meet.

Mix a moss highlight color with a portion of the medium mossy green, Titanium White and Naples Yellow. Paint highlights with a no. 10 round, blending where the colors meet with separate no. 10 rounds for the medium and dark mossy greens.

Lightly paint some medium mossy green over the high-lighted parts of the bear's coat with a no. 10 round, following the original strokes.

With a no. 8 bright and the dark mossy green, paint darker areas over the background with loose, dabbing strokes. Allow some of the original color to show through in places. Tone down the pine branches with a glaze of diluted dark mossy green.

13 Exotic Animals

Animals are considered exotic when they are very different from the animals you are used to seeing. Animals from Africa, India or Madagascar seem exotic to me, while a raccoon or opossum might seem exotic to someone from one of these countries!

What compels me to paint these animals is their beauty, character and striking coat patterns. The elephant's wrinkled skin and trunk make it a very distinctive subject, while the giraffe's long neck and spots, the zebra foal's bold stripes and the lemur's large, luminous eyes are also fascinating and a lot of fun to paint.

Visit zoos and wild animal parks with your sketchbook and camera to familiarize yourself with animals from other parts of the world. Once you become accustomed to their different characteristics, you will realize that the same techniques used to paint animals that are more familiar to you are used to paint exotic animals as well.

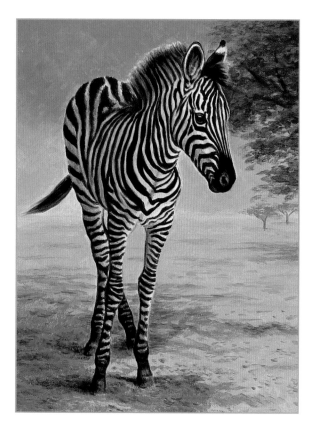

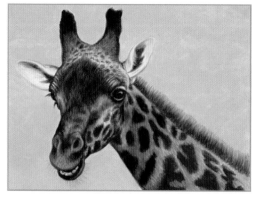

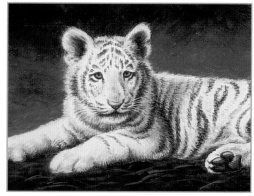

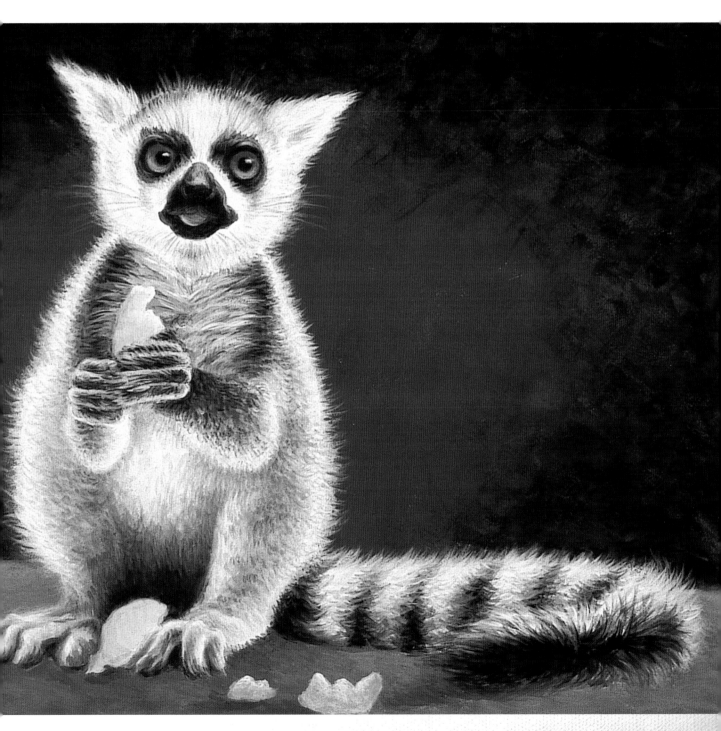

Project 44

Elephant

I met Conga at the Black Beauty Ranch in Athens, Texas, a sanctuary for abused and abandoned animals created by the animal rescue group the Fund for Animals. Female African elephants (unlike female Indian elephants) have tusks, but Conga had lost her left one at some point. While we were visiting, Conga played a game of catch with us through the fence: we tossed a stick and Conga picked it up and tossed it back.

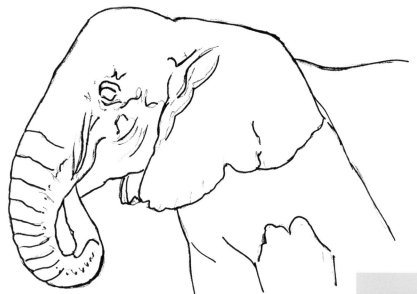

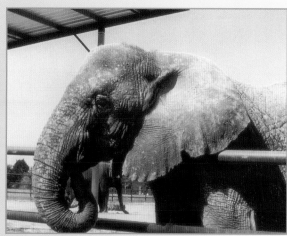

Reference Photo

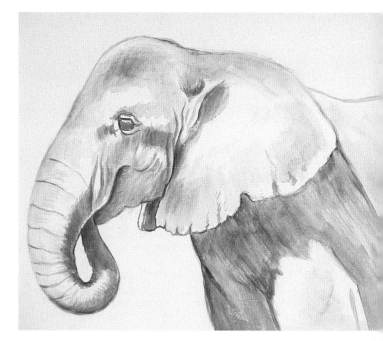

1 Establish the Form

Lightly sketch the elephant onto the panel with a pencil, using a kneaded eraser to make corrections or lighten lines. With a no. 10 round and diluted Burnt Umber, paint the basic lines and shading. Use a no. 10 bright for the broad areas.

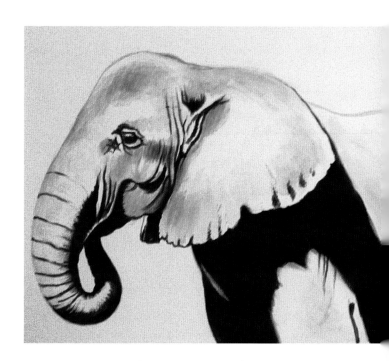

2 Paint the Dark Values

Create a dark brown with Burnt Umber, Burnt Sienna and Ultramarine Blue. Paint with a no. 10 round, switching to a no. 10 bright for broad areas. Use brushstrokes that follow the elephant's contours.

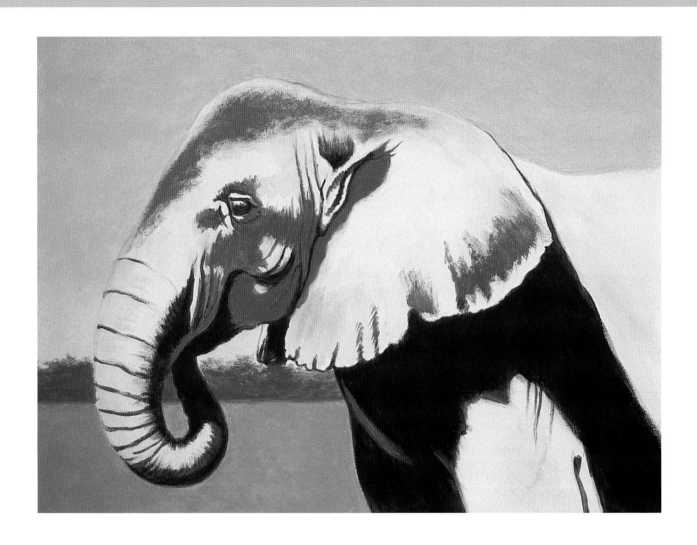

3 Paint the Middle Values

Mix medium brown for the middle value shadows with Titanium White, Raw Sienna, Burnt Umber and a small amount of Ultramarine Blue. Paint with a no. 10 round, using a no. 8 bright for the broader areas. Mix a reddish color for the top of the head with a portion of medium brown mixed with Titanium White, Burnt Sienna and Cadmium Orange. Use dabbing strokes with a no. 8 bright.

Mix a green tree color for the distant tree line with Hooker's Green Permanent, Cadmium Orange, Titanium White, Burnt Umber and Ultramarine Blue. Paint dabbing, horizontal strokes with a no. 10 round.

Mix a blue sky color with Titanium White, Ultramarine Blue and Naples Yellow. Paint dabbing strokes with a no. 12 bright. Mix light blue for the horizon with a portion of the blue sky color and Titanium White. Paint with a no. 10 bright, blending where it meets the blue sky color. Use a no. 3 round for the sky underneath the elephant's chin. Use a no. 10 round and the green tree color to blend where the tops of the trees meet the sky.

Mix a wheaten color for the dry grass with Titanium White, Raw Sienna and Naples Yellow. Paint dabbing strokes with a no. 10 bright; switch to a no. 10 round for around the elephant's outline. Use the green tree color to blend where it meets the wheaten.

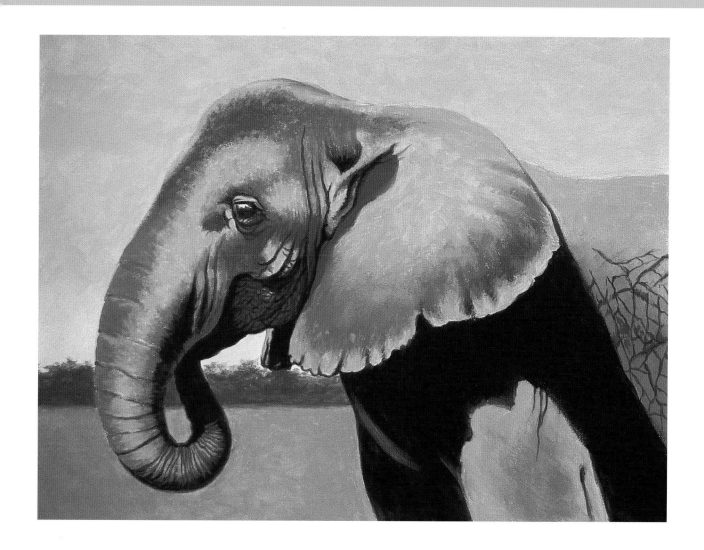

4 Paint the Lighter Values and Begin to Add Detail

Mix a brownish gray for the elephant's hide with Titanium White, Raw Sienna, Ultramarine Blue and Burnt Umber. Mix a lighter gray by adding more Titanium White to a portion of brownish gray. Paint the brownish gray areas with a no. 10 bright, using a no. 10 round for the smaller areas. Use the same size brushes to paint the lighter gray areas. Blend where the two colors meet, using a separate brush for each color.

With dark brown, blend where the shadowed areas meet the adjacent colors. Begin to paint the thin line detail in the elephant's hide using a no. 10 round and the reddish color.

TIP
Although I saw the elephant in the U.S., I wanted it to appear as though she were in her native Africa. I referred to a book about elephants to see how trees in Africa differed from those in the reference photo. They were more angular, with horizontal rather than rounded clumps of foliage.

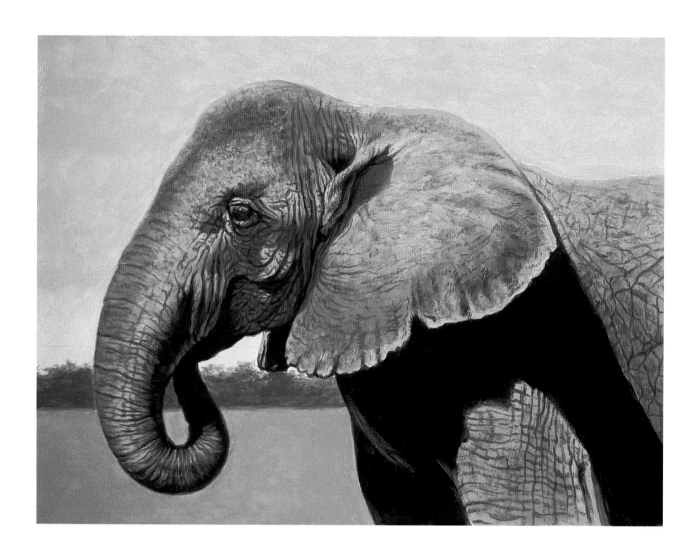

5 Add More Detail

Continue to paint detail on the elephant's hide. For lighter tone lines, use less paint. Darken the middle value shadowed areas as needed with dark brown and a no. 10 round. Paint over these areas with very light parallel strokes.

Use the reddish color to paint pebbly detail in the lighter areas of the elephant. Use the dry-brush technique with a no. 10 round to paint small, dabbing strokes. For broader areas such as the ears, leg and back, use a no. 8 bright.

TIP

Animal eyes, especially elephant eyes, often do not show up well in photos. Take close-up photos of the animal's eyes, or use a picture from your photo file or a book to see the detail.

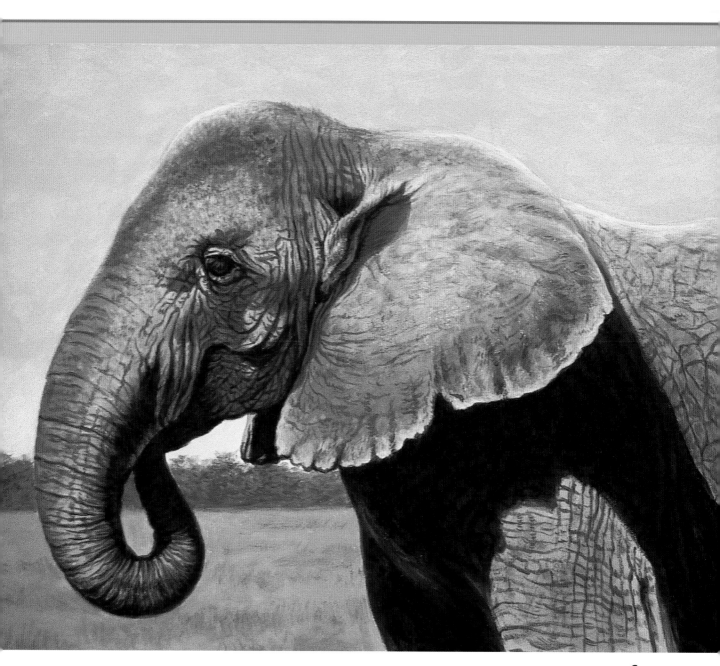

Conga
Acrylic on Gessobord
8" × 10" (20cm × 25cm)

6 Paint the Finishing Details

Mix a highlight color with Titanium White and a small amount of Naples Yellow. Paint highlights on the top of the head, ear and back. Paint highlights on the lower edge of the ear.

Mix a shadow detail color with a portion of medium brown and dark brown. Lightly paint detail in the dark shadowed areas with a no. 10 round. When dry, use a small amount of dark brown and a no. 3 round to lightly paint over and tone down the detail.

Mix the warm brown eye color with Burnt Sienna, Burnt Umber and small amounts of Cadmium Orange and Titanium White. Paint a small arc in the lower half of the eye with a no. 3 round, blending with a separate brush and dark brown.

Mix the blue-gray eyelash color with a bit of the blue sky color mixed with medium brown. Paint the eyelashes with a no. 3 round, blending with dark brown.

Mix a tree highlight color with a portion of the green tree color, Titanium White and Naples Yellow. Lightly paint detail with a no. 10 round, using quick, dabbing strokes.

Mix a dry grass shadow color with Titanium White, Burnt Umber and Raw Sienna. Use a small amount of paint on a no. 8 bright for the shadows, painting dabbing strokes.

237

Project 45

Giraffe

I have always been fascinated by giraffes. As a child on my first trip to a zoo, I remember that the first animal I wanted to see was a giraffe. I was not disappointed! I observed this giraffe at the Cincinnati Zoo.

MATERIALS

Paints

Burnt Sienna

Burnt Umber

Cadmium Orange

Naples Yellow

Raw Sienna

Titanium White

Ultramarine Blue

Brushes

no. 3 and 10 rounds

no. 12 bright

Reference Photo

1 Establish the Form

Lightly sketch the giraffe onto your panel in pencil, using a kneaded eraser to make corrections or lighten lines. With a no. 10 round and diluted Burnt Umber, paint the main lines and shaded areas.

2 Paint the Dark Values

Mix a warm black with Burnt Umber and Ultramarine Blue. With a no. 10 round, paint the tops of the horns, the lower lip and the shadows inside the ears.

Mix dark brown color with Burnt Umber, Burnt Sienna and Ultramarine Blue. With a no. 10 round, paint the eyes, the facial markings, the spots in shadow on the neck and the base of the mane. For good, dark coverage, paint more layers after the first layer is dry.

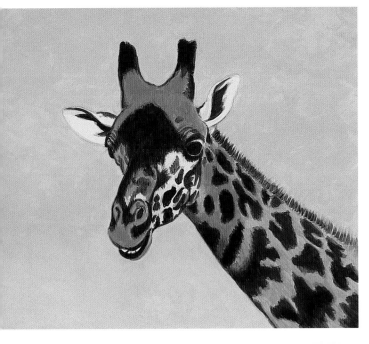

3 Paint the Middle Values

Mix reddish brown for the spots that are not in shadow with Burnt Umber, Burnt Sienna, Cadmium Orange and a small amount of Ultramarine Blue. Paint with a no. 10 round.

Mix a buff color with Titanium White, Naples Yellow, Cadmium Orange and Raw Sienna. Mix a dark buff color with the same colors, plus Burnt Sienna and Raw Sienna. Paint the darker areas of the coat between the spots with dark buff, and the lighter areas with buff. Use a no. 10 round to paint strokes that follow the hair pattern.

Mix a blue sky color with Titanium White, Ultramarine Blue and a touch of Cadmium Orange. Paint dabbing strokes with a no. 12 bright; switch to a no. 10 round for around the giraffe's outline. Mix a lighter blue sky color with a portion of blue sky and Titanium White. Paint the lower quarter of the sky, blending with a separate brush and the blue sky color.

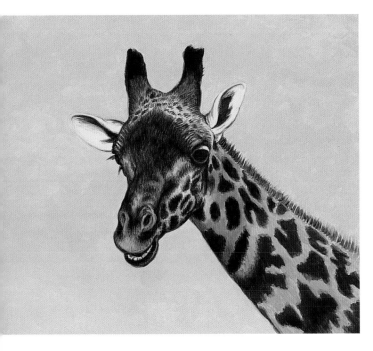

4 Paint the Light Values and Add Detail

Mix an off-white for the ear, face and forehead with Titanium White and a small amount of Raw Sienna. Paint with a no. 10 round. Paint the teeth with a no. 3 round.

Paint detail in the ears with separate no. 3 rounds and warm black, reddish brown and off-white, blending where the colors meet.

Mix a shadow color with Titanium White, Raw Sienna and a bit of Ultramarine Blue. Paint the lighter areas of the head with a no. 10 round, blending with a separate brush and the adjacent color.

With dark brown and a no. 3 round, paint detail in the upper forehead, muzzle and horns with small, thin strokes. Use the buff color and a no. 3 round to paint detail in the dark part of the forehead, blending with dark brown and a separate no. 3 round.

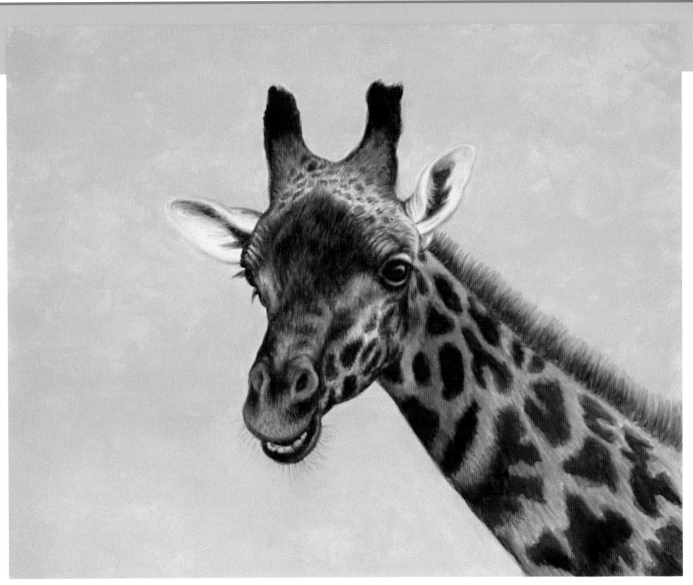

Elegance
Acrylic on Gessobord
9" × 12" (23cm × 30cm)

5 Paint the Finishing Details

Integrate the spots on the neck with the buff base color by feathering the edges of the spots with a no. 10 round and dark brown in the shadowed areas, and reddish brown in the more lighted areas. Use a small amount of paint with light-pressured strokes. Add detail to the buff and dark buff areas using the spot colors (dark brown and reddish brown) with small, light strokes. Use the same technique to integrate spots on the giraffe's head.

Lengthen the mane with a no. 10 round and thin strokes of reddish brown. Add some darker strokes with dark brown. Highlight the upper edge of the mane and reinforce the top line of the neck with buff.

Paint a highlight in the eye with the light blue sky color, blending the edges with a separate brush and dark brown. Reinforce the lower lid with dark buff, then use buff to carefully highlight the lowest part of the lid.

Paint detail on the muzzle with the reddish color and a no. 3 round, using short strokes. Tone down the teeth with buff, blending with dark brown. Paint a few hairs in the ears that overlap the shadows in the ears with a no. 3 round and a bit of off-white mixed with a bit of the shadow color.

Mix a whisker color with dark brown and the blue sky color. Paint lightly with a no. 3 round, toning down as needed with a separate brush and the blue sky color.

Project 46

Zebra Foal

This beautiful zebra foal was born at the Cincinnati Zoo. As I sketched and photographed the foal, I was struck by the interesting design its stripes created.

MATERIALS

Paints

Burnt Sienna

Burnt Umber

Cadmium Orange

Hansa Yellow Light

Hooker's Green Permanent

Naples Yellow

Raw Sienna

Red Oxide

Titanium White

Ultramarine Blue

Brushes

no. 1, 3 and 10 rounds

no. 6, 8 and 12 brights

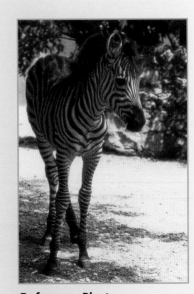

Reference Photo

242

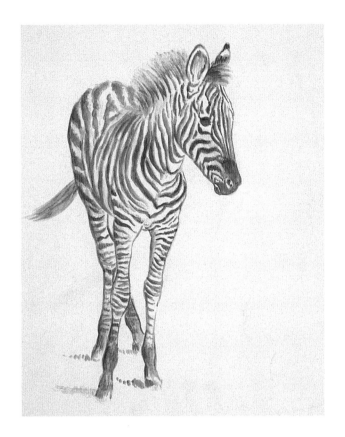

1 Establish the Form

Lightly draw the zebra foal onto your panel in pencil, using a kneaded eraser to make corrections or lighten lines. With a no. 10 round and diluted Burnt Umber, paint the stripes and other dark areas.

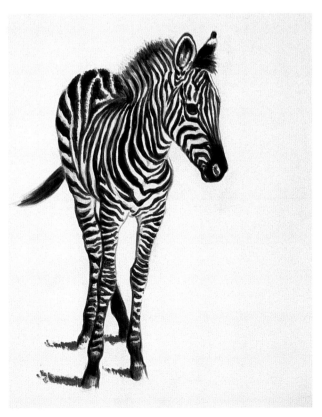

2 Paint the Dark Values

Mix warm black with Burnt Umber and Ultramarine Blue. Paint the stripes with a no. 10 round, making sure they follow the foal's contours. For good, dark coverage, add a second coat when dry. For the narrower stripes and smaller details, use a no. 3 round. Paint the stripes with smooth strokes. Use small, chopping strokes to paint the fuzzy hair on the foal's back and rump. Paint the dark parts of the ears, mane, muzzle, tail and lower legs.

Mix red-brown with Burnt Umber, Raw Sienna and a touch of Red Oxide. Paint the eye with a no. 3 round. Paint the shadows on the ground with a no. 10 round using choppy strokes.

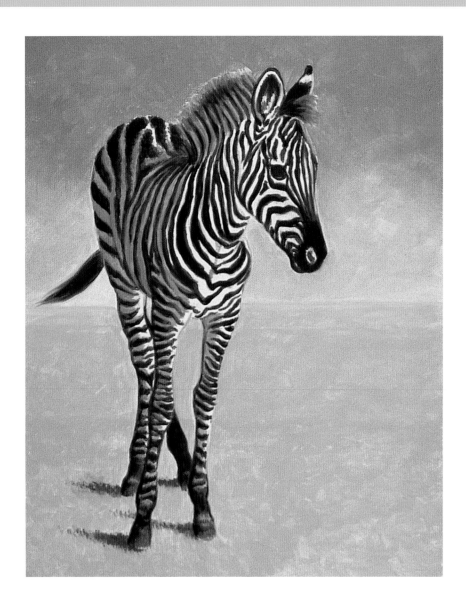

3 Paint the Middle Values

Mix a warm cream for the shadowed areas of the coat with Titanium White, Raw Sienna, Burnt Sienna and Cadmium Orange. Paint in between the black stripes with a no. 10 round.

Mix a wheaten color for the ground with Titanium White, Raw Sienna and Hansa Yellow Light. Paint dabbing strokes with a no. 8 bright.

Mix a blue sky color with Ultramarine Blue, Titanium White and a touch of Naples Yellow. Mix a lighter blue by adding more Titanium White to a portion of the blue sky color. Paint the blue sky color with dabbing strokes using a no. 12 bright; start at the top of the painting. With a separate no. 12 bright and the lighter blue, paint from the horizon upwards, blending with the blue sky color. Use a no. 10 round to paint around the foal's outline. Blend where the horizon meets the sky with separate brushes for light blue and wheaten.

Mix the grayish hoof color with Titanium White, Ultramarine Blue and Burnt Umber. Paint with a no. 10 round, blending where it meets the shadowed parts of the hooves with a no. 3 round and warm black. Mix a hoof highlight color with a small portion of the gray hoof color and Titanium White. Paint with a no. 3 round.

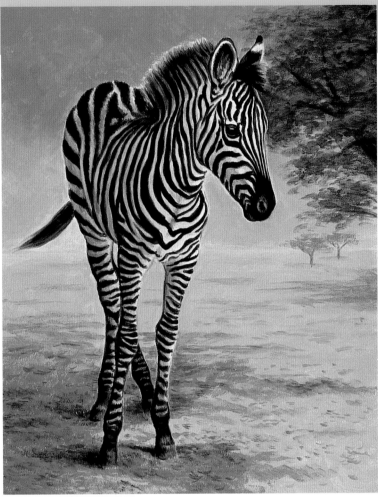

Little Striped One
Acrylic on Gessobord
12" × 9" (30cm × 23cm)

4 Paint the Light Values and the Finishing Details

Mix a lighter cream with a portion of warm cream and Titanium White. Paint the lighter areas of the zebra with a no. 10 round, blending into the warm cream.

Paint highlights around the nostril with a no. 3 round and warm cream, blending with the warm black. With warm black and a no. 10 round, re-establish and refine the stripes. Use a no. 3 round for the narrower stripes.

Using a no. 3 round, paint a highlight in the eye with a small arc of Titanium White. With a no. 3 round, paint the eyelashes and the lower eyelid with a bit of blue sky color, using small, parallel strokes. Paint the bar-shaped pupil with warm black.

Mix a blue shadow color for the ground with Titanium White, Ultramarine Blue, Burnt Umber and a touch of Cadmium Orange. Paint with a no. 8 bright, forming parallel, dabbing strokes. Use a no. 10 round to paint between the legs.

Mix a darker red-brown for the foal's shadow on the ground with red-brown and warm black. Paint with the dry-brush technique and a no. 10 round. Use a no. 8 bright to blend into the blue shadow color. Add detail to the wheaten ground with a no. 10 round and a small amount of dark red-brown, blending with the wheaten.

Mix a tree branch color with Burnt Umber, Ultramarine Blue and Titanium White. Paint the branches thinly with a no. 10 round. Mix a green tree color with Hooker's Green Permanent, Burnt Umber, Titanium White and a bit of Cadmium Orange. Use a no. 6 bright to paint the foliage with dabbing strokes.

Paint a very thin glaze of diluted Burnt Umber over the shaded parts of the foal with a no. 6 bright, using a very small amount of the glaze. Re-establish the highlights as needed with the lighter cream and a no. 10 round.

Add small stripes to the lower left hind leg with a no. 3 round and warm cream. When dry, glaze with diluted Burnt Umber. Paint a few light strokes of the blue shadow color on the tail with a no. 3 round, blending with warm black.

Add highlights to the head and chest with Titanium White and a no. 3 round. Re-establish and darken the black stripes as needed.

Mix a light green highlight color for the tree with a portion of the green tree color, Titanium White and Hansa Yellow Light. Paint with a no. 6 bright, using a small amount of paint and light, dabbing strokes.

Project 47

Ring-Tailed Lemur Baby

I met this baby ring-tailed lemur at the World Wildlife Exhibition in Gatlinburg, Tennessee, where I was showing my artwork. He was very cute with large eyes, a bushy tail and humanlike hands. The high point was when the baby lemur sat on my shoulder!

Reference Photo

1 Establish the Form

Lightly draw the baby lemur onto the panel in pencil, using a kneaded eraser to correct mistakes or lighten lines. With a no. 10 round and diluted Burnt Umber, paint the basic lines and shading.

2 Paint the Dark Values

Mix warm black with Burnt Umber and Ultramarine Blue. Paint the dark rings around the eyes, the pupils, the muzzle, the tail stripes and the shadows between the fingers and toes with a no. 10 round. For good coverage, paint two or three layers, allowing the paint to dry in between layers.

Mix dark brown with Burnt Umber, Burnt Sienna and Ultramarine Blue. Paint the dark shadow between the feet with a no. 10 round.

3 Paint the Background and the Middle Values

Mix reddish brown for the background with Burnt Sienna, Burnt Umber and Raw Sienna. Using separate no. 12 brights for each color, paint dark brown around the edges and reddish brown around the lemur. Use dabbing strokes, blending where the two colors meet.

Paint the eyes with reddish brown and a no. 3 round, blending the edges of the pupils with a separate brush and warm black.

Mix gray with Titanium White, Ultramarine Blue, Burnt Umber and a small amount of Burnt Sienna. With a no. 10 round, paint the fingers, the forearms, the top of the head and the shadows inside the ears.

Mix light brown for the fur with Titanium White, Raw Sienna and Burnt Sienna. Paint with a no. 8 bright.

Mix pink for the tongue with Cadmium Red Medium, Titanium White, Raw Sienna and Cadmium Orange. Paint with a no. 3 round.

Mix warm gray for the rock with Titanium White, Ultramarine Blue and Burnt Umber. Paint with a no. 12 bright, using a no. 10 round for painting around the contours of the feet and tail.

4 Paint the Light Values and Begin to Add Detail

Mix a yellow color for the fruit with Hansa Yellow Light, Titanium White and Cadmium Orange. Paint with a no. 10 round.

Make a warm white with Titanium White and a touch of Hansa Yellow Light. Paint with a no. 10 round with strokes following the fur pattern. Blend with a separate brush and the adjacent color.

Use warm gray and a no. 10 round to paint subtle shadows on the chest, head and toes. Paint fuzzy hairs from the outline of the lemur that overlap the background with slightly curving strokes of varying lengths that go in different directions.

Mix a shadow color for the toes and fur with portions of reddish brown, dark brown and light brown. Paint shadows on the toes, then begin to paint shadow detail in the fur.

5 Add More Detail

With warm black and a no. 10 round, add detail to the tail with long strokes and to the fingers with short strokes. Using separate no. 10 rounds for each color, use warm black, light brown and warm white to add detail to the fur with overlapping strokes.

Use the same technique to add detail to the chest with warm gray, warm black and warm white.

With separate no. 3 rounds for warm black and warm white, refine and add detail to the fingers. Paint the feet with warm white and light brown, using warm black for shadows and detail.

Darken and refine the shape of the muzzle and dark eye rings with warm black and a no. 10 round. Add fur detail to the head with light brown and warm white.

TIP

Painting with thicker paint will make the highlight pop out. This technique is called impasto.

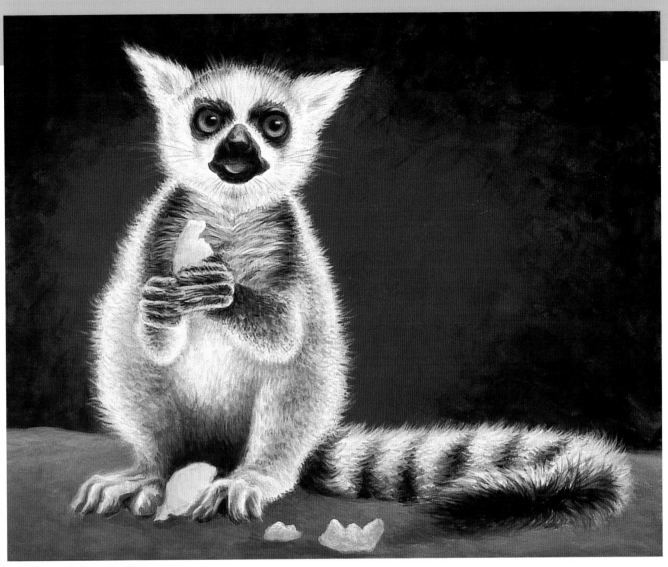

Afternoon Snack
Acrylic on Gessobord
9" × 12" (23cm × 30cm)

6 Paint the Finishing Details

Mix a blue highlight color for the nose with a warm white mixed with a touch of Ultramarine Blue. Mix a pinkish highlight color for the tongue with a bit of pink and warm white. Paint both with separate no. 3 rounds.

Mix a warm tan for the eyes with Titanium White, Raw Sienna and a touch of Cadmium Orange. Paint with a no. 3 round, blending with reddish brown and a separate brush. When dry, paint a very thin glaze of Cadmium Orange and water over the warm tan. Paint highlights in the eyes with small arcs of Titanium White using a no. 3 round.

Paint eyelid detail in the black eye rings with the blue highlight color and a no. 3 round. Blend with warm black.

Paint a glaze of Cadmium Orange and water over the yellow fruit. With a no. 3 round, add detail to the head with light brown, blending with a separate brush and warm white. Add detail to the feet using no. 3 rounds with light brown, warm white and warm black. Add highlights to the fruit between the paws with warm white.

Mix a rock shadow color with a portion of reddish brown, light brown and dark brown, and paint with a no. 8 bright from the bottom on up. When dry, paint a couple more pieces of fruit near the lemur's feet.

Paint cast shadows from the tail and fruit on the rock with some dark brown mixed with a bit of the rock shadow color. Mix a whisker color with a bit of gray and warm gray. Use a no. 3 round and a small amount of paint to make feathery, slightly curving strokes from the eyebrows, cheeks and chin.

251

14 Birds

Birds are found everywhere. Many species have adapted to city life, while others can be viewed and photographed in pet shops, zoos, parks and farms, and, of course, at bird feeders. When photographing birds, you need to be quick—birds seldom hold a pose and take off in an instant! One of the main considerations when painting birds is to get the feather pattern right. Otherwise, birds are fairly easy to draw, with their rounded, simple shapes. I enjoy painting birds because they are such beautiful creatures.

There is a great deal of variety in the world of birds, but all are enjoyable to paint, from the small brown sparrow to the showy bird of paradise. In this chapter, I've chosen birds that are both colorful and unusual.

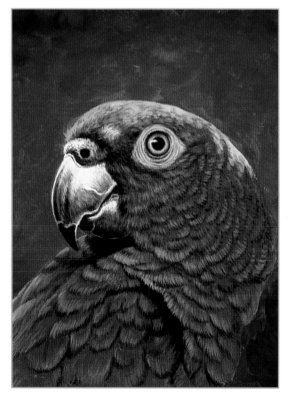

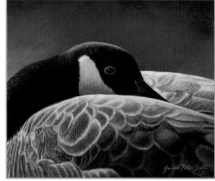

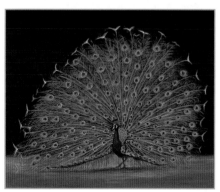

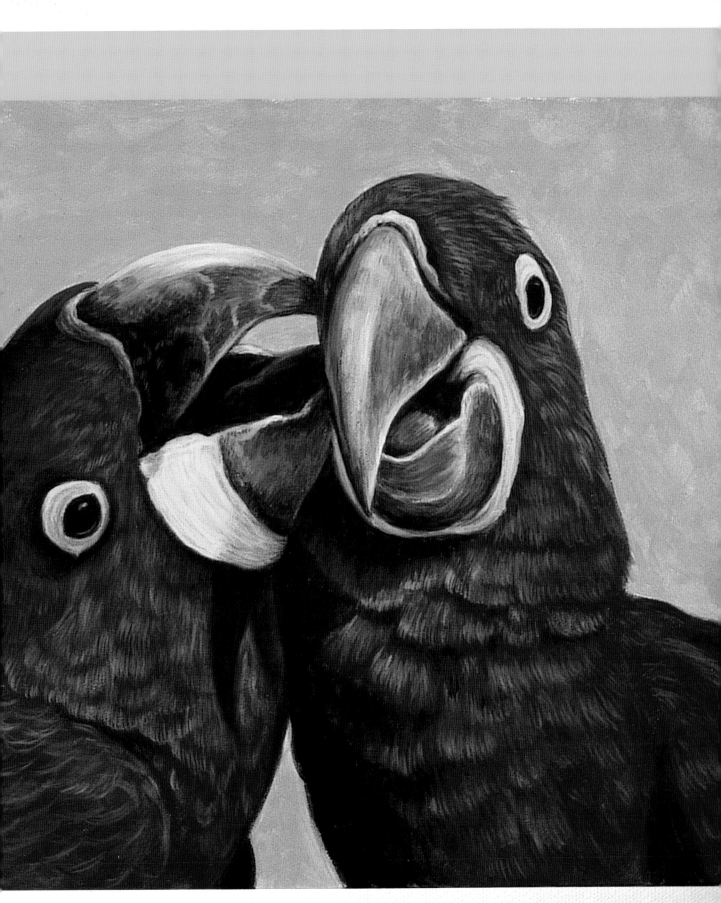

Peacock

The Indian Blue peacock has brilliant, iridescent blue-green plumage. The tail, also called the train, has a series of feathers called eyes, which are seen when the tail is fanned. This magnificent peacock lives at the Primate Rescue Center in Jessamine County, Kentucky. The peafowl roam freely around outdoor enclosures for monkeys and apes.

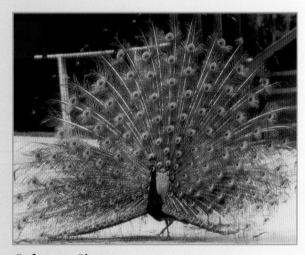

Reference Photo

1 Establish the Form

Lightly sketch the peacock onto the panel in pencil, using a kneaded eraser for corrections or to lighten lines. With diluted Burnt Umber and a no. 10 round, paint the main lines of the peacock.

2 Paint the Background and Body Colors

Mix warm black with Ultramarine Blue and Burnt Umber. Paint the dark shadows on the bird's body and the dark lines on the underside of the tail with a no. 10 round. Mix bright blue for the bird's body with Ultramarine Blue and Titanium White. Paint with a no. 3 round, blending with the shadowed areas.

Mix dark green for the background with Hooker's Green Permanent, Burnt Umber and Ultramarine Blue. Paint dabbing strokes with a no. 12 bright, switching to a no. 6 bright to paint around the feather patterns. Use a no. 10 round to paint around the peacock's body. After the first layer of dark green has dried, strengthen it with a second coat.

3 Paint the Foreground and Feather Patterns

Mix a dark brown for the bird's lower body, legs and feet with Burnt Umber, Ultramarine Blue and Raw Sienna. Paint with a no. 3 round.

Make a shadow color for the bird's shadow on the ground with Burnt Umber and Raw Sienna. Paint horizontal strokes with a no. 10 round.

Create a golden tan for the ground with Titanium White, Raw Sienna and Naples Yellow. Paint smooth, horizontal strokes with a no. 12 bright; switch to a no. 6 bright to paint around the bird. Blend where the shadow and dark green meet the golden tan, using separate no. 6 rounds for each color.

Paint the dark line at the underside of the tail with dark green and a no. 10 round. Mix Hooker's Green Permanent, Hansa Yellow Light, Cadmium Orange and Titanium White to create light green for the mass of feathers behind the neck.

Paint with a no. 10 round. With the same color and a no. 3 round, paint the feather eyes.

Re-establish the legs and feet with dark brown and a no. 3 round. Darken the bird's shadow on the ground with a few horizontal strokes of dark brown.

Make a light tan for the feather shafts with a portion of golden tan and Titanium White. Paint the shafts with a no. 3 round, using long, thin, slightly curving strokes; use just enough water to make the paint flow. Use the same color to paint the beak. More than one coat is needed for good coverage. Make any corrections, such as shafts that come out too thick or uneven, with dark green.

Mix a highlight color for the bird's body with some bright blue and Titanium White. Paint with a no. 3 round, blending with the adjacent color. Re-establish the white marking on the head with Titanium White. Add a tiny dot of Titanium White to the eye for the highlight.

4 Add Feather Detail and Modify the Foreground

Darken the golden tan foreground with a glaze of diluted Burnt Umber. Paint horizontal strokes with a no. 12 bright. When dry, create shadows at the lower part of the foreground and darken the bird's shadow on the ground with a glaze of Ultramarine Blue and water.

Make a brick red color for the feather eyes with Red Oxide, Titanium White and Naples Yellow. Paint the inside of the feather eyes with a no. 3 round, leaving a border of green. Re-establish the green borders as needed.

Create medium blue for the feather eyes with Ultramarine Blue and Titanium White. Paint small spots inside the brick red areas at the lower part of the feather eyes with a no. 3 round.

With dark green and a no. 3 round, sharpen and define the V-shaped feathers at the edges of the tail.

5 Paint More Feather Detail

With a glaze of diluted dark green, use a no. 10 round to slightly darken the feather shafts. Using light green and a no. 3 round, paint a fringe from the tip of each feather eye with small strokes. Use the same color and brush and a small amount of paint to create the feather patterns from each shaft with thin, parallel strokes. The overlapping lines will create a crisscross pattern.

With a no. 3 round, paint a thin glaze of Hansa Yellow Light and water over the mass of feathers behind the neck.

Reinforce the dark lines on the underside of the tail with a no. 3 round and dark green. Make medium green with some dark green, light green and Hansa Yellow Light. Paint along the underside of the tail with a no. 3 round, blending where it meets the dark green with a separate brush and dark green.

Paint the feather detail for the feathers overlapping the golden tan with dark green and a no. 3 round, toning down as needed with light green. Paint a thin fringe of feathers hanging down from the underside of the tail with dark green and a no. 3 round, using a small amount of diluted paint.

Fan Dancer
Acrylic on Gessobord
8" × 10" (20cm × 25cm)

6 Paint the Finishing Details
Use bright blue and a no. 3 round to paint the rounded dark spots on the feather eyes. When dry, reinforce as needed with a second coat. Paint the crest of feathers above the head with bright blue.

Use light green to paint fringes from any of the feather eyes you may have missed in the previous step.

Project 49

Parrot

This Yellow-Naped Amazon was part of a group of exotic animals shown at the World Wildlife Exposition in Gatlinburg, Tennessee, where I was also exhibiting my wildlife art. I was impressed by this parrot's intelligent eyes, as well as its beautiful feathers.

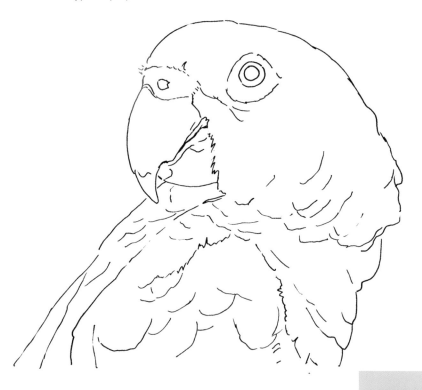

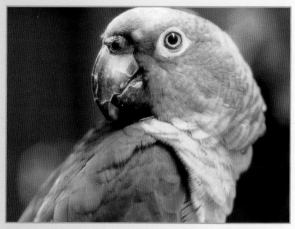

Reference Photo

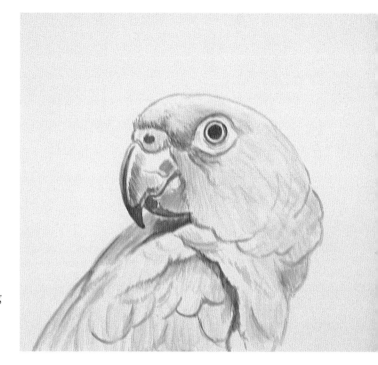

1 Establish the Form
Lightly sketch the parrot onto your panel in pencil, using a kneaded eraser to lighten lines or correct mistakes. With a no. 10 round and diluted Burnt Umber, paint the basic lines and shading of the parrot.

2 Paint the Dark Values and Background
Mix warm black for the darkest parts of the parrot with Burnt Umber and Ultramarine Blue. Paint with a no. 10 round, switching to a no. 3 round for the dark ring around the eye.

Make a cool red background color with Red Oxide, Burnt Umber and Ultramarine Blue. Then create a lighter red background color using the same colors plus Raw Sienna, Cadmium Orange and Titanium White. Paint with separate no. 10 brights, starting with the darker color at the lower part of the painting. Blend up into the lighter red with dabbing strokes.

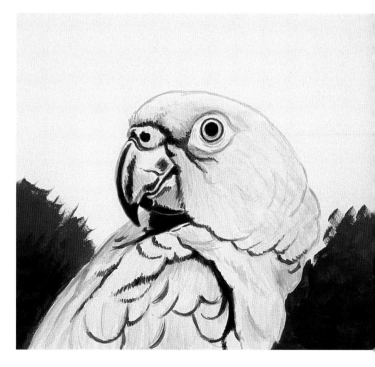

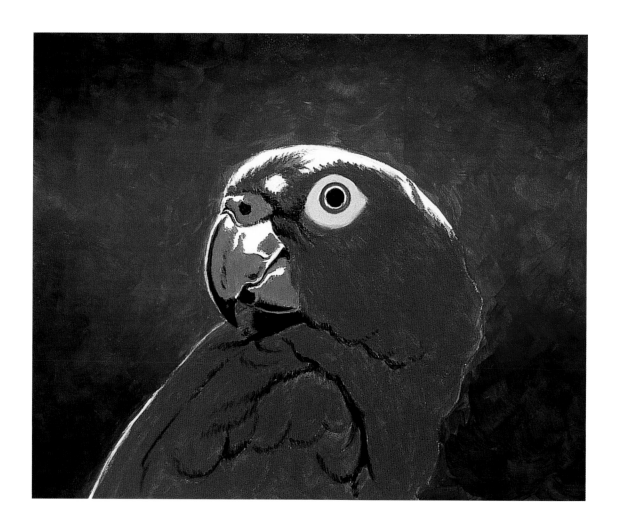

3 Finish the Background and Paint the Middle Values

Mix a green feather color with Hooker's Green Permanent, Cadmium Orange, Titanium White and Hansa Yellow Light. Paint with a no. 8 bright, using strokes that follow the feather pattern. Re-establish the main shadow lines in the feathers with warm black and a no. 10 round.

Mix gray with Titanium White, Burnt Umber and Ultramarine Blue. Paint the beak and the cere (the membrane at the base of the beak) with a no. 10 round. Mix blue for the ring around the eye with Titanium White, Ultramarine Blue and a small amount of Burnt Umber. Paint with a no. 10 round. Mix dark orange for the eye with Red Oxide, Cadmium Orange and a bit of Burnt Umber. Use a no. 3 round to paint around the outer edge of the eye.

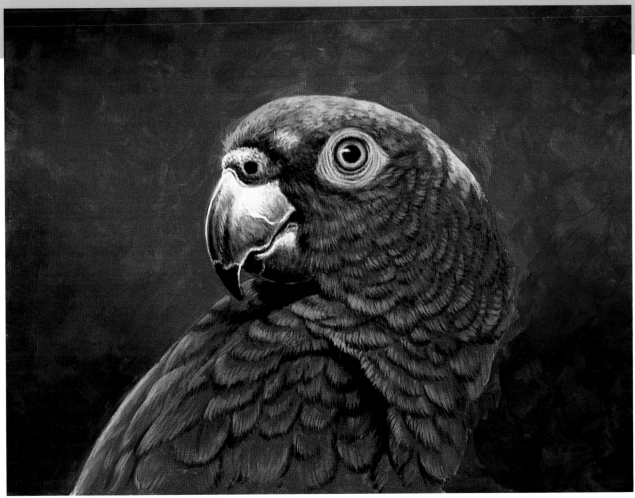

A Wise and Intelligent Bird
Acrylic on Gessobord
8" × 10" (20cm × 25cm)

4 Paint the Light Values and the Finishing Details

Make light green for the feather highlights with a portion of the green feather color, Titanium White and Hansa Yellow Light. With a no. 10 round, paint the highlighted area at the top of the head and along the back.

Create warm white with Titanium White and a touch of Hansa Yellow Light. Paint highlights on the back with a no. 10 round, using separate no. 10 rounds for gray and warm black to blend. Use no. 3 rounds for the finer details. Paint the cere with the same colors, using small, dabbing strokes to show texture.

Make a yellow for the ring of color around the eye next to the pupil with Titanium White, Hansa Yellow Light and a touch of Cadmium Orange. Paint with a no. 3 round, blending with dark orange and a separate no. 3 round. Re-establish the dark outer ring around the eye with warm black and a no. 3 round.

Mix Hansa Yellow Light and a bit of Titanium White to create bright yellow for the scattered yellow feathers on the head. Paint with a no. 10 round.

With warm black and a no. 10 round, begin to paint the shadows that define the edges of the feathers with light, parallel strokes. Blend with a separate brush and the green feather color, using small strokes. Paint the highlighted area at the top of the head in the same way, using the green feather color for the shadows, blending with small strokes of light green.

With no. 3 rounds, use warm black to lightly paint detail in the blue area around the eye, blending with blue. Paint a highlight in the eye with Titanium White and a no. 3 round, blending the edges with warm black and a separate brush.

Continue to paint the feather shadow detail with warm black. Paint feather highlights with light green, blending with the green feather color.

263

Hyacinth Macaws

I observed these hyacinth macaws at the Caldwell Zoo in Tyler, Texas. They were a very loving pair—constantly grooming and nibbling at each other and locking beaks in what looked very much like a kiss.

MATERIALS

Paints

Burnt Sienna
Burnt Umber
Cadmium Orange
Hansa Yellow Light
Naples Yellow
Raw Sienna
Titanium White
Ultramarine Blue

Brushes

no. 3 and 10 rounds
no. 10 bright

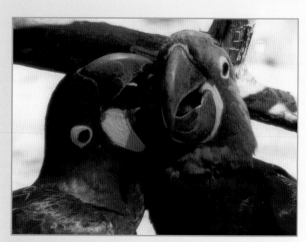

Reference Photo

1 Establish the Form
Lightly draw the macaws onto the panel in pencil, using a kneaded eraser to make corrections or lighten lines. With a no. 10 round and diluted Burnt Umber, paint the basic lines and shading.

2 Paint the Dark Value Colors
Create blue-black with Burnt Umber and Ultramarine Blue. Paint the darkest areas with a no. 10 round.

265

3 Paint the Middle Values

Make a blue feather color with Ultramarine Blue and small amounts of Titanium White and Burnt Umber. Paint with a no. 10 bright following the contours of the birds. Use a no. 10 round for painting smaller areas. When dry, add another coat.

Create yellow-orange for the shaded areas of the parrots' yellow markings with Hansa Yellow Light, Cadmium Orange and Raw Sienna. Paint with a no. 10 round.

Make warm gray for the beaks and tongue with Titanium White, Burnt Umber, Ultramarine Blue and Burnt Sienna. Paint with smooth strokes using a no. 10 round.

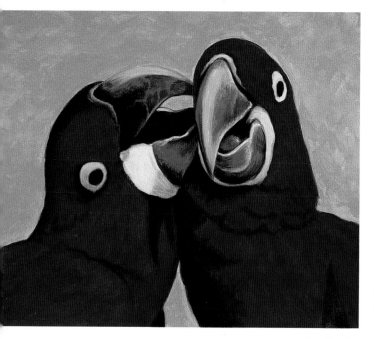

4 Paint the Light Values and Background and Begin to Add Detail

Mix a soft green for the background with Naples Yellow, Ultramarine Blue and Titanium White. Paint with dabbing strokes using a no. 10 bright; use a no. 10 round for around the parrots' outlines.

Mix light gray for beak highlights with a portion of warm gray, Titanium White and a bit of Raw Sienna. Paint with a no. 10 round.

Mix a yellow highlight color for the parrots' markings with a portion of yellow-orange, Titanium White and a small amount of Hansa Yellow Light. Paint with a no. 10 round, blending with a separate brush and yellow-orange.

Begin to add detail to the beaks and feathers with blue-black and a no. 10 round. Paint parallel, light-pressured strokes.

TIP

To achieve a semi-dry brush, wipe the brush lightly on a paper towel after dipping it into the paint.

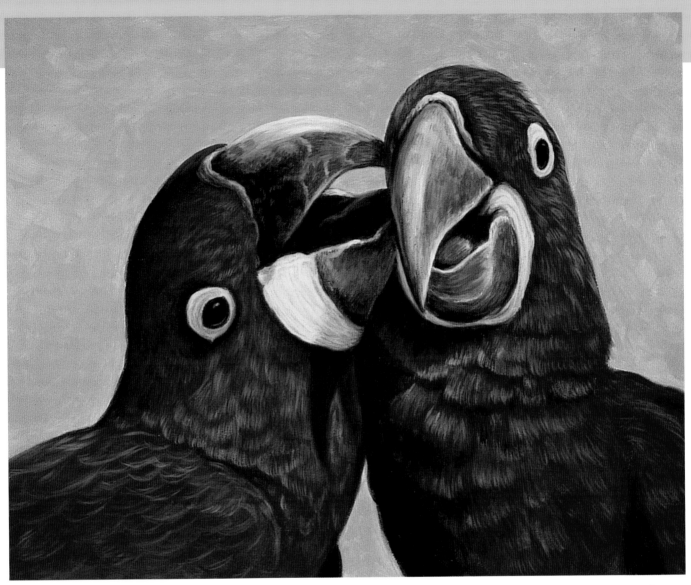

Affectionate Pair
Acrylic on Gessobord
8" × 10" (20cm × 25cm)

5 Add the Finishing Details

Mix some of the blue feather color and Titanium White to create a pale blue for the feather highlights. With a no. 10 round, paint lightly with semidry, parallel strokes that follow the feather pattern. If your paint is too soupy, transfer a portion to a dry palette. Tone down as needed with the blue feather color.

Continue to add dark detail to the feathers and beaks with blue-black and a no. 10 round. Indicate the tongue of the parrot on the left with warm gray.

Mix a rusty orange for detail in the yellow areas around the beaks and eyes with a portion of yellow-orange mixed with Burnt Sienna and Cadmium Orange. Paint thin lines with a no. 3 round, blending with a separate no. 3 round and the adjacent color.

Refine the shape of the eyeballs with a no. 3 round and blue-black. With a no. 3 round, paint the lower eyelids with a bit of warm gray mixed with a bit of light gray.

Paint highlights in the eyes with pale blue. Add a little more detail in the shoulder area of the bird on the left with quick, light strokes of pale blue and blue-black.

Mix a beak highlight color with Titanium White and a touch of Hansa Yellow Light. Paint with a no. 3 round, blending the edges with the adjacent colors: warm gray and light gray. Also, add more detail to the beaks with those colors and a no. 3 round.

267

Index

Little Jack
Acrylic on Gessobord
8" × 10" (20cm × 25cm)

Crimson Forager
Acrylic on Gessobord
8" × 10" (20cm × 25cm)

VISIT

artistsnetwork.com/50animals
for two free bonus demonstrations
of a Jack Russell terrier puppy and
a scarlet ibis!

Jeanne and Leo

Other fine North Light Books are available from your favorite bookstore, art supply store or online supplier. Visit our website at fwmedia.com.

17 16 15 14 13 5 4 3 2 1

DISTRIBUTED IN CANADA BY FRASER DIRECT
100 Armstrong Avenue
Georgetown, ON, Canada L7G 5S4
Tel: (905) 877-4411

DISTRIBUTED IN THE U.K. AND EUROPE
BY F&W MEDIA INTERNATIONAL LTD
Brunel House, Forde Close, Newton Abbot, TQ12 4PU, UK
Tel: (+44) 1626 323200, Fax: (+44) 1626 323319
Email: enquiries@fwmedia.com

DISTRIBUTED IN AUSTRALIA BY CAPRICORN LINK
P.O. Box 704, S. Windsor NSW, 2756 Australia
Tel: (02) 4560 1600; Fax: (02) 4577 5288
Email: books@capricornlink.com.au

Edited by Sarah Laichas
Designed by Elyse Schwanke
Production coordinated by Mark Griffin

METRIC CONVERSION CHART

To convert	to	multiply by
Inches	Centimeters	2.54
Centimeters	Inches	0.4
Feet	Centimeters	30.5
Centimeters	Feet	0.03
Yards	Meters	0.9
Meters	Yards	1.1

ABOUT THE AUTHOR

Jeanne's work has appeared in many exhibitions, including the Society of Animal Artists, Southeastern Wildlife Exposition, National Wildlife Art Show, Masterworks in Miniature, NatureWorks, Nature Interpreted (Cincinnati Zoo), American Academy of Equine Art, the Kentucky Horse Park and the Brookfield Zoo. Several of her paintings are published as limited edition prints, a number of which are sold out.

Jeanne's paintings are published on greeting cards by Leanin' Tree, and she has been featured on the covers and in articles of magazines such as *Equine Images*, *Wildlife Art*, *InformArt*, *Chronicle of the Horse* and *Hastfocus*, a Swedish horse magazine. She is the author of the books *Painting Animal Friends*, *Painting More Animal Friends* and *Wildlife Painting Basics: Small Animals*. In addition, her work has been included in the books *The Best of Wildlife Art*, *Keys to Painting: Fur & Feathers*, *Painter's Quick Reference: Cats & Dogs*, *Discovering Drawing* and *The Day of the Dinosaur*, which was later re-released as *The Natural History of the Dinosaur*.

She is a member of the Society of Animal Artists and Artists for Conservation (formerly known as the Worldwide Nature Artists Group).

Jeanne and her family live on a farm in Washington County, Kentucky, surrounded by woods, fields and the Beech Fork River. They have eight horses, including Squire Horse and Nelly (Belgian draft horses), Starlight (paint), Epona (pony), Poey (Arabian), Win Ticket (Thoroughbred), Chance (grade) and Brenna (Icelandic pony). She adopted the latter three from the Kentucky Equine Humane Center.

Jeanne, her husband Tim, and son Nathaniel often help animals in need, and almost all of their animals were rescued. Their animal family also includes ten dogs, twelve cats, a turtle, two rats, several cows and a mouse. In addition, many wild creatures enjoy the sanctuary of the farm, including opossums, deer, wild turkeys, raccoons, foxes, coyotes, box turtles, squirrels, woodchucks, rabbits, snakes, skunks, crows, owls, hawks, songbirds and buzzards.

See more of Jeanne's work on her website at jfsstudio.com and at natureartists.com.

Ideas. Instruction. Inspiration.

Receive FREE downloadable bonus materials when you sign up for our free newsletter at artistsnetwork.com/newsletter_thanks.

Find the latest issues of *The Artist's Magazine* on newsstands, or visit artistsnetwork.com.

These and ...ht Books for the latest
products ...apers, free demos and
favorite a... ...REE BOOKS!
store or o...
websites a...
and artist...

Visit artistsnetw...
get Jen's North...

Get free step-by-step dem...
reviews of the latest books...
loads from Jennifer Lepore...
Online Education Manage...

Get involved
Learn from the experts. Jo...